Veterans

FACES OF WORLD WAR II

SASHA MASLOV

PRINCETON ARCHITECTURAL PRESS

NEW YORK

Contents

6 PREFACE

8 Stuart Hodes
UNITED STATES

11 Pyotr Alaev
LATVIA

14 Michele Montagano
ITALY

17 Robert Bennett
UNITED STATES

20 Haku Kikuchi
JAPAN

22 Surjan Singh
INDIA

24 Hans Brandt
GERMANY

26 Ken Smith
ENGLAND

29 Herbert Killian
AUSTRIA

32 Tadakazu Usami
JAPAN

34 Jean-Jacques Auduc
FRANCE

36 Imants Zeltins
LATVIA

38 Anna Nho
KAZAKHSTAN

40 Richard Overton
UNITED STATES

42 Dmytro Verholjak
UKRAINE

45 Anatoly Uvarov
RUSSIA

48 Jaakko K. Estola
FINLAND

50 Konstantinos Korkas
GREECE

53 Sidney Owen Kenrick
ENGLAND

56 Harold Dinzes
UNITED STATES

59 Pingching Chen
CHINA

62 Ichiro Sudai
JAPAN

64 Lakshman Singh
INDIA

66 Alistair Cormack
SCOTLAND

68 J. P. Jayasekara
SRI LANKA

70 Alexei Georgiev
RUSSIA

73 Alfred Martin
NORTHERN IRELAND

76 Uli John
GERMANY

78 Anna Potapova
UKRAINE

81 Dutch Holland
CANADA

84 Sidney James Taylor
ENGLAND

86 Jack J. Diamond
UNITED STATES

89 Themistoklis Marinos
GREECE

92 Robert Quint
FRANCE

94 Thomas Blakey
UNITED STATES

97 Shiro Arai
JAPAN

100 Alexey Svyatogorov
UKRAINE

104 Pyotr Koshkin
RUSSIA

106 Luigi Bertolini
ITALY

108 Urszula Hoffmann
POLAND

110 Shiv Dagar
INDIA

112 Agostino Floretti
ITALY

114 Jaroslaw Ferdinand
Wietlicki
POLAND

118 Ioanna Koutsoudaki &
Rena Valyraki
GREECE

120 Yvliang Ye
CHINA

124 Marko Vruhnec
SLOVENIA

126 Nicola Struzzi
ITALY

128 Willie Glaser
CANADA

132 Hans Ransmayer
AUSTRIA

134 Mickey Ganitch
UNITED STATES

136 Roscoe Brown
UNITED STATES

138 Endre Mordenyi
HUNGARY

141 Chisako Takeoka
JAPAN

Veterans came into being not only through a personal interest in the legacy of the Second World War, but also through a sense of urgency—a sense that the stories of a generation and conflict that have indelibly shaped our modern world are soon to be lost. My photos strive to document each life from both a historical and an individual standpoint; in doing so, I am interested in exploring the relationship between the past and present, the personal and collective. The result is a mosaic of people who were all engaged in this incredible tragedy at one moment and in the next were living their separate lives in different corners of the planet. The way that the world came together and then stretched out again, permanently changed, has always been a source of wonder and inspiration for me. Every individual and every country remembers the war differently. It is this diversity of experience that I hope to have captured so that these stories remain and these lives are remembered.

This project began while I was transitioning in my own work from documentary photography to portraiture and thinking about how to tell stories through portraits. *Veterans* seemed to be the perfect project with which to explore that union, for I was equally interested in the historical and personal aspects of each individual's experience. While the interviews helped articulate the historical account, I chose to capture each story through a portrait in order to give a glimpse into the private universe of each person. Perhaps the personal nature of each portrait allows us to reflect more deeply upon the relationship between the large-scale, generational narrative and the unique life story of each veteran.

I was in Moscow with an exhibition when the idea first began to form (although I am sure it had been in my subconscious for quite some time), and I started reaching out to local veterans through friends, family, social media, and archival research. Once I started working on the project, I found an active network of veterans' associations in many countries, and the momentum of social media allowed me to gather a wide range of personalities and narratives, as a result of which the project expanded more than I could have imagined. Especially in smaller countries, the veterans were immensely proud of the role they had played in the war and maintained strong, supportive communities, which they graciously welcomed me into. While I originally had planned to focus on only a few major countries, I slowly began to realize that I needed to seek out more and more voices in more and more locations to begin to do justice to the diversity of experiences of this generation. The project expanded organically and unexpectedly from there. This could happen only because people were so helpful and supportive at every turn, and I believe that is a testament to the way in which almost every one of us feels a personal or emotional attachment to the stories of World War II and to the generation that survived the war.

It was important for me to photograph each person in the interior of his or her home because this environment helped me understand the private world of each individual and helped to portray the contrast between the personal aspect of the portrait and the historical scope of the interviews. I wanted to include things that would signify the individuals and show their lives through their objects and spaces. While it may sound like a cliché, in many cases, their rooms could talk. I tried to understand where to place the hero of each shot—the veteran—within each environment to create a harmony between the veterans and their settings.

Many of the people I photographed have since passed away, and I will be forever struck by their respect and openness. Most of the time, they were happy to be interviewed, and sometimes they seemed to feel it was their final chance to tell their story; I do hope if that is the case that it was meaningful. In other cases, the interviews were more difficult, and there were those who did not want to talk. There were a few instances when people told me things they had never spoken about before or had blocked from their memories. Regardless, a lot of the veterans replied with a note after they received their photograph, thanking me, in many different languages, for coming to speak to them. It is this respect for human connections and generosity of spirit that was one of the most powerful parts of the entire experience.

I cannot precisely formulate the impact that this project had on me, but I can leave you with some of the things that these stories left me thinking about. The timing of this project was very important, not only because there are relatively few veterans left from the Second World War but also because their age made the subjects talk differently about their experiences. There was an incredible power of forgiveness, no matter how big the atrocities were that they had endured, and it was clear to me how much one's perspective changes with time. These stories also made me reflect on how much our world has changed and how different the contemporary generation is. By their early twenties, these men and women had the weight of the world on their shoulders in a way that most of their grandchildren have not experienced. Learning how they went through such tragedies and still maintained the desire to live illuminates so much about the resiliency of the human spirit, as well as the triviality of many of the concerns of today's culture. All of the people whom I interviewed showed a great level of respect, thoughtfulness, and awareness of their environment that sometimes feels lacking today in our increasingly developing world.

This generational difference shows itself in an explicitly visual way and informs my approach to photography. We are living in an age when visual stimuli, in a variety of media, populate the waking moments of our lives. Our memories are inhabited by fragments of life—experiences from around the globe, objects, products, familiar faces—all intricately tied together in a complex web of associations. This visual overload has, in its worst manifestations, made our tastes less discerning and ultimately has degraded the standards that define meaningful photography. Instead of reveling in a complex photo that encourages intense visual engagement and reflection, many viewers now expect to devour and digest imagery in one gulp. It is essential to me that every image I release embodies a sense of purpose and meaning, provokes thought, and sparks dialogue.

I hope I was able to achieve this with *Veterans*.

Sasha Maslov

Stuart Hodes

NEW YORK, NEW YORK, UNITED STATES

My name is Stuart Hodes, originally Stuart Hodes Gescheidt. I was born in Manhattan on November 27, 1924. I grew up in Sheepshead Bay, Brooklyn. My father had trouble with his ears and went to a warmer climate. I think he and my mother just were happier apart. I attended PS 98 for elementary, then Brooklyn Technical High School, which was all boys. I didn't like that. But I loved the things we studied, which included every kind of shop: sheet metal, woodwork, forge, foundry… I enjoyed working with my hands.

I remember the day of the Pearl Harbor attack very well. My brother and I were in the kitchen of our apartment in Flatbush, and we jumped up and down in excitement. We both wanted to get into the war.

I wanted to be a pilot. I'd read the ads in the paper, and in 1942, I went to a recruiting office in Times Square. I was almost eighteen by then. I asked about it, and they said, "Well, you're going to be drafted in a couple of months anyway." And I was drafted into the Army Air Corps in March 1943—we didn't call it the Air Force yet. We wore army uniforms. I went to Camp Upton in New York.

I spent basic training at Miami Beach, where I'd spent a year as a child. I was able to visit my old house. I had planted a palm tree after a hurricane, and there it was, all grown up. From there, I went to Sioux Falls, South Dakota, in June, for training as a radio operator and mechanic. I was halfway through the course when they sent me to preflight training.

I went to preflight itself in August, in Santa Ana, California. Ten weeks of tests. They tested us for everything. We had color blindness tests; we were put in a room with tear gas—all the stuff an army recruit went through. One of the tests was to see if we could swim. We went to a pier and were told to take off everything except our shorts, so we left our clothes in piles and walked a few blocks away. They were going to count to ten, and anybody not in the water by then was going to get washed out. I'd been a competitive swimmer, so I was pleased to lead the parade back to our clothes.

Each stage of training took about eight weeks. When it came time for assignment, the cadets there were going to either become a pilot, a navigator, or a bombardier. My first training was in Wickenburg, Arizona, a desert training facility.

And I loved it there. I had an instructor, one of the best teachers I ever had of any kind. You were allowed to get about ten hours of training, then you had to fly solo. I soloed at about nine hours. The instructor got out of the plane and walked away. He told me to take it around and land. No sooner had I gotten the plane off the ground when it hit me that I loved flying. I loved being in charge of the machine, entering a new dimension. I was absolutely crazy about it.

I flew around, and from then on I wanted to fly every single second. After we had our daily hour—we had a lesson two or three times a week—we would have to sign out a plane and practice. I would sign out a plane, and after the hour in the air, I'd come down and ask if I could get another plane. Most of the time, they assigned me another.

Then I went to Bakersfield, California. I discovered a town about sixty miles away from there called Selma. I was in love with a girl with that name, so I'd fly over the town, and at the end of my flying, I would always do a turn onto my back. Right into Selma… very Freudian—I was aware of that.

Another moment of truth came when I graduated. You had to go to school for multiengine planes—bombers—or for single-engine planes, which were fighters. I was sent to a twin-engine school because they needed bomber pilots. Part of the reason you wanted to be a fighter pilot was the glamour, but the secret was that they were also safer. The casualties were fewer than bombers. We weren't fire-breathing Top Gun types. We wanted to survive.

I almost missed the war. When I got to Italy, we were two months from the end. My high point as a pilot was flying the Atlantic. We left from Labrador to fly to one of the Norwegian fjords, but it was socked in with weather, so we flew to the Azores instead and from there to Morocco. The flight to the Azores was very nice, very thrilling. The reason that we didn't go to the fjord was that a storm passed overhead. We were canceled. The next day we passed through the same storm. This was when I put all the theory to use. It was a large front, six hundred miles each way. So you find a saddle, and you go through it. I went through at about twelve thousand feet, and we were smashed around. But we came through fine and spent the night in the Azores with the rain coming down. The next day we flew through it again. But this time it wasn't so bad, and I went through low. We stopped at Marrakech, and the storm passed over. The next day, on the way to Italy, we passed through it a third time, but now it was weak. We landed in Cairo and spent the night. From there to Foggia in Italy, not far from the spur of the boot.

We were given tents. I guess we flew about two missions a week. I flew seven of them. One night I'm looking up, and they're shooting flares, and that's how I found out that the war was over. Because I only flew seven, I wasn't qualified to return home early.

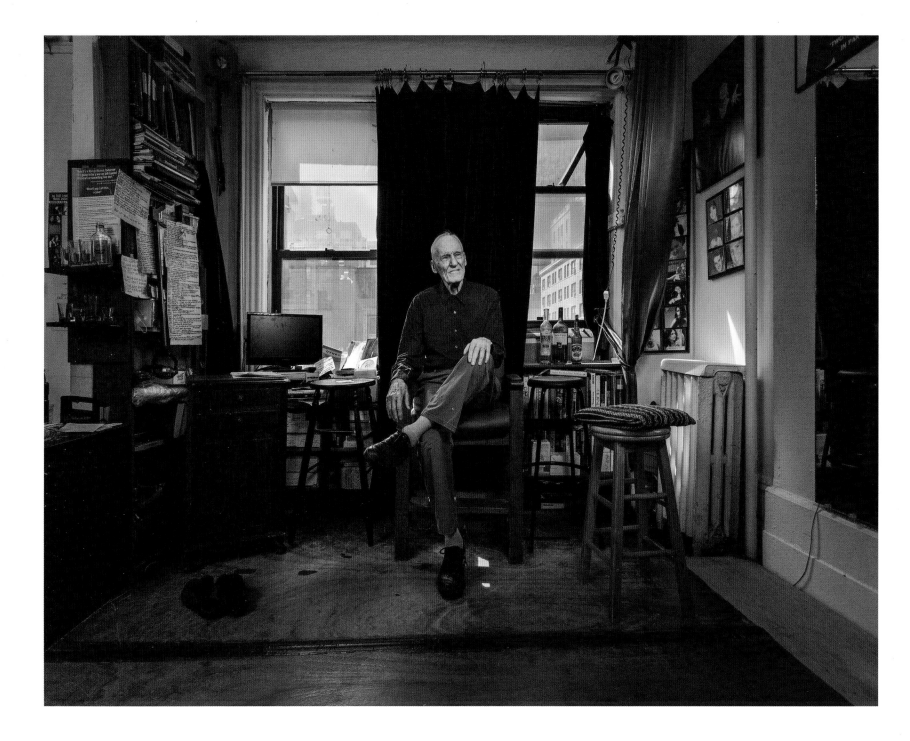

Another mission, we were socked in. The target was covered by clouds. We were allowed a target of opportunity.* I think that this was my sixth or seventh mission. We looked for a bridge. We were over the Alps. We found one and bombed it. I turned the plane on one side because I wanted to see if we'd hit the target. That was the first time I got a real sense that I was maybe killing people.

I was reassigned to the army during occupation. But first there was a project to fly troops back to the USA on their way to the Pacific Theater, which turned out to be a lot of fun. We were transferred near Naples, to a town called Pomigliano d'Arco. About two or three times, a bunch of soldiers would climb into a B-17, which was a very bad transport plane. It couldn't hold many. The bomb bays took up too much room. There were thousands of planes sitting on the ground, millions of gallons of gasoline—why not use them? We'd fly across the Mediterranean, past Sardinia, along the coast of Africa. Then we'd turn through the Strait of Gibraltar, drop our soldiers off, and fly back. It was a two-day thing. I don't know how many of those I did.

But on one of them, flying to Italy, I heard on my telephone that the Japanese had surrendered. It was Victory in Japan Day. I told the soldiers, "You're going home now. You're not going to go to the Pacific." By the time we landed in our field, they were all too drunk to walk. That was a nice day.

Not long after that, I was sent back to Foggia for the occupation. Instead of a tent, we lived in a very nice building. That's when I discovered that I had no job. They didn't need pilots anymore. I was being assigned dreadful tasks. Officer of the day, latrine

* A target against which bombing has not been planned in advance

inspection, God knows what. Someone asked me if I'd like to join a newspaper. I said, "Sure." "Well, you'd be our pilot because we have stories in Rome and in Pisa." I said, "Well, fine." So I joined, and I got out of all the other stuff. They began to let me write articles. That's when I discovered I loved writing.

We had press cameras, and we had our own jeep. We had a darkroom and all the film we could conceivably use. What they called the Class Ten Warehouse. The size of an airplane hangar, filled with lab equipment. Cameras, enlargers, the works. We interviewed people like Padre Pio, who's now Saint Pio—we wanted a picture of him holding his hands up with the stigmata showing. But we didn't dare. That turned out to be one of the best years of my life.

We were offered a chance—some of us—to go to college in Zurich or Lausanne. I could have gone to either one, but I wanted to get home, so I did, in the summer of 1946. It was great to come home and see my folks and go back to college. I went to Brooklyn College to be a journalist or a writer.

But then an odd thing happened. My first job was as a publicity director for a summer theater in Bennington, Vermont, where an actor friend of mine—I'd known him from college—told me that he was studying dance with a woman named Martha Graham, and I went back to college with her name in my head.

One day, I was down in Manhattan, and I looked her up in the phone book and found that her studio was very close. Lower Manhattan, on Fifth Avenue. I signed up for a month of lessons. Long story short, I became a dancer, a foolish thing to do. I stayed a dancer most of my life. I don't know why, except that I enjoyed it. And this, people don't quite understand… it's like flying. When you fly, you're magically taken away from the everyday world. When you dance, the

same thing happens, only you're still on the ground. But you're really in another place. I guess I liked that.

I stayed with Martha Graham for eleven years. I started doing Broadway shows. Some roles, I was a replacement, and some I was there from the start of the production. I started doing nightclubs because it was extra money. I did television between shows. Then I started teaching, and I worked for a while for the New York State arts council, which I liked. When I was offered a job running a dance department at NYU, I took it.

I was in my late sixties when I stopped dancing, and I was deciding that I would try to write again. I wrote a couple of books, and one was published in 1996.

Pyotr Alaev

RIGA, LATVIA

My name is Pyotr Alaev, and I was born to the family of a worker in 1922 in Biysk, which is in Altay. Funny enough, when I was in primary school, a teacher asked us what we wanted to be in the future, and I remember writing on a piece of paper that I wanted to be a pilot. When I was in the seventh grade, a man from a local flying club came to our school. I remember that he was rather well-dressed, wearing a suit, a coat, and felt boots. I think it was in March of 1937 or 1938. I immediately signed in for the medical checkup. When I told my mother about this decision, she was surprised and asked me what was to become of me in the future, then. What kind of question was that? A pilot, of course!

I studied in the flying club for about two years, without giving up secondary school. In 1939, I finished my training in the club, when a representative from Omsk Aviation School came to our club recruiting student pilots. I enrolled in February 1941, and in June, the war broke out. We had already had some training, on small agricultural biplanes. Besides, we used to have those R-5 planes, similar to the modern An-12. We went on to training on SB planes, which were the most advanced modern bombers for the time, as well as I-16 fighter planes, which had a nickname: *ishak* [donkey].

When we were finishing our training, things got pretty tough, indeed. A lot of other pilot schools from western regions were being evacuated to Omsk. So instead of four training squadrons in our school, we had twelve.

After graduating from the aviation school, I, as well as my 120 other fellow students, were sent to the Far East. That was in 1942. They gave us the military rank of sergeant. In fact, we were supposed to become lieutenants, but I guess the economic situation in the country was too tough. If they make you an officer, you should be given higher wages, a new uniform. But as long as we were sergeants, we could go to war wearing the same clothes as we did when we were in pilot school. However, the wages were a bit higher, as we were pilots, after all. It wasn't until 1943, when Stalin issued a decree saying that military school graduates should be promoted to the rank of officers, that we finally became junior lieutenants.

We were doing pretty well in the Far East. I and some other guys from my regiment were given special assignments. Once—it was the first day when hostilities started on the border with Manchuria, near Bikin and Khabarovsk—we were given the assignment to destroy all the communication lines of the enemy, which basically meant hitting the wires from above. They even organized some training for us so that we could practice hitting such narrow targets.

You can't imagine how patriotic we were at that time, but it's hard to expect anything else from nineteen- or twenty-year-olds, right? We even thought of raising some funds and buying our own plane. A small biplane could cost, say, forty-seven thousand. By that time we had already bought some clothes, boots, et cetera. So the plan was to club together and buy another plane, and if we didn't have enough money, we could always cut wood in the taiga, where we were staying, and sell it. Our political supervisor (deputy commander in charge of propaganda) kind of liked the idea, but then his superior officer came from Khabarovsk and criticized us, saying that it wasn't good for a fighting unit to engage in that sort of trading.

Interestingly, three months later, somewhere in April 1944, we found out that our commander had gone away to headquarters. When he was coming back on an SB plane whizzing low above the ground, he made a special stunt in the air, and our officers understood that we were about to set off to get some new planes. So two weeks later, we flew to the west, to Zaporozhye, where we were trained to fly on the Pe-2, which is a dive bomber. There, we finally received our planes, straight from the Kazan aircraft plant. In fact, those planes came as a gift from Lozova. *Kolkhoz* farmers from that area collected money to buy us those planes, so our squadron was called Lozovskiy Kolkhoznik.

In 1943, we had our bases on airfields that were literally fields, or agricultural fields leveled with rollers. You can imagine having to land on this! Once, we had a flying mission to bomb the Vistula. There were nine of us in the group of bombers. A usual bomber plane crew consisted of a pilot, a navigator, and a gunner who was also a radio man. The latter was sitting in the third cabin. The battery was also located there. So when we were coming back, the gunner told me that the battery was boiling. I told him to switch it off, but once he did it, the communication ceased as well. I was about to land but noticed that the previous plane had not yet left the runway. So I took another circle around, when I understood that the plane was in complete disorder. I had to land it as soon as possible, but that field was a complete mess: snow mixed with earth and God knows what.

Before too long, I realized that I had lost the right course. Luckily, I saw an IL-2 attack plane flying ahead of me. I guessed that it was heading for its airfield, so I followed him. I got a warm welcome there. Planes that had a forced landing were usually received well. Then they checked my plane and found out that there

was an oil leakage in one of the two engines, and the antifreeze was leaking in the other. They wired to my unit. It turned out that it was thirty kilometers away.

Being a pilot, you don't really have time to look around. Your main job is to fly the plane and keep up with the rest of the group. If you lag somewhere behind, you'll definitely get hit. There were usually four fighters escorting us—two on either side. It felt safer that way.

I remember one assignment when we flew out to bomb some crossing. One of our pilots was not allowed to fly that morning, because he had gotten loaded up the previous night. As our group was incomplete, they gave us a new guy. In fact, he wasn't really new; he even seemed to have more experience than us. All his chest was covered with medals. So he was in the leading group of three planes, flying on the right-hand side in front of me. We were about to make a turn and fly back home when he suddenly started to fall back on me. I naturally fell back on the one behind me, and the whole formation got disrupted. To make things worse, my radio man reported that there was a strange plane approaching us from behind with an unusually long body. German planes —Messerschmitts, for example—had just this kind of long body. So I told the radio guy to give it a burst from his machine gun. We actually had two of them: a large-caliber 12.7-mm short-range machine gun and an ShKAS, but the former one got jammed. Some sand must have gotten inside. That was a hot battle, I should say. Luckily, we survived it.

Later, in September 1944, we were sent to the first Belorussian front. Brest-Litovsk, Brest, and then Warsaw. We made flights with all sorts of missions. Once, we even bombed the ice on the Vistula River so that the retreating German troops could not cross the frozen river. We also attacked groups of tanks, mostly at crossroads, where they were most visible. Our regiment bombed Finsterwalde, Frankfurt an der Oder, and some other German towns.

Not long before the war ended, we had a flying mission near Werneuchen, which is a big airfield. I also took part in three air raids in Berlin. We bombed the railway stations where most German troops were located. First Silesian and then Stettin railway stations. We had some flying missions in Seelower Höhen as well.

One thing I remember very well is Berlin. It really struck me to see its gray dim buildings, which were very unpleasant to look at—at least this is how they seemed to me from above. It was very different from Zaporozhye, for example, with its pretty white houses and tile roofs.

Once, we flew to Stęszew, and our task was to bomb a road there. However, when we arrived, we saw a huge number of German troops, so the commander of our squadron told us to attack them, forgetting the initial assignment had been completely different! So we did hit them, and quite successfully, I should say, but none of us was awarded for that, because we were not authorized to change the task. Discipline should always come first.

We were staying near Landsberg, a town on the Warta River, which is now known as Gorzów Wielkopolski, when we learned about the victory. There, in Poland, I continued my military service after the war was over.

In December 1949, I found myself in Vilnius. Because of my deteriorating eyesight I couldn't fly anymore, so they transferred me to the command post. Our job was to send our fighters to patrol the air space so that everybody could see that we weren't sleeping there and the border was being guarded. Once in a while the Americans would send out their planes flying along the Baltic border, so we had to send ours too, as a warning.

Then I was transferred to the Far East and then back to Germany. In 1956, I was sent to Sakhalin, where I served for three years as an aircraft controller. It was already Khrushchev's time, when a lot of people in the army were made redundant. Some people had only one year left before their legal retirement after twenty-five years of service, and they were made redundant all the same.

I was lucky to survive those redundancies. I was sent again to Germany, where I stayed until 1967. I was even promoted to the rank of a major, and I served as a deputy commander of a unit.

Have you ever watched that old Soviet movie *Only Old Men Are Going to Battle*? Where Bykov's character organizes an amateur music band in his squadron? [During the war] we also had something like that. There was that talented guy—Sasha was his name—who wrote poetry and music. We even had our own small orchestra! You know, bottles with different levels of water in them to make different notes. One would make a melody on this makeshift xylophone, and somebody else would accompany him on the accordion.

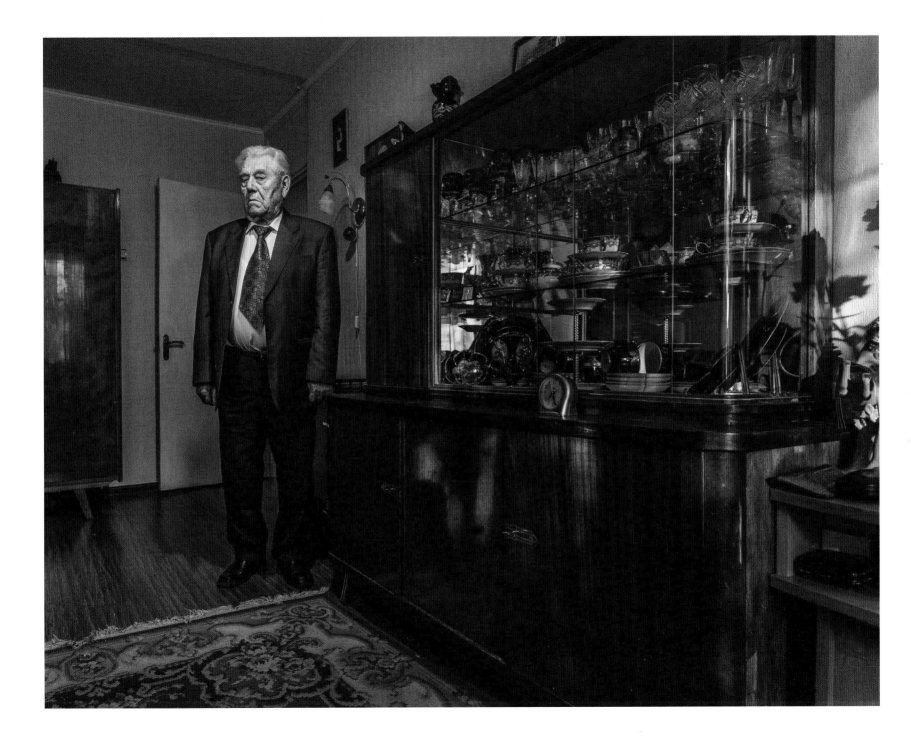

Michele Montagano

CAMPOBASSO, ITALY

I was born on October 27, 1921, in Casacalenda, Italy. My father was an elementary school teacher there. I studied in Casacalenda, and then I went to Campobasso High School. I graduated in 1940, almost the same day that Mussolini declared war, and traveled to Rome to study law. In 1941, I was called back by the state to enlist as a soldier and joined the army on February 1, 1941. I took an army course and became a sergeant. I was sent to Cephalonia and Corfu in Greece with the Acqui Division of the Italian Army—the same division that Hitler destroyed in 1943 in the Cephalonia Massacre. I returned from Greece soon because I had to take another course. I was promoted from sergeant to a lieutenant in Italy.

In September 1942, I was sent to Gorizia, in northern Italy. I was one of the GAF, a group of soldiers fighting against the Yugoslav Tito Partisans. This group of soldiers resembled Alpini soldiers because they used to wear similar hats. It was a tough situation. There were people all around the mountains and valleys who were fighting us. In the daytime, they were smiling and saying hello to us, but at night, they were our enemies. Tito's Partisans didn't have uniforms, so you never knew who they were. Besides that, temperatures were freezing that winter.

In September 1943, the state ordered us to immediately return from Yugoslavia. We had orders to bring with us all the people that we could: teachers, civilians, farmers, et cetera—everyone we found on the road. Thus, we had quite a sizable crowd of civilians and soldiers heading back to Italy. The Nazis were still in the city of Cremasco, Italy. It was easy for the Germans to arrest all these people and put them on the train to Germany. Italy had just become the enemy of Germany, and they didn't know that all these people were from Yugoslavia. The Nazis caught us on September 11, 1943, two days after we returned from Yugoslavia.

They put us in the train wagons and asked us, "Do you want to fight for Germany, or you want to fight with Allied troops?" Everyone provided the same response: "We don't fight against the United States and England, because our king said, 'Now, our enemy is only Germany!'" Just a few freshmen agreed to fight against the Allies, but the vast majority refused to fight against their country, and they willingly chose to go to the prison camp. This was the first and only time that Nazis asked their prisoners to choose what they wanted. They never gave a choice to their Polish, English, or any other prisoners before, and had directly sent them to the camps. The worst thing was that the Germans treated us like animals. There were about fifty or sixty passengers in each train car, which was closed, and we remained inside without fresh air for nine days. The German soldiers used to stop the train at five o'clock in the morning each day, in the freezing weather, and would give us two minutes each to attend to our personal needs outside.

We were then taken to various places, including Chesnokovo, Russia, on October 1, 1943; Ternopil, Ukraine, on November 2, 1943; and Ciche, Poland, on December 27, 1943. They were really angry with us, and they gave us very little food, about one piece of bread to each of us per day! It was very cold in December and January, but we had to stand outside, either during the day or during the night, so that the Nazis could count us. We had been severely suffering from cold, hunger, and lack of sleep.

The Italians still fighting for Germany put out a newspaper. And German soldiers would give it to us occasionally, hoping that some of us might think about joining the German Army after all. From the newspaper, I came to know that my father was also a German prisoner in a nearby camp. So I asked the German officer if I could see my father, and he said yes! It was the first time that I heard a Nazi saying yes to anything.

In my father's camp, there were a lot of high-ranked army officials. A few of them had died from the cold weather and starvation. The people who were left accepted the offer to fight with Germany against Italy, including my father. They took me to see my father so later I could tell my fellow prisoners about the situation in my father's camp. I could tell them that if we didn't agree to fight against our country, we would die there!

It was a beautiful reunion with my father. Everyone in the camp got emotional and happy when we kissed and hugged. A few minutes later, my father told me that he was going to join the Fascists and fight with the Germans. Though I respected his decision, which was made very much out of necessity, I felt like I was going do what I had set out to do and not join the Germans. Therefore we were father and son by nature, but enemies by politics!

They let me stay with my father for twenty days, but I didn't change my mind. My father did change his mind once and told me that he would not join, as I would be left alone there. But I told him, "No, you have to join the party; your other sons are waiting for you back in Italy." I told him that it could be the only way he could be freed from this prison. After twenty days, my father was set free and taken back to Italy, and I went back to my prisoners' camp. Before leaving, I told my father, "I swear on the flag of Garibaldi to have my faith in the Italian republic and Italian king. I swear I will never give even one of my fingers to Hitler."

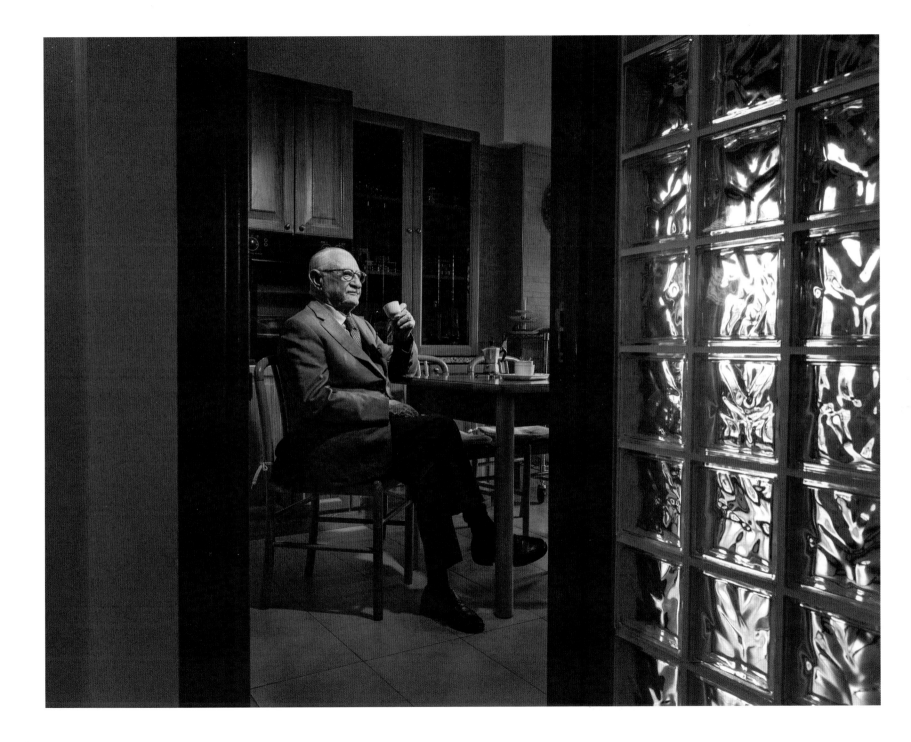

When I went back to my camp, I told them about the situation in my father's camp. So the prisoners in my camp divided into two groups. One group consisted of the people who accepted the offer to go against their country, and the second consisted of those people who didn't. I was among the second group. The people who agreed were taken back to Italy. People, including me, who didn't agree were taken to another prisoner camp. The other camp was close to Poland, and the rumor was that there was a strong Polish resistance growing. So we had a hope that we would be freed.

Polish people tried to save us and to take us back from the Germans, but they couldn't stop our train. We were taken by railroad to another camp in Sandbostel, Germany. We arrived in Germany on March 24, 1944. In that camp there were a lot of university teachers. They all used to have discussions about international law. I designed a regular discussion panel, and it was like taking courses at an Italian university.

However, some kind of sickness broke out, and the Nazis stopped coming inside the camp. They used to bring food and water on a rolling cart and just leave it by the door. We suddenly felt free because we didn't see the faces of Nazis for a long time.

An agreement between Mussolini and Hitler took place, which required that all the Italian army officials and soldiers be treated as civilians and go to work like civilians. But all the officials refused to work and give up their uniforms. The Germans took us from the Sandbostel camp to another camp, where there were 214 soldiers and Italian army officials who refused to work. The German soldiers then divided these 214 officials into groups of 10. For every 10 people, they picked 1 person. In this manner, they picked 21 of us. And then one of the German prison

guards said, "You're never going to see these friends of yours because we're going to shoot them." At this moment, 44 other officials, including me, said, "If you kill our friends, you will have to kill us too, because we will never work for you. We are officials, and the international law says that you cannot make official soldiers do civilian work." The Nazis then took us instead of the 21 they had picked earlier and took us outside to be shot. Most of the soldiers had pictures of their wives and kids, and they started looking at them and praying. We waited for six hours to be shot, but nothing happened. Later we heard that it was decided on the government level to leave us alive to avoid conflict with the Italians who were loyal to Germany. Anyway, we were transferred again to a new prison, where they had all kinds of people. The guards were mostly Russian and Polish, and those people were animals. They used to kick the prisoners all day long, to let them die with broken heads and bones. This camp was called Unterluss, where our destiny was basically to die!

We stayed there for forty days, and six of our fellow soldiers died. One of them was shot in the head, and the other five died because of the beatings. After forty days, the Allied troops appeared. Just like that, in a day, they took over everything, and we were free. We exploded with happiness when we heard on the radio that our war was officially over. That was in the beginning of May 1945. At the same time, I was worried about my father.

Right before the Americans came, we asked the Germans to give us some bread. They said, "If you want bread, you have to sing for us because you're Italians and you're good singers." We started to sing, and after that they left us all the bread they had. The Americans facilitated provision of the most basic things we needed, as we were not only starved but

naked, too. The Americans also took us to the hospital in Celle, Germany, where we stayed for fifteen to twenty days. We were then taken back to another camp, where about fourteen thousand Italians were waiting for the train to take them back to Italy. The Vatican assisted by sending hundreds of trucks to pick up the Italians from Germany. I was on one of these trucks.

When the truck passed through the Garda Lake in Italy, I saw the blue sky, the blue water, and suddenly my heart felt joy, and I knew that I was home! I came back to Italy on September 1, 1945. I rushed to see if my father was alive, and I was really happy to see him at our home. However, I found a catastrophic situation because my mother and father had three more children, who had no food. These three kids were my cousins. My mother adopted them after the death of their parents.

I decided to leave for northern Italy to search for a job. I found work in Milan at Shell Petroleum, but I was really depressed because of my horrific memories of the German camps. However, I fell in love with a woman in Milan and forgot about all the misery and pain of the concentration camps. Later, Shell sold the company to an Italian company, and I lost my job. I came back to my family and started to study. I graduated and then started working again at a bank in Campobasso. I then fell in love with a young lady in Casacalenda, and we got married. We had two kids, a boy and a girl. Unfortunately, my wife died and left us all grieving seven years ago. I live with my nephew now, who takes care of me. My daughter also lives with us, and my son lives close to us. We get together four to five times a week, and we have dinner together. The only sadness in my life is that my wife left me so soon.

Robert Bennett

ENGLEWOOD, NEW JERSEY, UNITED STATES

My name is Robert Bennett. I was born Beno Benczkowski in the Free City of Danzig on March 15, 1933. I lived there with my parents and my sister. In 1939, Mr. Chamberlain gave Danzig to Hitler, and it became very uncomfortable for us, so we moved to Lodz, where my family was from originally.

My father started his business in Lodz and was doing pretty well for about a few months, when the Germans came in and we were forced to move into the Lodz ghetto, where we all lived in one room with my father, my mother, my sister, and my grandmother. In the ghetto, we worked in a factory that made uniforms for the Germans. I was at the time seven years old, and I worked on a buttonhole machine.

We didn't have much food, but the whole family was together. Every so often, they would clean out the ghetto. My aunt was a pharmacist, so she had a special pass, and she was able to get in and out. She sometimes would put a lock on our door from outside. That's how we survived many of those cleanouts— the Germans thought that there was no one inside the room, since it was locked from outside.

The life went on; we managed somehow. But in 1944, we decided that we couldn't keep on living like this, and the ghetto was almost empty, so we went to a meeting with this German officer, who gave us a German word of honor that we were going to this other place that would be much nicer, where they would give us clothing, better food; we'd be getting a new job…

And that's how we wound up going to Auschwitz-Birkenau. When we got off the train, they separated us—men to one side and women and children to the other. They told us we'd be getting in a shower and getting new clothes, which I thought was a shame because I had this really nice coat on. I figured they wouldn't let me take a shower with my mother, so I stayed with my father.

Finally, we got to this man, who I later found out was Mr. Josef Mengele himself. He asked me how old was I, and I, for some reason, said twenty-one. I didn't look anything close to twenty-one, obviously, but I did speak perfect German, and maybe that's why he let me go by. Then everyone needed to be examined by a doctor, and by that time we were all completely naked. All of a sudden, a capo* pulled me from the line to the other side, where the people who already went through the doctor were standing. I never found out who this person was, but he saved my life; I'd never have made it through the doctor, as they were looking for the strong, able men for labor—all others were sent to the other side.

Of course, we didn't know anything at that point. In fact, when we were going through all that mess, I smelled something in the air, and to me it smelled like, you know, when my mother used to clean out the chickens and she would burn up the feathers. I asked my father, "What's that?" and he said, "Ah, they're probably cleaning up the chickens to cook." But it was burning hair from the chimneys.

Then the night came. We wound up in this hangar. And every few minutes, we heard: "Whoever has gold, diamonds, whatever hidden—drop it, because we will X-ray you and find it." And sure enough, there was stuff lying on the ground. That went on all night long. Finally, they gave us uniforms, and we went to the barracks.

*A prisoner working as a camp guard

On that morning, they lined us up. I was in the first line because I was the smallest kid. The officer that was doing the count had it in for me. When he got close to me, he swiped me with his hand, and he broke my nose.

My father applied for all kinds of jobs because we knew that if we didn't get out of Birkenau, we would end up in the ovens. But they didn't want to take me. Finally came a guy from BMW, and my father told him, "Yes, I'm a mechanic"—which wasn't true—"and my son has golden hands." I guess that man was a nice guy, and he accepted us together.

On the way to the train, we passed the women's camp, and someone recognized my father and called my mother. That was the day I saw my mother and my sister for the last time. It took me a long time to find out what happened to them. Eventually, I discovered that they were sent to Stutthof concentration camp, and that's all I know.

We were on a train and ended up in Görlitz, Germany. And same thing—there was a camp, and the officer who was in charge was this little Czech guy. From the signs on his uniform, we could tell he was a criminal, but he was in charge of the camp. Anyway, they lined us up, and he was walking along the line, and once he approached me, he looked at me, and guess what? He hit me in my nose. Again!

In our camp, we were working at the Messerschmitt factory, and I was working on the landing gear, particularly on the pump. My job was to put a leather sleeve on the pump. This pump would close up on me, so in order to avoid that I would put a wrench inside to hold the pump and then take it out. One day, I forgot to take it out.

Two Gestapo guys came and said, "Sabotage." They took me to the head of the factory, who happened to be the guy who interviewed my father in Auschwitz.

So I explained the situation, thankfully being able to speak perfect German. I told him what happened, and he said, "Yes, he's right—it wasn't a sabotage, just a mistake." That only got me ten lashes, which was better than being killed.

That headmaster saved my life twice. First, when he took me and my father out of Birkenau, and this second time, with the wrench. Later, I was trying to locate him or his family; I wrote to BMW, and they said that the factory was completely destroyed, along with all of the records. So I never was able to thank him.

The guards at the camp were Ukrainians. Some of them were nice to us; some of them weren't. We only got a piece of bread in the morning and soup during the day, and sometimes the Ukrainian guards that didn't finish their soup would give it to us. But some would just throw it away. I used to be on the cleaning duties at the dining room, and, as a matter of fact, on the first day a Ukrainian soldier came to me, nodded and smiled, and made some motions with his hands mimicking the mopping of the floor that I was doing. Later, that soldier came to me and gave me his whole soup. There were also some Russian soldiers and some Russian women among the workers, and a Russian woman would give me a potato once in a while. So there were some nice people.

One day in May, we heard the noise and we saw silver planes zooming over. Someone said: "Americans." Soon after that day, one morning we woke up and there was no one there. All the Germans were gone. We cut the wires but were afraid to go outside because we didn't know what was outside. We finally decided to go outside of the barracks, when the guards started to shoot at us. Got me right here, under my left arm, but I ended up escaping anyway.

When we were in town, Germans started inviting us into their houses, saying, "Come on, we'll help you." At the same time, Russian planes were flying very low, barely over the roofs of the houses. We stayed in the basement of a German who said that he was a Communist. All of a sudden, all Germans were Communists.

Next morning, the Russians entered Görlitz, and, oh boy, they were in rough shape. The first Russian I saw was on a bicycle with no tires, and he didn't have any boots on, just some rags tied around his feet.

Anyhow, my father, myself, and two other guys took over a house and stayed there for a couple of weeks until we were recuperated enough, and then we started to march back to our home in Lodz.

There was no transportation, so a lot of people were marching in every which direction. We had a little wagon on which we put a lot of scraps, food and stuff we took from the Germans, and there were a lot of incidents along the way, as you can imagine. Everyone was afraid of the Russians now, because they were all crazy for three things: bicycles, motorcycles, and women.

When we finally got back to Lodz, we started looking for our relatives. We couldn't find anybody, except one cousin. There were only about five hundred Jews that were left in the ghetto. And those five hundred were made to dig graves for themselves. I guess the Germans didn't want any witnesses and wanted to clear the ghetto. But the Russians came just in time. That grave is still open, as far as I know, and those five hundred were lucky not to be in it. Among those five hundred, there was a friend of mine. I saw him shortly after I got back to Lodz, and what was funny—we were the same size when I left the ghetto, and now, he was twice as big as me. But I gained weight and strength soon enough.

So we went back to Danzig for a little, but there was nothing there for us. We then went to Prague, and from there we worked our way west to Paris. There, my father got in touch with my aunt, who was in America. She wasn't able to get us a visa to the States, but we arranged a Cuban visa. We were in France for about three months, waiting for the visa to get approved, and then we wound up going to Cuba. We actually went through New York and spent about a month here, and what big mistake it was, not just staying here. But we couldn't think about doing something illegal like that, so after thirty days we went to Cuba.

It took us five years to get a visa to get to America, and finally, on December 31, 1951, we arrived here. The Korean War was going on, and five or six months later, I was drafted into the American army. I was in the army for three years. I got back in May, and in September, I got married to my wife. I was working as a cutter. Later, I started my own business, Superior Pants. I started with making pants, then leisure suits, and later tuxedos.

I miss my work. I try to play some golf; I go to the gym every day and play with my dogs. I have my family: one son and three daughters. I got fourteen grandchildren, and as of yesterday, I have my third great-grandchild. My family today is twenty-four people. Just imagine if out of the six million that were killed, an average person would have half of that—how many Jews would there be today.

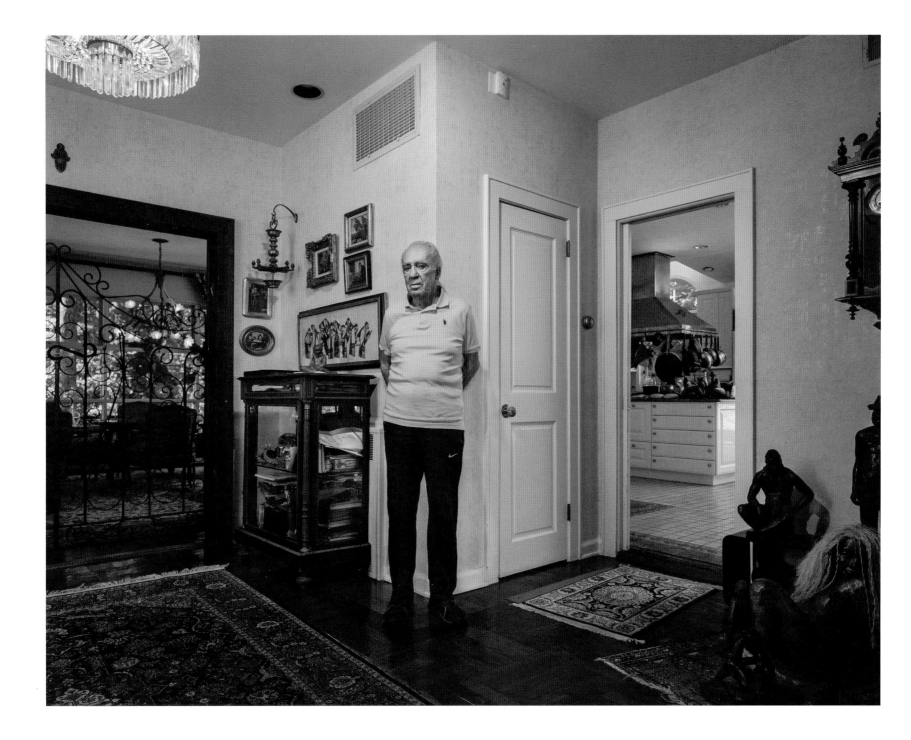

Haku Kikuchi

TSUKUBA-SHI, JAPAN

I was born in the Ibaraki Prefecture on June 10, 1929. I was born into a family of farmers; I didn't find much difficulty in getting food. Generally, the quality of life was low in Japan. It must have been hard for others. My father was a fisherman before he was married. He sailed on a big ship, traveling all over the world, to America and Great Britain. He married a woman from the next town over. I was the fourth of six children and the only boy. We mostly farmed when we were young. The other men in the area went on to be soldiers.

I began training in 1941, in Kashima city, at twelve years old. I was young. I wanted to help out Japan. I had no fear of death. We had been taught that we should be honored to die for the country. Everyone was brainwashed. We all thought it was noble to die for Japan. So I applied to become a child pilot when I turned fourteen.

All these American planes would fly over and bomb us. When the Japanese airplanes met them in the air, the Americans would shoot them down. I do remember being very scared then. Once, a bunch of P-51s flew over. There were so many, I couldn't see the sky. They shot up everything.

Emperor Hirohito had the ultimate power over all the citizens. When I heard the war was over, I thought everything was ended. I didn't even think about what would happen next. We had been told that we were winning. We couldn't believe it at first. Then again, we were brainwashed to believe the emperor was God. After we heard his admission that he wasn't God, we lost our will to fight. There were so many people who died for nothing in the war. We were embarrassed.

The Americans came and established bases where we had our training centers or our old bases. They were waiting to see if the citizens would do anything against them. But I never thought to attack. They didn't really affect our lives directly after the war.

My father, having traveled so much, spoke a little English. Some Americans would come to our place, and they'd meet to go hunting with him. He found them very friendly.

The biggest problem was poverty after the war. Even the people with good jobs had difficulty. There was so little distinction between the poor and those who used to be rich. I only saw some difference in the 1960s. Industrial progress began to pick up then.

After the war, when I reached adulthood, things were still difficult. If you were stronger, you got to survive. I fell under the influence of some people I knew and became a yakuza. I realized later that the government should be the most important aspect of society. I started to work for a politician, in government. I retired when I turned fifty.

Now, I'm much older. I've given up many hobbies. I have a weekly group; I meet with young people and listen to their stories and give advice.

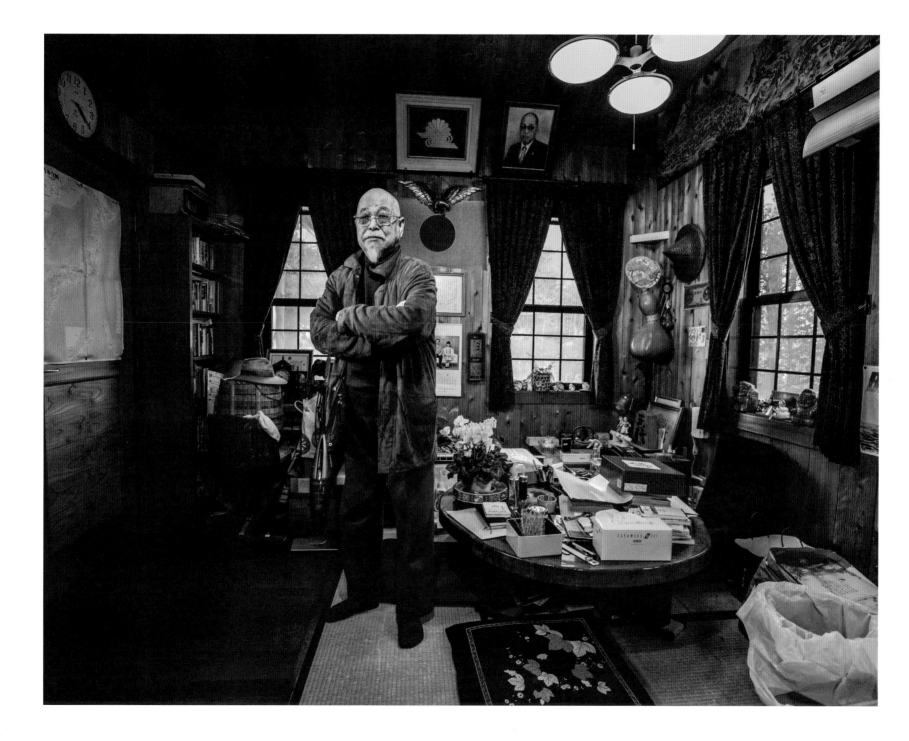

Surjan Singh

NEW DELHI, INDIA

My name is Surjan Singh, and I was born on July 29, 1921, in Delhi. I had a pretty good childhood. India didn't have a great education system, but I made the most of my formative years. I was a playful, energetic child, always interested in having fun in my village.

When I reached fifteen, my family believed that it was time for me to begin working on the family farm. The fun of my childhood was over when I realized just how bad things truly were. The British were in control in India, and they were basically pillaging our land.

Many people across India were forced to work in the agricultural industry. Eventually, it got to the point where so many were doing this that it was very hard to actually succeed. Besides that, there was mass malnourishment across India, and my family felt it as much as everyone else. What little farmland we had, it wasn't producing enough to keep us properly fed.

How would I survive if I was literally dying of hunger? By the age of eighteen, I felt that my best option was to volunteer for the army. It paid fifteen rupees a month, which was vital income for my family. Additionally, I wanted to serve my country in the terrible conflict that was going on.

Upon enlistment, I was sent to Madras for basic training. My memory is a bit hazy, but I can remember learning how to drive, how to conserve my body, and how to be an effective soldier overall. We used to run for kilometers at a time. In the military, I also became familiar with pistols, hand grenades, and rifles. By the time I had graduated basic training, I felt like I was suited for combat.

We Indians were the lowest rank in the entire Allied Forces. Our entire command was British. They didn't even have the decency to learn our language—we had to learn theirs. We would be in the trucks, training, and they were saying, "Go left; go right." Because we had such a poor education system, we had no idea what they were saying sometimes, but we soon had to learn or risk catastrophe. A misunderstanding in a combat situation could be fatal.

We were deployed to Burma first. Japan was a formidable enemy. We had tanks, machine guns, rifles, and even horses for combat. All of us were prepared for the worst, but it soon became apparent we weren't prepared for the Japanese tactics. The Japanese were waging aerial attacks against us, shooting and even throwing bombs out of planes. Our regiment spent most of the time hiding in the mountains and forests from overhead attacks. We had weapons that were capable of many things on the ground, but not in the air. So we couldn't even use them! What would a rifle or even a machine gun do against a plane?

I can remember once, we were traveling through Burma and I was eating in the car. Our cars were relatively low quality. Instead of windows, we put up bamboo sticks to shield us. The car made a sharp turn, and I was flung from the car like a cartoon character! It's funny in hindsight, but my fractured knees and one-month stay in the hospital weren't very funny.

One story that's not funny at all is what happened to a gentleman from my village who was also in the war. He and a few other soldiers were arrested by the Japanese and kept as POWs for six years. Many in the village thought that he was dead, as there was no trace of him. He very nearly was, he told us later—the Japanese were going to kill him. They had thousands of POWs, but after losing the war were in no condition to feed and maintain all of them. Their initial plan was to mass murder the Indians, but the revolutionary Subhas Chandra Bose's affiliation with Japan got him and the others spared. On his say, all Indian prisoners were released and sent back to India.

In 1945, we heard that the atomic bomb was dropped. As devastating as the effects were in Hiroshima, people a hundred kilometers away were also getting sick. Our commanders gave us masks, so we wouldn't be affected by the radiation. After we heard the news about Japan surrendering, we were ecstatic. We all chanted, "We're saved!" and rejoiced in the possibility of going back home. Not long after, we were sent back to India.

Once I got back to India, I was faced with the same issues of my past. I wasn't educated, so I couldn't get a decent job. I went back to the family farm and lived off my pension from the Indian Army.

Soon, India was divided, and the Muslim portion of the country was renamed Pakistan. There was a lot of tension that grew into a conflict, so splitting the country was seen as the best alternative.

After retiring from the army, I married my wife, Khajini Devi, in the 1960s, and had four sons and one daughter. Today, I mostly spend my time relaxing with family. This life is much better now.

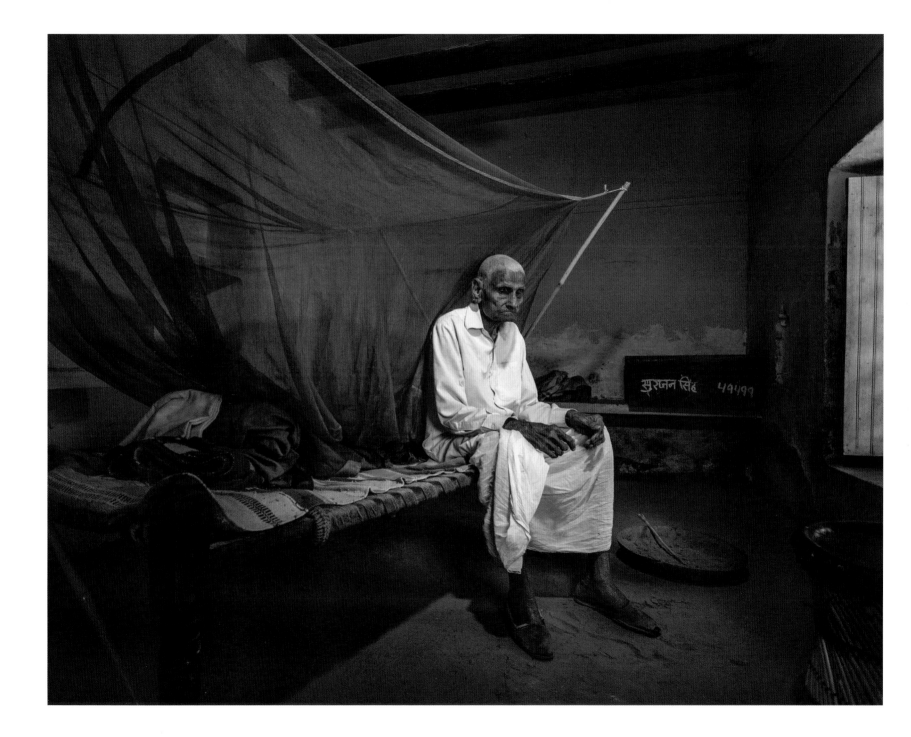

Hans Brandt

CHEMNITZ, GERMANY

My name is Hans Brandt. I was born in Chemnitz on December 25, 1925. I went to school here.

I was sixteen when I was conscripted. And when I was seventeen years old, I started to learn how to work with antiaircraft systems. I was sent to Czechoslovakia first, in Mährisch-Ostrau, for training. I advanced in rank; then, we went on to France in 1943, near Paris. There, we built new units. I was tasked with securing the airports.

When the Americans arrived in France, on D-Day, I went to Regensburg, Germany. We were given the orders to retreat, and that's when I was captured. I was eighteen.

They paraded us through many towns in France, to display us as a symbol. There were two or three thousand of us imprisoned in the camp. We got very sick because for several days we didn't have anything to eat or drink; we could barely stand. We were told that the food we did get was from destroyed German shipments. They divided us into several groups, and I was part of one assigned to go into the forest to cut firewood.

By the winter of 1944, I was placed in an internment camp in the north of Normandy. I remained there until 1945. Before the Americans came, it had been a fully equipped German camp, but it had been destroyed, and we had to rebuild everything for the winter weather.

Later, I was transferred to another camp in Le Mans. In March, I was taken to Marseille, where I remained until April 3. From there, we went on a ship to Gibraltar and on to New York. The journey lasted twenty-six days. By then, Germany had surrendered.

In May, I was sent to a smaller camp and was put to work with dairy machinery. We were observed by Americans, but they were forbidden to talk to us, and we weren't allowed to talk to them. I never learned any English. I only ever spoke German with other prisoners. There was an American woman who gave us orders directly, but this was forbidden, so the Americans shot her in the leg. Just because she spoke to us. But the man who shot her, he was sent to Japan to fight because her punishment had been too severe. We didn't understand at the time why he shot her. Mostly, we communicated through motions, moving arms and legs.

We were in groups of ten people in the camps, and we wanted to survive, so we decided to say that we were all artists, all musicians, to avoid the harder work. The Americans believed us. There was one very tall man, a man who looked like he'd worked hard all his life. They asked him what instrument he played, and he said, "I play the harp." They never asked us to play these instruments. I said that I played the trumpet.

In November, they moved us to Boston, where I worked at a paper-processing plant. At the beginning of December, we were sent to Le Havre on a big ship, the *George Washington*. There were three or four thousand prisoners aboard.

From there, we left by train, and the Americans turned us over to the French. We arrived in Berlin, and from there, I was sent to mine in the mountains for coal. We were to be paid, but we got only half of our salaries, with the other half promised to us once we were free. I tried to flee the mine in April, but I was recaptured within a few weeks. Eventually, the prisoners in the east were turned over to the Russians. We came to Eisenach, Germany. I was freed on December 6, 1948. We never got our money. The French kept it. The Russians gave us a single deutsch mark each, in small change.

I returned to my town, to the place where I had worked as a locksmith. The manager asked me if I would enroll in studies, because many educated men had been killed in the war and those with a good education were in demand. I began my education in Chemnitz, in a facility for workmen and agriculture workers. Then I went to Dresden and studied to become an engineer. I finished university in 1957.

In the meantime, the town changed its name from Chemnitz to Karl-Marx-Stadt. I worked so well when I came back that I was promoted to second director. We built cooling systems for trains.

In 1967, however, I became very sick and was too ill to continue working. And when I regained my health, I worked only in the planning aspects of my profession. By 1990, when everything changed again, I was sixty-five. I was lucky because after the train factory closed that year and many people lost their jobs, I was able to retire.

I had been friends with my wife before the war. She was a widow and had a son. Her first husband had died in Slovenia. We married in 1950 and had four more children together. The children all went on to have good professions. Before 1990, they were able to travel only around East Germany. Later on, they traveled around the world.

We had a wonderful garden that the family would work on together. I just prepared it for the winter. But I'm getting too old to tend it now.

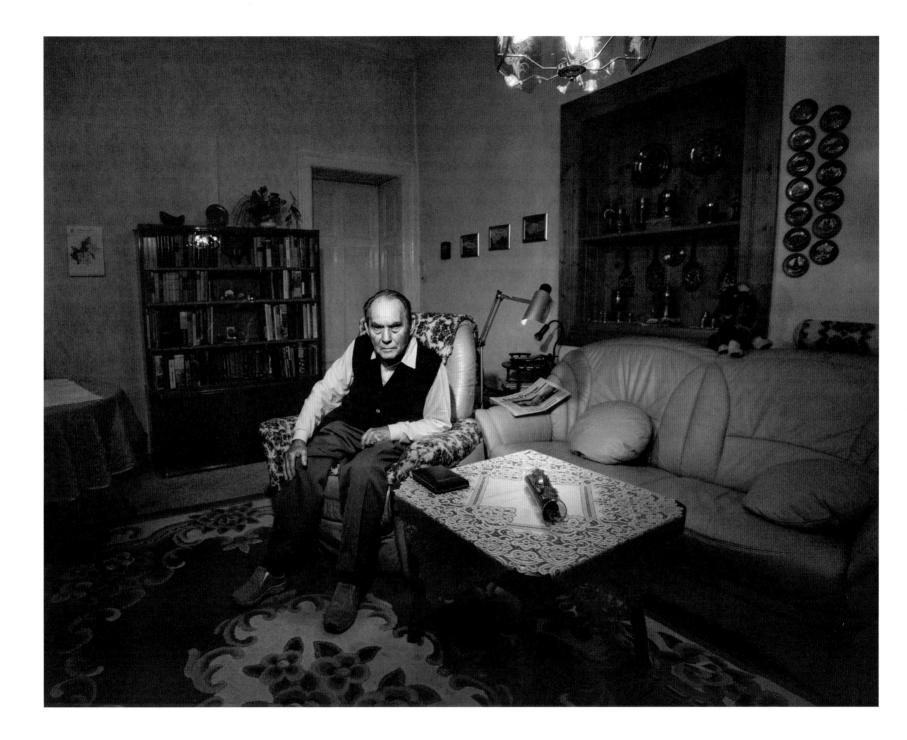

Ken Smith

PORTSMOUTH, ENGLAND

My name is Ken Smith. I was born on April 12, 1922, in Portsmouth. My parents were very religious. I was in the dockyard choir. I left school at thirteen. I worked on houses. I used to make flights of stairs until the war, when timber became so scarce the government commandeered all of it.

I remember the day the war broke out. I was in church that day. At eleven, Chamberlain was going to make an announcement. I ran home. I remember him saying, "We are at a state of war." We were told to be ready for air raids. The first thing I did, I went down to the bottom of the garden and dug a big trench about eight feet long. I was there the whole day, expecting an air raid that night. But during the night, it rained heavily. I couldn't stay there. The next morning it was filled up with water.

I loved football, and a friend of mine said, "Join the Royal Marines; you'll get plenty of football." I joined when I was eighteen. I did six months of training near Dover, where we expected the invasion to begin. Every night we used to stand on the beaches. When the invasion didn't happen, I was moved to Plymouth. I passed two naval gunnery courses and was sent up on a ship in Newcastle, HMS *Manchester*.

We used to go around Iceland looking for German weather ships. We'd live on the upper deck in the bitter cold. We'd live around the guns. We pulled into Scapa Flow off the coast of Scotland for supplies, and I was on the meet party to our biggest battle cruiser, which was the HMS *Hood*. I went aboard to get supplies to take over to our ship. The next morning, I received a telegram that said my father was dying. I tried to get leave, and I put in a request to see the

commander. Because I was a gunner, he said no. I asked for the captain of the ship: he said no. So I said, "Can I see the admiral?" He was on the *Hood*. I put in to see the admiral. I had to dress up in my best uniform. While I was doing that, they spotted the *Bismarck* coming out. The bugle went, and we shot out of Scapa Flow. I was dressed in my best and had to go down to help hoist the ship's anchor.

We went looking around the north of Iceland, up the east coast. The *Bismarck* went around the Denmark Strait. The *Hood* went along the south. The *Bismarck* sunk it, blew her to bits. We chased the *Bismarck* until we ran out of petrol. We were lucky enough that the *Bismarck* was sunk about a week later.

We took a convoy down to Malta, stopping at Gibraltar to organize a larger convoy. We were near Malta when we got attacked by torpedo bombers. The stern of the ship was blown away; we had a lot killed. The ship was heeling over, and I fired. I tried to aim uphill where we were tilting, where the deck was covered in blood and oil. There were bodies all around. We managed to make it back to Gibraltar, and we were patched up there, but they weren't equipped for all the repairs we needed.

Those days, when you left port, you never knew where you were going. You were zigzagging all the time, avoiding U-boats. And after all those days at sea, where we were living around the gun, I said to the gun crew, "I wouldn't be surprised if we were going to Canada or America." Shortly after, the commander of the ship said over the radio, "The ship is bound for the United States of America." Within ten days we approached the American coast, then up the Delaware River to Philadelphia. It was marvelous, seeing it all lit up. Hundreds of workmen came aboard. Right away, they started to repair us. They weren't in the war at the time. This was hush-hush because

they didn't want to be involved. We spent months there. It was a lovely experience, traveling around, playing football.

In December, I was playing for the ship's football team against an American representative team in Camden, New Jersey. I was on duty that day, so I had to go straight back to the ship after the game. I was at a bus station in Philadelphia, where there was a news office with these big, glittering lights flashing the news. I looked up and saw "American Battleship Sunk." I couldn't believe it. It was only when I got back to the ship that I learned what happened. The Americans joining the war was a blessing for us.

Once we were repaired, we went down to Florida, then to Bermuda, where we met one of the worst storms I've ever encountered. I thought, "Oh no, we'll never get out of it." We pitched and tossed and rolled. We eventually arrived back in England, and I left the ship so the repairs could be completed. I was sent to another ship, the HMS *Penelope*. The *Manchester* was sunk the very next convoy.

Right away, we went to the Mediterranean. We were known as HMS *Pepperpot*, we were hit and blown up so many times. The Germans were about to invade Greece in 1941, so we left Algeria and bumped into a German invasion armada on the way. We sunk most of it. While leaving, we were hit with a bomb. We had a lot killed on the gun deck. The sergeant major asked me if I would like to be a commando. I said, "Anything to get off this ship." They were forming a special air service, which was top secret. I was sworn not to tell anyone. I joined the unit and left the ship. The *Penelope* went out shortly afterward, and she was hit with three torpedoes, and 417 men went down with her.

We boarded a train in Alexandria, to Cairo, then caught another train to Palestine. That's where the unit

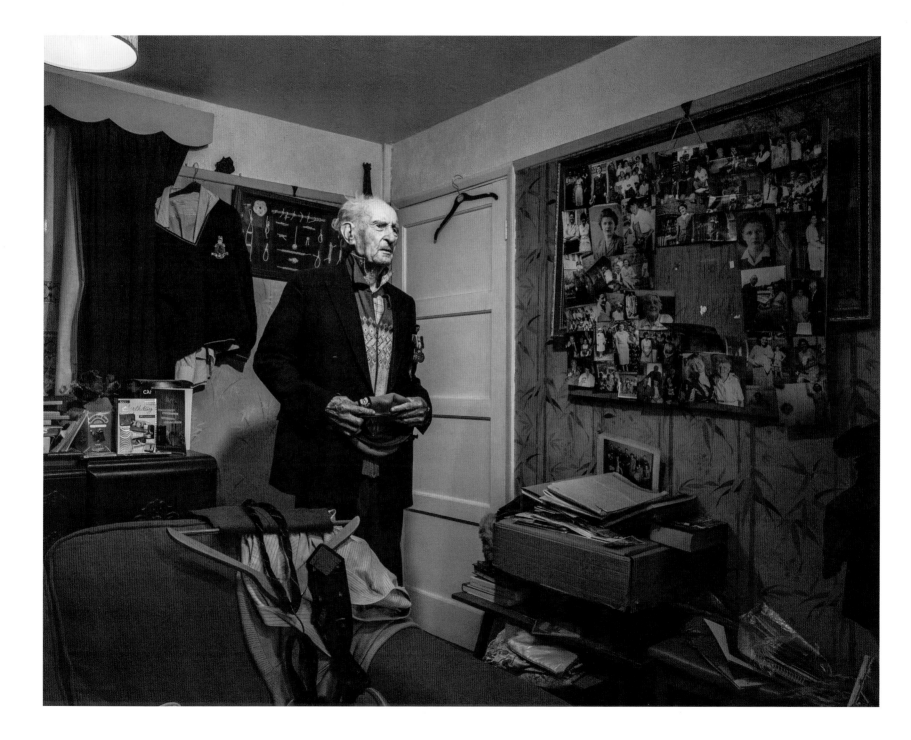

had its base, in Haifa. I continued doing raids after my training. I did ski training; I did a parachute course. I took a gunnery course in Jerusalem. I got sent to Cairo to do a few days' sniping course. I went to the pyramids, where they had a range. I was a patrol sniper. We were sent up the Dodecanese Islands. I was attached to the special boat section, on two-man canoes. During the training, we would go to sea every night, and we'd have to swim back to shore. If we didn't make it, there was only one punishment—return to the marines. Luckily, though, I was very fit. I was sent to Italy. From there, to Albania. We lived in the mountains for a couple months.

We did commando raids on various islands. I got a bullet in the arm in 1944; it's still there now. We did one raid where we landed at night on the island of Lošinj, in Croatia now, and climbed the mountain with a guide. He knew we were going to blow the place up, and he wouldn't show us. We tried again another time, but the Germans had taken over from the Italians and were waiting for us. They opened fire. I got hit then. We got under a tree. It was dark, and I said to the sergeant, "I think I've been hit." My hand was all sticky.

Later, we discovered a German in the bushes. He had a stick grenade. I took it from him and lifted him and slung him on my shoulder, dragging him along. Then I heard this bang in my ear. This prisoner had gotten his gun and shot himself. I heard it drop, and I thought, I'm going to have a souvenir.

I was at the back as we were going up the mountainside. I lost a lot of blood, and I could see that I was in trouble. So the officer came and took over for me and said, "Go up front." One of the marines was guarding a prisoner, and I was going to take the prisoner from him and escort him back to a ship, on the other side. The prisoner was older than I was.

He was badly wounded and mumbling. I told him to shut up. It was getting to be dawn.

They sent a few sailors to shore to help, and they paddled us back to the ship. The German soldier had messed himself; he had his trousers down. Smothered in blood, resting on the deck. They helped me up and told me to go down to the mess deck. Just as I was about to go, I collapsed.

I came to in Yugoslavia, on a cruiser. There were a lot of sailors there. Around me, a lot of other people on stretchers. I was flown back to Italy. The hospitals were so full with the wounded, I was laid on a stretcher in the corridor. From where I was, I could look out and see all these badly wounded chaps with legs hanging up in the air, all wearing awards. I wasn't a serious case.

After a few days, I was sent back to the front line, to Lake Comácchio. It was my birthday. We would be out in our two-man canoes, marking the way across the water for the fleet to come through. Then I heard the Germans going on the roadside. It was all horse and car then because they had no petrol. I could hear the Germans singing as they walked, and I was fascinated. As they approached, they started firing. I said to the officer, "I'm twenty-two today, sir." He replied, "Everybody paddle for your bloody lives!"

We zigzagged, paddling until we got out of range. A few hours later, the officers sent for me and congratulated me on being awarded with the highest award, with wings over my medals instead of my arms.

When the war ended, I was sitting on the roadside watching hundreds of thousands of prisoners go by. The Royal Marines in this SAS unit were ordered to return. I was on the first boat back to England. I got a couple of weeks' leave before I was sent to China, to fight the Japanese in Hong Kong in late 1945.

After that, I was recalled to Malta. I had to teach young marines arms drills. But I dropped the rifle when a pain in my shoulder was too much for me, where I was shot. I was sent back to England and discharged. I was considered disabled. I took up building again. I retired at sixty-five. I had nine children.

My only hobby is growing chrysanthemums. I love growing them. They're so expensive, but so rewarding. I live for them. First thing in the morning, I spend all my time sifting the soil, getting a nice mix.

I'm still here. And the only reason I'm still here is because I was a choirboy. I was brought up in the church, and that's the only reason I'm still here, I think. The years are hard to remember, but I can recall the exploits like they were yesterday.

Herbert Killian

VIENNA, AUSTRIA

I was born in Austria in 1926, in the city of Korneuburg. I attended high school in Stockerau. At fifteen, I was conscripted. At the time, I was not enthusiastic or fanatical, but I did admire the regime. I was happy and felt well protected. We had been taught about the war in school, and we helped out, focusing on civil activities like providing the population with water, as well as construction efforts. For twelve years, I was part of the Hitler Youth. As part of my duties, I supported farmers during their harvest seasons because many farmers were also soldiers.

In 1943, I was stationed at Wiener Neustadt, working for the Luftwaffe. Later, I transferred to a different unit in Poznań, Poland, that helped provide medical treatments. After this, I returned home and became an active member of the military. By June 1944, we received orders to repel the invasion of France. But when I got to Paris, I was immediately sent home because the Americans had landed successfully. By that September, I was transferred to Slovakia. In December 1944, we moved to Germany, near the Eifel Mountains. After this, we marched through Luxembourg to Belgium because most of the transport means had been destroyed. We lacked winter equipment, and we were starving. We spent much of the time on our journey hunting deer. We intended to meet the Americans in Bastogne, Belgium, but we lacked the equipment and necessary support and failed. We had to sew our own winter clothes out of things like curtains and cushions; the population suffered because we were taking their materials. I am very lucky that I wasn't wounded; many other soldiers with me were wounded or killed.

I was then tasked with gathering the wounded and caring for them at a hospital. There were three of us. We searched the grounds near the hospital, which had been captured by Americans and subsequently abandoned, and we found food in the forest—breakfast foods, chocolate, things we hadn't seen for a long time. But we were spotted by the Americans. I wanted to open fire, but the others asked me to surrender. We had no chance.

They imprisoned us, and we found ourselves sent to a camp where many of our colleagues already were. The Americans questioned us about the "wonderweapons" they suspected our military was developing. After that, they moved us to a former German airfield in Compiègne, France. We were integrated into the larger camp, which totaled about one hundred thousand people. We lived in tents, in January cold, and we had little food, no beds or winter supplies. Then one day, we received many supplies: straw for the ground, a stove, some more food. We were surprised by this. It turned out that there was an independent commission arriving from Switzerland, consisting of Americans, British, Swiss, and Germans. They were there to check on the quality of the camp. Once they left, the supplies were all taken from us.

I had a friend in this camp. Together we decided to escape from our imprisonment. Escape was relatively easy, since there were few guards—it was basically an open field, so we just snuck away. After three days, we met a young farmer. We spoke little English, but we pretended to be Americans. He didn't believe us. When the farmer went to notify the authorities that we were hiding, other farmers from the village surrounded and captured us. One of them spoke German and treated us kindly. Much to our surprise, we were taken into a house, and he cooked for us and we were allowed to eat as much as we liked. He said that he

had been a prisoner of the Germans and they treated him well, so he wanted to give back something. We were hoping to be freed, but they still intended to hand us over to the French police. We were then taken back to the camp.

In March, we were asked to volunteer for a labor camp. I thought that it would take me farther east, closer to Germany. I was lucky because I ended up in the city of Russ. I was assigned to maintain the garden of the headquarters there. They provided me with plenty of food, and it was not a bad time.

There were three of us, as before, and one of us worked in the kitchen. He snuck us extra cans of food. We stored them in the yard and planned for another escape. We waited three weeks to leave, and this time we had plenty of supplies. We traveled only at night. However, one day, we were feeling thirsty, and we had an orange with us, and two of us wanted to eat it and the other wanted to conserve it. He left after an argument over the orange.

The remaining two of us had run out of food by the time we reached Verdun, France. Eventually, we came across a train that was headed east, and we jumped on. The train soon passed a train station, and it was bright and there were many French and American guards. All but one of them overlooked us —a French soldier. I saluted him, and he saluted back, and nothing happened.

The next day, as the train was crossing a large river, I said to my friend, "This could be the Moselle River," which I knew was the border. On the other side, we jumped off. For a month and a half, we walked across Germany. We rummaged through the ruins of homes, searching for supplies. This was 1945, and the war was over.

By May 1947, I was back in school. I lived in an apartment, and the house beside us was occupied by

a Russian soldier and his family. The Russian barracks were across from where I lived. One day in June, I was studying and heard a lot of noise outside. Some Austrian and Russian kids were fighting. I shouted at them, and they left. Later, they returned, teasing me and throwing rocks at my window. I got into a physical altercation with one of the kids and got arrested. I was taken to Vienna, given a short trial, and sentenced to three years, the maximum penalty for hooliganism.

I was shipped across the Soviet Union by train. I was categorized as a common criminal and sent to a gulag labor camp among murderers and thieves, harder criminals. They took us by boat to Magadan, in the Kolyma region, where there was a gold mine. I lived in temperatures as low as minus fifty degrees centigrade. I got weak from the scarcity of food. There was a quota, and because I didn't meet it, they gave me even less food. After a while, I had dropped to just thirty-six kilos.

One day, I escaped the camp and survived nine days on my own without food. I was lucky that after those nine days, I somehow ended up back at the camp. I fell unconscious shortly after arriving. This was a psychologically difficult period. I didn't think I would ever get out. There were no Austrians. It was mostly Russians, some Germans. I was alone.

Much to my surprise, I was eventually released from the camp. Immediately, I went to the police and told them that I wanted to go back home. The officer asked me if I had money, and I said, "No. I have nothing, but I expect that the Russian government, which has taken me here for free, will also take me back for free."

The officer replied that when I was taken to Siberia, I was a prisoner. Now, I was a free man, and it was my responsibility to get back. I had to find a job, which was difficult because I had no work

experience. Luckily, I found one at a nearby hospital, using some skills I learned in the war. After four and a half years of this, someone advised me to write a letter to the Austrian embassy, and I received a passport. At that time, I was living in a barracks with a lot of ex-criminals.

The day we heard on the radio that Stalin had died, everyone was crying. I didn't know how to hide my feelings because I was happy he was dead.

The passport I got was valid in all of Europe, but I wasn't allowed to travel beyond twenty kilometers of the town I was working in unless I transferred. I wrote letters to multinational corporations, asking to be moved from the area. I got permission, finally, in October 1953. I soon sent a letter to the embassy and asked them to remit the money for my journey home. But I never heard from them. I hadn't spent much of my pay and had gotten extra wages from a labor dispute with the hospital where I worked. I traveled to the port, where the last boat was leaving the next day. After that, the water would be frozen for eight months. I couldn't get a ticket, and the boat left without me. My permit to leave would expire in just four weeks. So I went to the airport, only to find that there would be a three-week wait. Frustrated, I went to an officer of the secret police, and I lied that I was an Austrian journalist and there was a conference going on in Moscow and I was stuck there. He looked at my passport and found no proof of entry, but he believed me and supplied me with a voucher to get my ticket for the next day.

It was a small airport, surrounded by mountains. The only transport to this region, even to this day, is by plane or boat. There are no trains or roads. Every day, only five planes departed from the airport. They were small, seventeen-passenger planes. The flight to Khabarovsk was five hours. Luckily, I still had enough

money for a flight to Moscow. There, I discovered that the ambassador of the Austrian embassy was a relative of mine, which I didn't know. I made it to Austria by train.

I learned that my mother had died during my time away. There was no home waiting.

It was a challenge reintegrating from a society of criminals to a civil European society. I had left home at fifteen and now returned at twenty-eight. After all this, I finally finished school. But I didn't want to socialize with anyone. I wanted only isolation, and so I decided to become a woodsman. I felt like a foreigner in my own land.

At the end of the war, we did see American footage of the concentration camps and the massacres, and we thought it was propaganda—we laughed at it. None of us knew about the crimes of the Nazis. We only learned long after the war was finished, and even then we couldn't believe it. I only reconsidered my thoughts about the regime after I returned from Russia.

Eventually, I met a woman. I had lived for years among only men, and they had been paranoid—some criminals, others spies. I just wanted to build a family. The forest where I worked belonged to a nobleman. I had to apply for his permission to have the marriage approved, and he declined my request, so I terminated my employment and got married anyway. I am still with her.

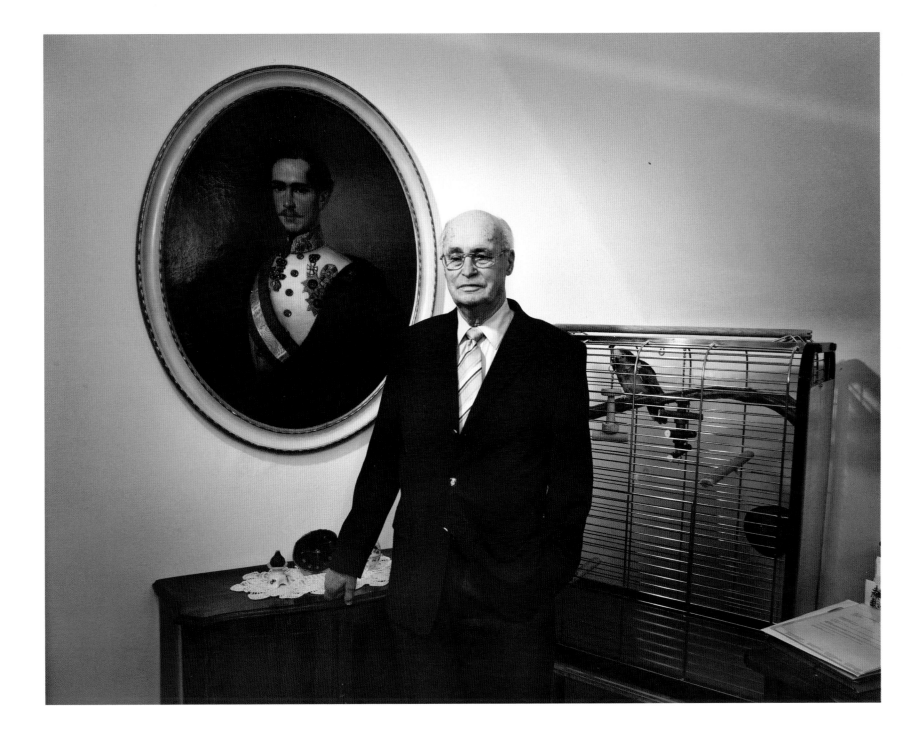

Tadakazu Usami

NARITA, JAPAN

My name is Tadakazu Usami, and I was born in the village called Otsuka in the year Taishō 9, which, in the Western calendar, I think means 1920. My kids tell me that my birthday is January 20, 1920. My youth was modest and busy—I was an active child.

We were prepared to fight from an early age. My school had military classes, and I learned to shoot a rifle when I was just twelve. The draft age for young men was twenty at the time, and I was looking forward to the day I would join the armed forces of our emperor. The day I turned twenty, I volunteered for the army. The Sino-Japanese War was already in full swing, and after completing my basic training, I joined Aoyama Infantry, Seventh Regiment, and was sent to Hebei, China.

We didn't consider it a world war or anything like that—we saw it as a war to prove the power of Japan and our emperor. No one knew that things would turn out the way they did. I was a young kid; of course, propaganda played a trick with my mind, and I was fanatical about the war.

China was very exciting, but not in a very good sense of the word. Wherever we went, from day one, there were people dying next to me, bullets flying in all directions. That was a real mess. But what could I do? Our commanders would say, "We're moving here tomorrow," and we move here. They say, "Move there," and we move there. We had to honorably follow the orders of our leader—we were soldiers. At that time, I started understanding what the war really was about, and most of all, I was just missing my home. It was tough to survive every day, to go through all the atrocities and violence; you had to distance yourself from your body and become a different person. And just fight to win, like they taught us in our training.

One particular fight was crucial for my regiment. We were going back and forth along the Great Wall for a few days, trying to confuse the enemy and get them where they least expected us. But at some point, we got surrounded by the Chinese Army, and my whole regiment was practically wiped out. I got shot in my right arm during that fight, and I was among the very few who survived. I still consider myself lucky to be alive.

After some time, I ended up in a hospital in Peking and spent two years there. Then I returned to Japan to be reenlisted, but because of my disability I wasn't fit for active duty, so I worked at various military-related jobs. I was working for the Tsudanuma Railway Regiment as a security person, and then I continued my duty in Wakayama city ship engineering, Ninth Regiment. At that time, some people started talking about the fact that Japan was losing the war. I refused to believe that—I thought it impossible.

Later, I was sailing military transport ships to Korea and back. And that's when the war ended. I felt a great shame and couldn't speak with anyone for days. I still feel ashamed, even though now, I have a much clearer image of what was going on and how we all were fooled into believing what we believed.

There's nothing else to say. I hope that you'll excuse me. I often have dreams about my fallen comrades calling me from beyond the grave. I feel guilty that I was luckier than many of my fellow soldiers.

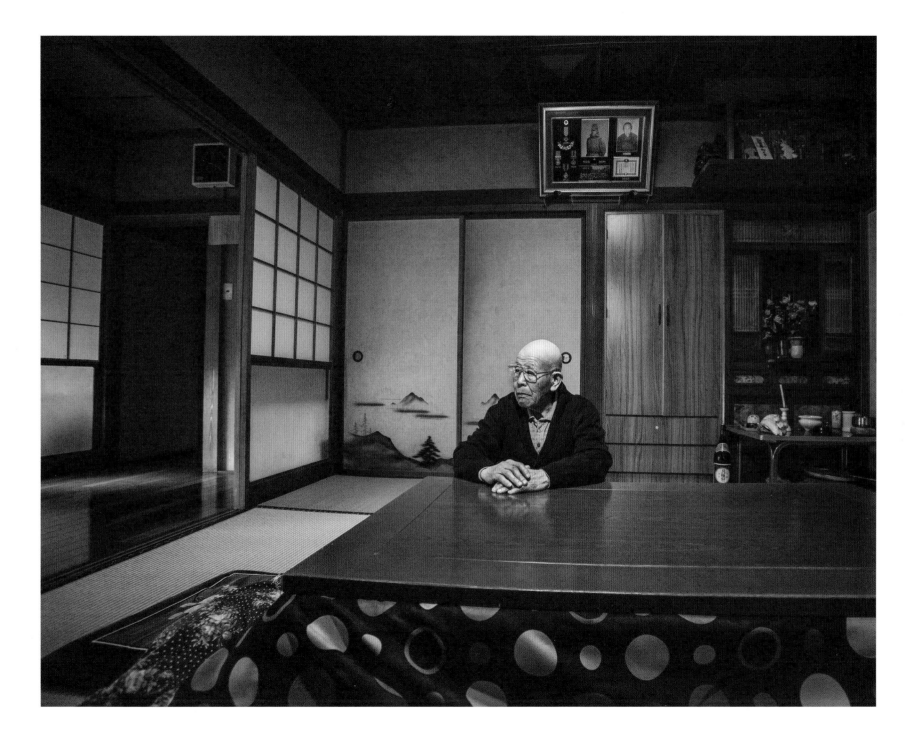

Jean-Jacques Auduc

LE MANS, FRANCE

My name is Jean-Jacques Auduc. I was born on July 9, 1931, in Cérans-Foulletourte, to a modest family. My father used to make windmills. My mother was a secretary. I was nine when the war started. Our father was imprisoned by the Germans, but he escaped. On his way home, on May 10, 1940, he came upon an orphanage on the border between France and Belgium, where they had slaughtered a hundred children. They had killed everyone there. That's when he decided that he would go into the resistance.

My parents, uncles and aunts, and grandmother joined. Our job was to gather information, but also to take care of American or British soldiers whose planes had crashed. I could go everywhere that adults couldn't. I would retrieve messages from a hotel, where they were hidden behind a radiator, and I would bring them to my grandmother's house. I kept them in the handlebar of my bicycle, and I cycled the twenty-five-kilometer distance. It was very difficult to get out of Le Mans at the time, because of the German and French police everywhere. But as a child, I never had problems.

One mission I had came from the British photos of the airfield in Le Mans. They had noticed a fleet of planes, so I went there with my kite, to play. The German soldiers were quite old and not very frightening. They even played with me. I realized that the planes were made of wood—they were fakes. The Germans hadn't even painted them underneath. So I sent the message, and the British dropped fake bombs carved out of wood, like a joke that was also an intimidation tactic. They wanted the Germans to know that they didn't have complete control, that there was resistance. To make them paranoid of spies hiding everywhere.

Guns were sometimes parachuted behind my grandmother's house. The whole family had to be there because there was much to be carried away immediately. I used to keep watch. Once, I gave the alarm. It turned out to be just some cows. But they still congratulated me because I was eleven and I was doing my job carefully.

A few Allied pilots had been shot down around the surrounding villages. One of them was David Butcher, in Poillé-sur-Vegrè. He was a tail gunner for a B-17 bomber. The tail section had been shot, and he parachuted into a field. The nine other men on board were all killed. We kept these survivors at our home because we couldn't take them through the Pyrenees at the time—we would've been arrested.

Four Americans stayed in a small room in the attic. My mother made fake papers for them at her secretarial job. They were supposed to be deaf and dumb. I was the one who escorted David Butcher, and I was apprehended for it. I was scared—I was twelve then. But he gripped my hand to signal me not to run away. He took papers from his pockets that explained his condition. The Germans seemed apologetic. We were very scared, but they let us go.

My parents were arrested in early November 1943. One of our neighbors was waiting for me at the end of the street and told me not to go home, that the Gestapo were waiting. Because I was a child, they knew it would be easy to make me speak. My family had expected something like this, so there were plans. I was to go to Paris, where somebody from the organization would be waiting for me. When I arrived, there was nobody—that person had been arrested also. I didn't know what to do. However, I was lucky because one of the men helping with the luggage in the station approached me after seeing that I was alone on the platform. It turned out that this man was from the same village. He took care of me for a while.

Three months later, my parents were sent to a camp. Our mother in one, our father in another. Everyone separated.

I had several addresses where I could go, but I had to keep moving. There was one place I stayed for three days, and the Gestapo arrived the day after. The last people I stayed with were prostitutes in Montmartre, who were very nice to me. Some people didn't want me in their house—it was too dangerous. But the prostitutes kept me safe. Eventually, I was able to return to my grandmother's house, where my brother was, because the Gestapo had lost interest in me.

We used to listen to British radio, and that's how we knew the landing had taken place on D-Day. There was mainly hope, the end of the nightmare. When the war ended, we placed this hope in the Americans.

As a child, I thought only about seeing my parents, my mother. Most people didn't know what the concentration camps were. We thought that they were like factories where people were sent to work. The horror was unimaginable at the time. One of my uncles was killed there. My father and another uncle managed to return. While my mother was in a camp, she was sold to a laboratory for experiments; 98 percent of these women were killed. But she came back, though in a bad state. The doctors said that it would be good for her to have another child. She died five months after my sister was born, at forty-one years of age.

Later, I ended up studying forestry. I spent my time in the forest with animals, as my father had done. I currently belong to the French-American Association. I have a medal that was presented to me by General Eisenhower.

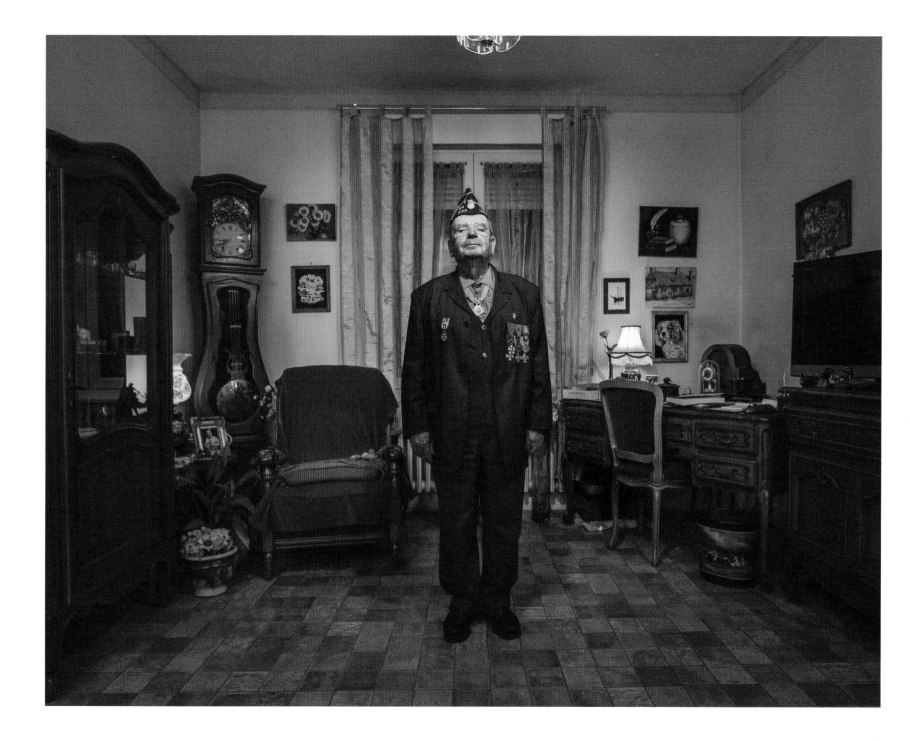

Imants Zeltins

BAUSKA, LATVIA

The beginning of my childhood was difficult after World War I. Eventually, my family managed to acquire some land. By 1939, we were doing very well. I remember these as good times. In 1938, we could afford a bicycle.

We had no thoughts of going to war. In school, we were taught that Germany was our biggest enemy. But in 1940, when the Red Army occupied Latvia, that perspective shifted dramatically.

When Germany attacked Russia on June 22, 1941, we thought that they would be our liberators. On May 1, 1943, I attempted to volunteer for the army. I was sixteen, so they didn't take me. A general had us all in a line and said, "Those who are underage, step forward." There were fifteen of us. They sent me back to Bauska. I found work at the police station. By then, Latvia was under German administration.

In 1944, the Red Army was pushing back and closing in on Bauska. On July 28 of the same year, I joined the volunteer force. I was finally eighteen. But there were people who were as young as fifteen and as old as eighty, and everyone wanted to fight the Russians. No one wanted another Soviet occupation. We waged guerrilla war for several weeks. I was injured on September 14, 1944. That's where the war ended for me. I was injured in the fight where twenty-eight Soviet T-34 tanks went up against two hundred Latvian conscripts. We were trying to cross a river, but the Russians came at us from all sides. There were planes flying over, tanks on the ground, artillery fire. It was hell. Many men died trying to swim across the river. We had six mine throwers, and all the men that knew how to use them were dead.

I tried to use one from a rooftop, but a tank fired at the building and everything caved in beneath me. I was brought to a German hospital. My right arm was attached only by skin, so they cut it off. My left was completely smashed. The doctor there told me that I had twenty-eight injuries total.

By February 1, 1945, the Americans had invaded Germany. The soldiers put signs on hospital doors that forbade patients to leave the area. After a few days, all the Latvians there got together and literally cried, not because the war was ending, but because they knew Latvia would be once again occupied by the Russians. On April 9, we were free to go. I knew a Latvian woman who had married a German. I went to see them, and they gave me a room, but they were short on food. I stayed there until the Americans handed that territory over to the Russians. I no longer remember the name of the town we were in. Eventually, I was arrested for taking part in the resistance.

I was moved across different concentration camps in Germany, Poland, and Russia. Most of the people held alongside me ended up in Siberia, where they would remain for decades. I was the only one who didn't go. I hadn't done anything wrong. I told them that if they thought I had, I wanted them to shoot me right away.

When I was free, I returned to my home, only to be mistaken for a vagrant by my mother before she realized who I was. After three days back in Bauska, I tried to get my documents. But I was arrested and jailed for two weeks. They asked me for a list of names of all the people I worked with during the war. I gave them one and was set free. I still didn't have any documents, so I couldn't find work. I yielded to failure and left Bauska. I married a woman in Riga. I found a job there as a security guard for different shops. When my boss discovered that I hadn't served in the Red Army, he fired me after only three months of employment. I couldn't find another job. I started my own business, and that's how I earned money to raise my children.

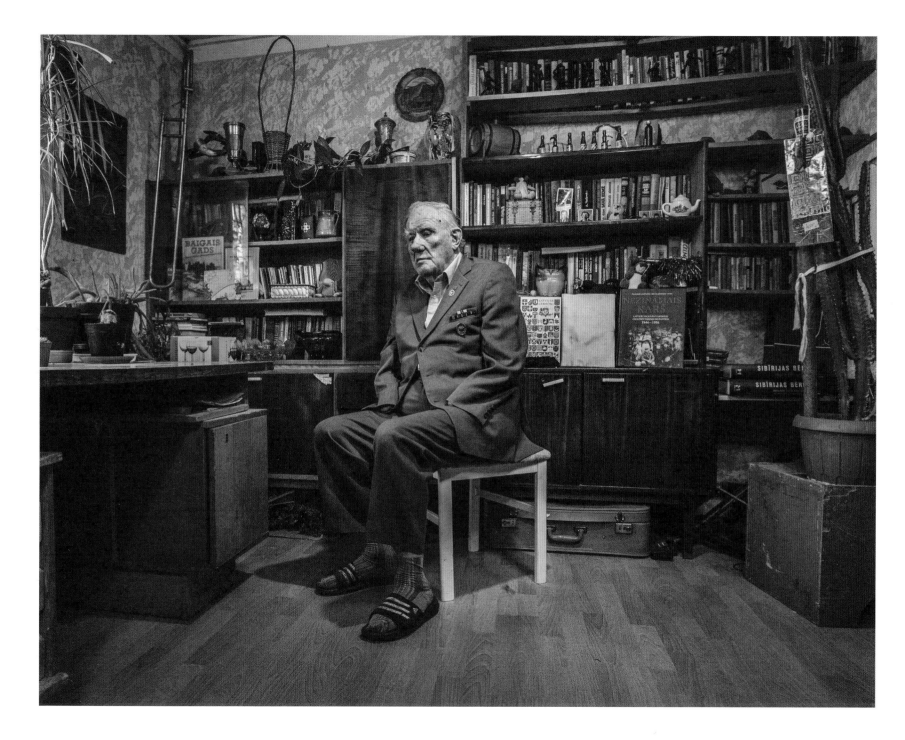

Anna Nho

ALMATY, KAZAKHSTAN

Anna Nho is my name. I was born in Vladivostok, Primorsky region, in the USSR, on November 25, 1927. My family was Korean. My mother taught Korean, and my father was a fisherman. Our family owned a small island and a motorboat for our fishing business. When our dad died early in life, he left twelve children, and I was the youngest. So we had to look for help from the government. One of my brothers-in-law was the first secretary of the local Communist Party branch, and he was able to arrange a personal meeting with some high-ranking government officials. We agreed to give our business and island to the government. In exchange, we received a house and land for farming. Life was more comfortable after that.

In 1937, many Koreans were deported from the Far East [of Russia]. We were transferred to Karaganda in Kazakhstan. They put up tents for housing. A few families lived in each one, but it was so cold that someone died every day. Then they suddenly decided to move all of us to Bukhara in Uzbekistan. They loaded all of us up on freight trains.

Our uncle, who was with us and couldn't take it any longer, decided to go and meet with Stalin in Moscow. He actually had met Stalin before. He had a picture of them together, which he carried around. He said that he would walk to Moscow if he had to. We all thought that he died, but he did make it. He looked like a homeless man and tried numerous times to get into the Kremlin. He was finally let in after one of the NKVD* officers told Stalin that there was

a very persistent man determined to see him. Stalin remembered him, so they fed him and cleaned him, and then they finally talked.

Stalin said to him, "I can't help you, but I can offer you this: I'll send you to Ordzhonīkīdze, where they don't know how to grow rice, in the Caucasus. You can help them organize a rice *kolkhoz*.†" Some time later, we saw in the paper that our uncle was looking for us, so we went to the Caucasus. After that, things were fine; Mom remarried and studied and worked.

Then in 1941, when I was in the eighth grade, I heard on the radio that the Great War had broken out. I saw a notice on the bulletin board in school that our motherland needed volunteers. So I passed all my exams for the eighth grade in June, and on July 1, I signed up as a volunteer and as a daughter of my motherland. I was a Komsomol‡ member on the northern Caucasus front. Our duties were mainly digging trenches. In the evenings, I started taking medical courses. I became a field nurse, giving first aid to our soldiers. I was on the front lines until Stalin ordered all underage volunteers to return to their studies in November 1943.

So I went back to my family. Shortly after that, we were evacuated to Kazakhstan. I worked various jobs and moved around a lot, but it was troubling to realize how people treated me differently because I was Korean. One guy in a kolkhoz I was working at told me that I was a liar—that no Korean was allowed to be on the front lines. I got so angry that I threw an ink bottle at him, and he got all dirty. I almost got kicked out of Komsomol, but shortly after that incident, my family moved again. We were ordered to work on a rice kolkhoz, but I worked as a nurse. There

was a typhus epidemic at the time, and anybody who knew medicine was in high demand. I worked in the hospital room in the morning and at the Komsomol office in the evening (I was once responsible for party agitation in our kolkhoz).

I had always been devoted to the party and was always loyal to the ideals of Komsomol, despite how my family and other Koreans were just thrown around and constantly relocated throughout the Soviet Union by Stalin and the Communist Party. I guess my youth and that of other Koreans was pretty rough because of this. Still, loyalty was an important thing.

In 1948, I moved to Almaty without any papers, only my Komsomol card and medals. I struggled at first because it was virtually impossible to work without identification, but finally I got new papers and found a job as a cashier. After that, many things happened. I continued my studies and working in retail. I worked once at a train depot too. I was very active in my community, and I always remained loyal to the party and to the Komsomol. I always believed that my work was to do good for society.

In 1949, I was happily married. But my husband worked for the government and was killed on duty. Both of my sons are also dead. The first one died from sickness, and the second one died tragically while in the police service. He was a policeman here in Almaty and saved a woman during a fire. He saved her, but couldn't save himself. So yes, life has been hard. But many are the memories that give me joy and happiness.

* Narodnyi Komissariat Vnutrennikh Del (People's Commissariat for Internal Affairs), the Soviet secret police

† Soviet collective farm
‡ Kommunisticheskii Soyuz Molodyozhi, a political youth organization in the Soviet Union

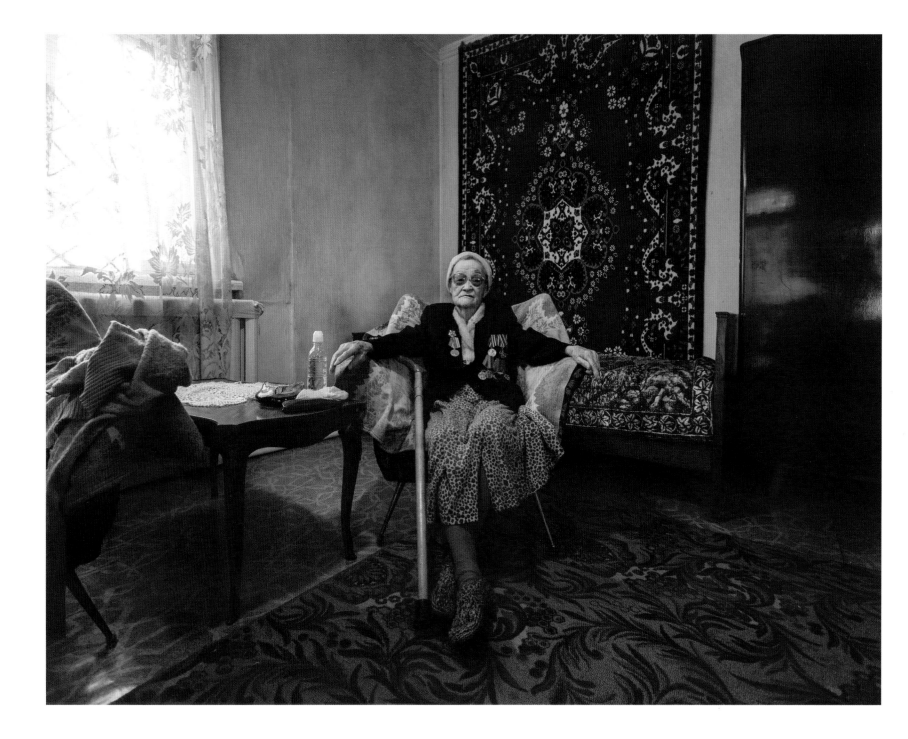

Richard Overton

AUSTIN, TEXAS, UNITED STATES

I was born in Texas, between Fayetteville and Bastrop, St. Mary's Colony, down toward Houston. It was all right growing up. When I was twelve, I knew what to do for myself. I worked on bridges. I built houses. I picked cotton. I pulled corn. Hauled trees, hauled shrubbery. I did all kinds of work.

I didn't want to go to war. Uncle Sam picked me; he enlisted me. I didn't have a choice. I went to the army in 1942. The South Pacific. I went to Iwo Jima. I was part of the 1887th Engineer Aviation Battalion. The lucky men got killed, that's what I remember. I got back here safely. A lot of them didn't get back safe. A lot of them didn't get back at all. I lost a lot of friends. Everybody in the army was my friend. I did regret going, but after I went, I was glad I went. I learned a lot.

We'd leave one island, get on to the next island. Get on a ship and move. I joined the war in 1942 as a private, got back home in 1945 as a sergeant. I did a lot of shooting, a lot of fighting, a lot of running, a lot of work. I drove the officers. I was treated well. We were fighting. I loved to shoot.

I was a hundred miles out of Japan when the war ended. I didn't think that I was going to go to Japan. But we were fighting them. They were nice people.

Coming home was the brightest memory I have from the war. I went to see the people at the furniture company I worked for before the war, and they wanted me to start back to work the next week.

I got one eye. Doctor put one of my eyes out. I used to go to the range. I don't shoot anymore. I still can shoot. You have to know how to hold your gun.

I drink whiskey like everybody else. I don't get drunk. I drink it like I do medicine. Put it in your coffee, good medicine. I don't take medicine. I take whiskey.

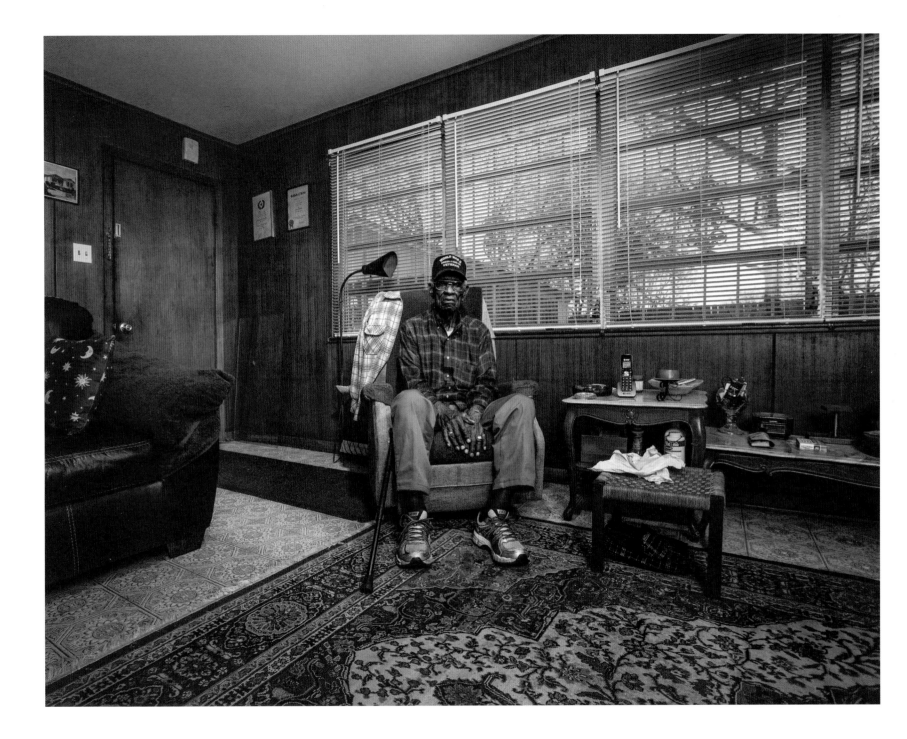

Dmytro Verholjak

MARKOVA, UKRAINE

My name is Dmytro Verholjak, and I was born in Manyava, in the Ivano-Frankivsk province of Ukraine. When the first Soviets came, my brother told me that he'd rather flee to the West than serve the Russians. Later, I searched for him and with God's help found him, after fifty years of not seeing him. He was in Australia. Our family had been heavily repressed by the first wave of Soviets, then the second wave almost wiped us out.

During the German occupation in the war, I moved to the Ternopil province and found work on a farm. There was no work where I lived, and when I left home, my mother told me: "The bread you earn with your hands will taste the best." It was hard to say good-bye to my mother—we loved each other very much. Another thing she told me was that no matter how hard things got, to never take my own life, that it was the biggest sin you could commit. I remembered that so clearly—how she said it—especially later on, when I was in a camp.

The people I worked for on the farm were very nice, civilized. I am very thankful to them for all they did for me, for what they taught me. I was there for four years, and by the time I returned home, the Russians had arrived as so-called liberators—throwing some people in prison and sending others to work in the mines in the East. I saw how they tortured people and humiliated Ukrainians. I felt that there was little for me to do but join the Ukrainian Insurgent Army. I spoke with the partisans in my area and said, "I'm going with you." They didn't want me, because I was still a kid. They said, "We have our path, but you have to wait to follow this path, in twenty or thirty years." I told them I wasn't leaving them. So one of them shrugged his shoulders and turned around, and I followed them.

The first time I was injured was a year after I went underground. Five bullets in my foot. I was living in the forest with a few others, all young kids. We were busted in the forest by the NKVD, the People's Commissariat for Internal Affairs. There were five of us, and they fired at us. I got hit then, in my left foot. I wanted to blow myself up with a grenade so they wouldn't take me alive, but once I realized that I could still walk, I threw the grenade in the direction they were shooting from and ran with the others. They fired more shots, blindly, but didn't hit anyone else, and we were able to escape. I received three injuries when I was with the insurgents. That first injury has haunted me all my life. A nurse bandaged me once after that incident, and for three or four weeks after that, no one took care of the wound, and it was literally crawling with bugs. It smelled bad enough that people didn't want to be around me.

One time I was left alone because I couldn't walk, while two others went off to the village to get some food. I was found by Honta, an older member. He asked why I was all by myself and why no one took care of me. I told him the story of how I got injured and no one attended the wound for a month. He got angry and told me to hang tight, told me that wasn't the order of things, that he would take care of it and I would never be left alone again like that. Then he left.

Later that night, my guys came back and told me that they'd never leave me again. The next morning, the nurse found us in the forest with another partisan. When she took the bandage off, we saw that the wound was crawling with all kinds of insects. She kept saying, "Don't worry. If there are bugs, it means there are no germs." I don't know what kind of medical school she went to, but at that time, I had no idea what she was saying. Now, I understand she was trying to get me to calm down. As she was cutting my pants with scissors, I was thinking, "These are my only pants—what am I going to do?" The nurse said that when you're alive, you can get new pants, but if you're dead, there'll be no pants for you at all. She stepped away momentarily with the other partisan she'd arrived with, our commander, and started yelling at him: "How could you let this happen? How is it that your soldiers aren't even trained to change a simple bandage?" Soon after, those in command decided that the nurses would need to train the soldiers to treat each other. I knew a little Latin, so it was easier for me to learn than for others. But for the most part, we didn't even know simple hygiene at the time. We didn't have paper or pencils, not to mention medical instruments. And I was learning to do everything with my own wound. After I learned many of the simpler things and could walk, they asked me to travel to one of the insurgent centers in a different village, where there was a wounded person who needed to be taken care of. I learned how to give injections there. I practiced on pillows, of course, before I did it to people. After that, I was sent from one village to another, taking care of the wounded as well as acting as a courier between groups.

Doing that, I learned all the paths through the mountains. I walked everywhere—my legs were so huge that if I sat, my knees would practically be under my chin. I was a big, healthy guy at that time. They gave me a nickname: Oak, like the tree.

Even after the war ended, we carried on fighting against the Soviets. They were as bad as the Germans, if not worse. The NKVD were everywhere, looking for insurgents. They tried to bribe or scare people for

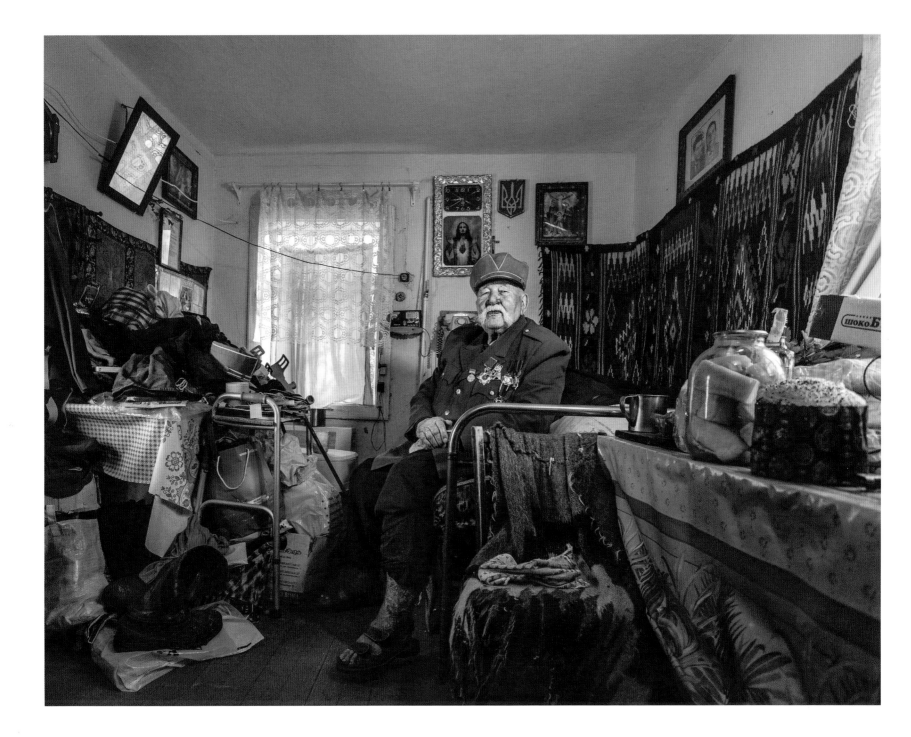

information, and many of us were killed or sent away. I was finally arrested in 1952, after being sold out. They tortured and interrogated me, put chemicals in my food. There was an agent with me in my cell who was on a "special diet" while they basically fed me poison.

My health declined there, and eventually, I was sent to a camp in Potma, in Mordovia, for twenty-five years. There were Poles, Russians, other Ukrainians there. Everybody. They quickly learned that I had been a medic, and I was sent to work in the camp's hospital. The warden was against this; he was scream-ing, "Do you know who he is? He's a nationalist, a Banderivets!*" and the nurse told him, "I don't care who he is. As long as he's treating others, he'll be working here." That was twenty-five years of my life. They were "correcting" me and didn't correct any-thing. When they released me, I was very nervous. My sister arrived to meet me at the gates. It was 1980 when I finally got back to Ukraine. But even free, they didn't let me do much. I couldn't work as a doc-tor or a medic with my record. I had to stay in my village all the time, and I wasn't allowed to leave my house after 10:00 p.m. That was my freedom.

But I got a job as a masseur. It was tough to even get that job, but I managed it. I worked as a masseur for ten years, from 1981 to 1991, when Ukraine finally gained independence. Now, I'm here in Markova, and the people from the village help me a lot. I have a pension.

That is how I started to live freely only after I turned eighty.

* A follower of Stepan Bandera, a Ukrainian insurgency leader

Anatoly Uvarov

SAINT PETERSBURG, RUSSIA

My name is Anatoly Gavrilovych Uvarov. I was born in Moscow, to a family of government workers. Both of my parents worked in the Supreme Soviet of the People's Economy—that was a large government institution. At the time, both of my parents were planning engineers.

In 1931, I started first grade at a public school. I studied there for nine years, and then in 1940, there was a possibility for me to attend one of several special military schools. I wanted to be either a pilot or a sailor, and I went to the first one that became available, which was the naval school. So in my tenth year, I continued my education at the military school and graduated exactly a week after the war broke out.

Everyone who graduated was then sent around the country to continue their military education. I was sent to Leningrad, which is now Saint Petersburg, to be trained at the Dzerzhinsky Higher Naval Engineering School. In the summer of 1941, I went through basic training. That autumn, the school had to be moved from Leningrad because the Germans were steadily approaching the city. We managed to move everything just days before the siege of Leningrad began on September 8, to a town called Gorky, which is Nizhniy Novgorod now.

We attended lectures and further training at a nearby town called Pravdinsk, but the number of students had been reduced by nearly 70 percent because many of the cadets had been sent off to the front or had stayed behind in Leningrad to fight. Most of them died because they were basically a shield. You have to understand that this was a very hard period for Russia—someone had to stop the German war machine. Their soldiers were well trained and well equipped, and we didn't have much of an army at that point, so we did what we could. About a million and a half kids who had just gotten out of school were killed within the first two months of the war. Some were my classmates.

Out of about 2,000 people, there were around 500 left. I was among them. This was October 1941, and the German army was approaching Moscow. The Soviet government needed to act to defend the capital, so it was creating new battalions. One was a marine battalion that was joined by another half of our school. So just a few months after the evacuation, there were 250 students. But those who were on the front line weren't there for long. Stalin ordered all the students from the front lines to return to their schools.

We trained on military ships in the summer. Even though it was wartime, my classmates and I attended our first naval training with the Caspian Flotilla in May 1942. There was a lot of action there because there were a lot of Germans going through the Caucasus trying to get to Baku and capture the oil rigs. The "floating antiaircraft battery" I trained on was basically a regular vessel that had been rebuilt for war use, with one antiaircraft gun on the bow of the ship and one on the stern. We were acquainted with its operation, but mostly we carried the shells and handed them off to the gunners. There was a lot of fighting there.

The oil traffic was busy. Tankers came from Baku and transferred the oil to smaller tankers that would go up the Volga River to the refineries, and the Germans learned that this was happening. They began to bombard the transfer points. All of the Caspian Flotilla was involved in taking down German planes.

Our ship was called *Polyus*. We were effective and active enough that the Germans were forced to bomb from higher altitudes, reducing their accuracy. I remember only one bombardment that reached a tanker. It was at night, and the oil had spilled and caught fire over the water. A terrifying scene. It looked like the sea was on fire. I could see people jumping from the flaming vessel. There was nowhere for them to go but into the fire in the water.

I spent the summer of 1942 on this floating battery. Initially, we were defending the oil traffic. Later, we transported soldiers from Astrakhan to Makhachkala. The Germans were still approaching Baku, and we tried to get more army personnel there.

We went to Astrakhan to pick up the soldiers. God, it was hot—so many mosquitoes you wouldn't have known where to hide from them. We made eight trips because we could only take up to five hundred people each time. Most of the soldiers came from Central Asia and barely spoke Russian. They were poorly dressed. Some didn't even have shoes. But we needed to take as many as we could. It was nearly impossible to get through the deck, it was so full of soldiers. When we needed to change shifts near the engine, we'd have to search for gaps between them to walk.

The Caspian Sea isn't big, but it's very unusual. After a storm, it has these strange, swelling waves —long and very tall. And many of these soldiers were uneducated, poorly fed. We would lose them during a storm. They would sit on the edge of the deck to, you know, relieve themselves. A wave would throw them off the ship. It was pitiful to watch.

Soon, I returned to the academy and was there until the winter of 1943. I graduated in early 1944, and that winter I was sent with the other cadets to join the Northern Fleet, where I served on a small submarine M-201, a so-called Malyutka, which means "the little one." It broke down almost immediately after I joined the crew and was recalled for repair. I was

approached by my direct superior and asked if I wanted to join one of the submarines headed into battle. Of course, I said yes. He sent me to the town of Molotovsk, which is now Severodvinsk, where another submarine was being repaired and was almost ready to rejoin the Northern Fleet. The submarine was a beauty, an S-16 (Stalinets series)—new and large, with a powerful diesel engine, six torpedoes, and a crew of about sixty people. I was appointed to the engine team, because I was formally educated in diesel engines. We did some drills and soon headed straight to Polyarny, where the base of the fleet was located. In October 1944, we embarked on our first combat mission, to Nordkapp, which is the northernmost point of Norway. This was a crossing point for the Northern Convoys, a group of vessels that carried strategic supplies to Murmansk and Arkhangelsk: food and various goods, military gear. These convoys were formed in various ports of Iceland and Scotland. Each would consist of fifteen to thirty vessels and would be guarded by few military ships until the convoy reached its destination. German planes regularly attacked those convoys. These were goods delivered under the Lend-Lease program between the Soviet Union and the Allied Forces.

The day the war ended, I was on night duty at the submarine. Everyone was asleep. I heard on the radio that Germany had surrendered, but I couldn't celebrate with anyone because I wasn't allowed to wake people up. I had to wait until morning, when I woke up the crew with a fife. Everyone was ecstatic. Someone started a pillow fight. We didn't have much of a celebration. When we returned to the base, there was a fireworks show, with pistol signals on the outskirts of the town where we were stationed. We went to a small restaurant nearby, had a bottle of wine to warm up, and then returned to base. I continued

to serve for another five years, on submarines in the Baltic Sea. One of them, interestingly enough, was a trophy boat from the Germans. It was very well made. I spent two years improving it and learning how it was put together. After finishing my service, I decided to continue my involvement with the military and went on to teach. First, I was sent to Sevastopol, where we just reopened a naval academy. Then, I returned to Pushkino, near Leningrad. In 1983, I retired from the military sector. I continued to help out with classes, as a civilian.

I was awarded a medal "For the Victory over Germany," and this happened during the Victory Parade in Moscow, on June 24, 1945. It was something outstanding. An incredible parade that occurred just a month and a half after the war, by order of Stalin. About fifteen thousand soldiers took part in the parade. I'll never forget the day. It's something that's stayed with me my entire life. I have some footage of the parade. Sometimes I show it at schools during talks or to cadets at military academies. The youngsters are always so interested.

I learned English and can proudly say that I achieved a good comprehension of the language. I've been to the United Kingdom a few times, meeting with my brothers-in-arms—people who took part in the Northern Convoys. Also, I've been writing articles; I've been active in sharing my experience during the war.

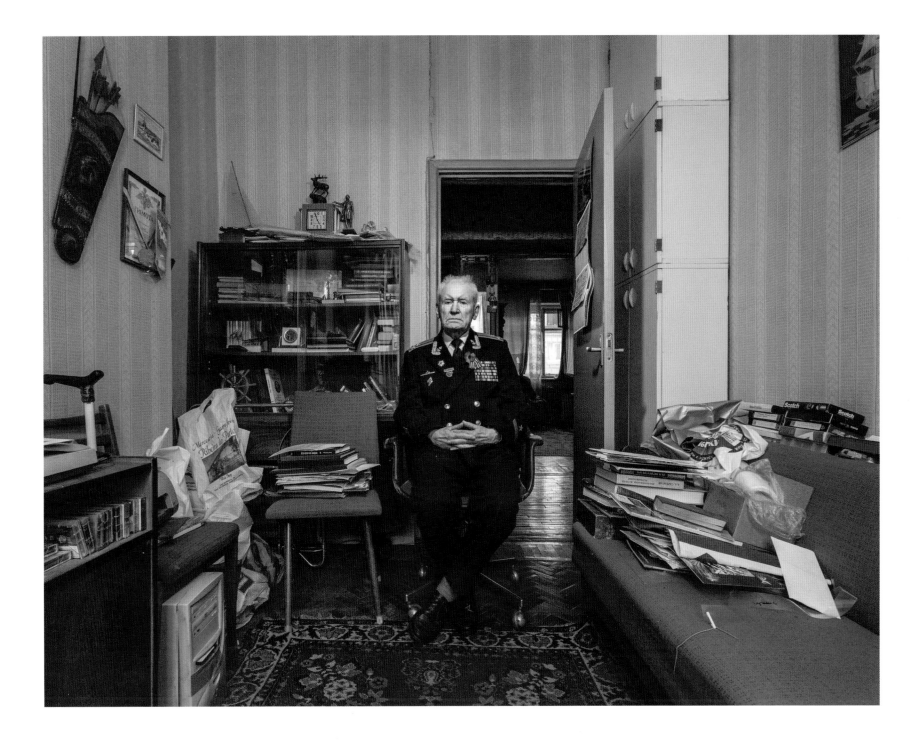

Jaakko K. Estola

HELSINKI, FINLAND

I was born just outside Helsinki, Finland, on December 8, 1918, in a time of great deprivation, after the civil war. My father ran a shop. My two sisters were in charge of raising me.

Germany began to display its power in 1939, when it attacked Poland. I was told to make sure I was too skinny and too small to join the army. But when the war with Russia began, all my friends were drafted. I was rejected but later proved myself fit enough in 1940. I can still remember the patriotic feeling that comes over you when you have to defend your country. I couldn't remain there on the home front. I had to believe that Germany was strong enough to defeat the Soviet Union.

I was sent to a small town, where the army had converted a school into a training camp. I went through ammunition and weaponry training, but at the school we didn't have any real weapons, so we would chop wood and train with pretend ones. It was very poor training.

The following year, I entered the war. I was stationed at the Finnish coast for two months. Once, we had to go through Russian territory, and on the way back, we found ourselves trapped in crossfire between the two sides. Another time, some of us took our bikes for a ride to the front lines, south along the coast. We were coming back and passed a pile of pine needles; these were usually placed to mark a salute or to signify danger. We continued on until someone yelled to us that the road was mined. I could have been blown so high, I would've seen the church towers of Leningrad.

In August, we were ordered to attack. The Russians had retreated to their old borders, where they had taken their positions. But as our tanks reached the river crossing, their soldiers began to retreat. That was a good feeling.

It was mostly peaceful on the southern front. Every so often, Russian planes would fly over and harass us. We decided to go up on a dune and shoot down the next plane that flew over. When one got closer, we aimed our rifles. But it attacked us at the same time. It was hard to see, and the sand blew everywhere. A bomb fell several meters from where we were, and a massive wall of sand washed over us.

Another time, in 1942, five or six of us were walking. Something exploded beside us. I felt small stings in my back, like children had been shooting me with pellet guns. The injury wasn't life-threatening, and they removed the shrapnel. It left a scar; it's like a tattoo memory of the war.

Toward the end of January 1943, we formed a new brigade and traveled seven hundred kilometers into Russian territory by train. It was minus twenty, minus thirty degrees centigrade. After only three days of fighting, we lost seven hundred men to the weather. The next month, we were attacked at night. There was a full moon out, and we were lying on the ground beneath enemy fire. I was staring at the moon and asking for help. But the moon was spiteful. I assumed that the moon wanted to kill us, to let us freeze in the ice.

We were in constant conflict. The Russians tried to take prisoners almost every night. There was a lot of trouble with our housing. Cases of lice, lots of rats, water damage. But when summer came, we enjoyed the warm and sunny days. We listened to military radio, and sometimes they played requests. They played one of our songs.

On the morning of January 16, 1943, I was on my way to train at the base camp, after a heavy snow. I was shot from a hundred meters out. I felt a wetness on my back. I fell with blood in my mouth, certain that I'd been shot through the lung. But it turned out, I was shot in the neck. Another bullet had gone by my spine and broken some of my ribs. Chips from the bones tore a large hole in my back. I received treatment over six months and was deemed fit to serve again, but they sent me back to Finland, and I experienced the Soviet bombing of Helsinki in February 1944. But I don't feel comfortable talking about that.

The rest of the time I served was peaceful, and I was glad to reenter civilian life. Still, after the war ended, I felt hollow. I wasn't happy about the defeat, but I also wasn't sad about it. Though there wasn't much food, I was glad to be alive and healthy and surviving. Finland hadn't been invaded, and I was in a hurry to get to university. Two boys suggested that I study agriculture. It was a strange idea to me because I wasn't from a farm. I started to study it, and it was very close to nature, and I found joy in that.

I graduated in 1948. I worked at a dairy farm and in a mill where they harvested feed for animals. In 1956, I got a job for a large company, where I became chief of a department in charge of processing animal feeds and manures.

Now I am content, happy. My children and grandchildren always call to see how I am. Soldiers have a saying: "No one is left behind." This is a saying in my family as well. The peace I've found in life is very important. I am not alone.

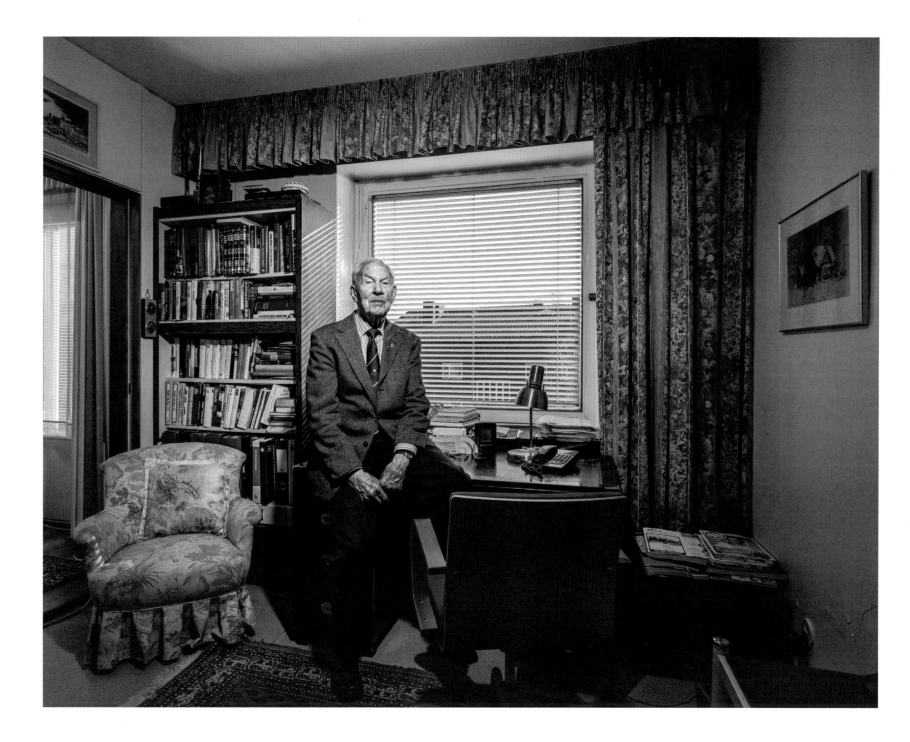

Konstantinos Korkas

ATHENS, GREECE

My name is Konstantinos Korkas. I was born in a village in Greece called Poullitsa, which is close to Vrachati, on January 7, 1921. I am now ninety-three years old. I attended high school at Kiato, also in my homeland of Greece.

Our childhood years were difficult because we had to walk one hour and fifteen minutes every day to get to our school in Kiato and the same distance to get back home. After school, we would have lunch and then work in the fields. Our families used to produce olive oil and wine. After dusk, we would return home and do our homework for the next day, usually up until midnight. By the time we went to bed, we were already exhausted. It was a hard way of life at our village that made us strong. So later on, the military was a piece of cake for us. But this is how we withstood the hardships of the war and its extreme circumstances—because war was an adventure to us.

I joined the Hellenic Army Academy on October 2, 1940. War was declared on October 28, when the Italian Army invaded Greece from Albania. We were still students. But we were very happy, for we had no idea about the war, only that we were throwing our hats in the air, shouting, "WAR! WAR!" We were yearning to go to war because we were young back then. Yes, we wanted to fight, but we didn't know much about the war or fighting battles at all.

Then, when the Germans attacked us on April 5, 1941, we had asked to go to Thermopylae, to fight where the ancient Greek leader Leonidas had fought the Persians centuries before with his noble Spartan army of three hundred. But the military leadership didn't allow us to do so.

On May 20, 1941, the Germans landed at Crete, and this was the first time we fought with the German paratroopers. We didn't join the battle because we had to but because we wanted to. Our military leaders had prohibited our involvement. But we joined the battle despite their orders, on our own. We had to commandeer buses and trucks, but we got to the island and fought.

It was a difficult battle. Some of our classmates lost their lives. In truth, war cannot be described or comprehended. It is hard, weird, cruel. You have to keep on fighting the whole day without food, water, or rest while your mates are getting killed or wounded. Even I cannot properly describe it despite the ten years of war I experienced.

We tried to climb the White Mountains, aiming to leave for Egypt, but we didn't make it, because there weren't many ships available. As a result, we got captured by the Germans at Sfakia at the end of May. And we were held for two and a half months at a concentration camp close to Chania, Crete. There were thousands of prisoners there, of various nationalities. The Germans treated us very well, however, and they kept us at a separate place from the other prisoners because we were students of the military academy. Then, in the middle of August, we were transferred to Piraeus, and the Germans set us free.

From there, I walked all the way home. One had to obtain permission from the occupying Italian forces to travel to this village, because travel and movement within the country were restricted. But I wasn't granted the permission I needed, and I didn't have the money to pay for the transportation. So as a result, I walked for twenty-four hours to arrive at my home.

In December 1941, I joined a technical college to become a civil engineer, but during that time, there was a strike at the college. By that time, Greece had

been taken over by the German Army. We had lost our freedom, and food was scarce. I decided to leave for the Middle East. So I got on a ship bound for Turkey. And from Turkey I made it to Cyprus and then to Haifa. All the countries that had been taken over by the Germans were organizing their armies at Haifa. There were Polish, French, Ukrainian, and Greek soldiers there. I joined the Greek Army.

Later, the British Army began to hold seminars and organize training programs. And we were trained by them in such things as using British weaponry, strategy, and army management. In the end, two Greek brigades were formed, with four or five thousand soldiers each.

The leaders of the brigades were in constant conflict with each other, and this resulted in the punishment and restriction of a group of soldiers. This was due to a great extent to their hypothetical political affiliations. A number of volunteers from a group of soldiers formed a special unit called the Ieros Lochos [Sacred Company] on September 6, 1942. We were, in a way, simply volunteering to die, since paratroopers have to face grave dangers daily.

Soon, all of us participated in the Battle of El Alamein in Egypt, where Montgomery and Rommel were the leaders of opposing forces. The battle lasted for eleven days, from October 23 to November 2. Then the Germans started to lose ground. Many battles followed El Alamein, in Tobruk, Benghazi, on the island of Sicily, and in Tunisia.

We won the battle in Tunisia, but we were almost captured. The British, French, and Greek soldiers participated in the battle, and it lasted for three days, from March 10 to March 13, 1943. At the end of the battle, we were waiting for the replenishment of food, water, and fuel. But our supply truck drivers were captured, through a mistake of their own. We had to

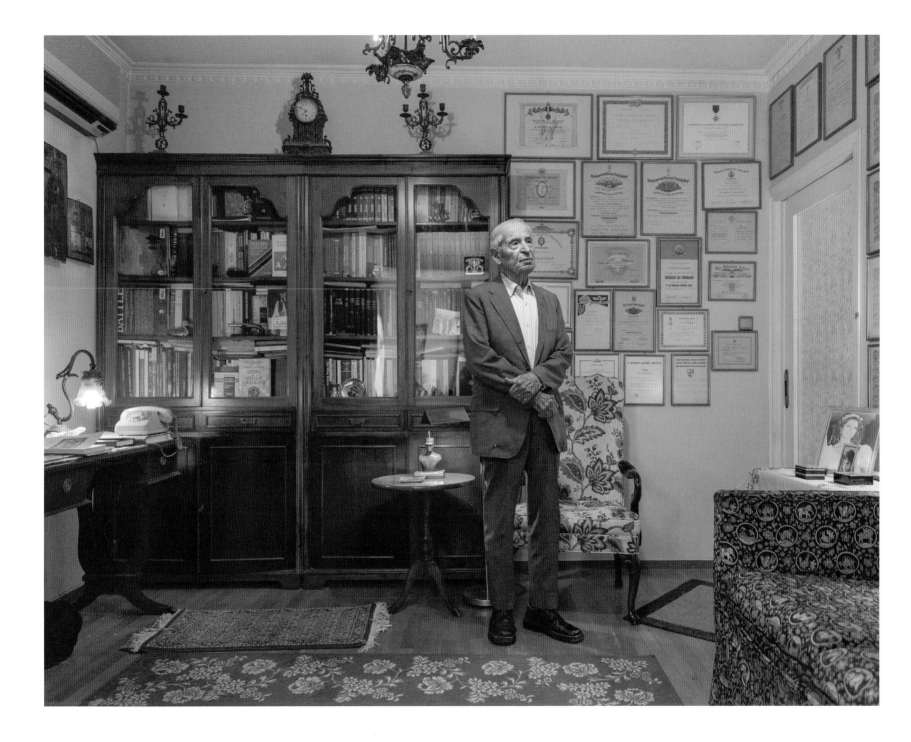

endure two or three days without food or water. Then the Germans surrendered but were subsequently set free.

After this battle, we joined the Second Brigade of New Zealand. Together, we proceeded to liberate many major cities until the end of the war. We returned to Cairo, then went on to Egypt and Palestine, and arrived at Dodecanese. More than a thousand new soldiers joined our ranks on the way there, and we proceeded to set the islands free one by one. On October 31, 1943, we landed on Samos a little bit after midnight. We were 202 paratroopers. The rest arrived by ship.

The weather was stormy and windy. The pilot made a mistake and released us over some rocks instead of a field. As I was falling, I could not see the ground, and I wounded my head, my hip, and my shoulders. I lost consciousness. When I regained it, I went on to search for my men. All of them, however, were lost. By midday, I had found none. Fortunately, I found them much later on.

Then we left from Samos and got to Cairo through Turkey because the Germans once again took over the islands we had liberated. Thus, we kept on fighting. Personally, I had been trained by the British in Haifa to the methods of the secret war, and subsequently, I was transferred to Naxos on April 12, 1944, where I stayed until the end of the war.

When the German Army surrendered at Symi, their leader left his weapon on the table. Then the British brigadier gave it to the leader of the Sacred Company, saying that this trophy belonged to the Sacred Company, the liberators of the islands.

After that, I was transferred to Kálimnos to collect the hostages. They surrendered without resistance, and I collected their weapons. During the process, almost 350 Germans marched before me, singing that

Germany is above all. After a week, they were moved to the concentration camps in Africa.

At Kálimnos, there was a reception party in our honor. During a toast, our brigadier said to the German general that he was sorry for all the pain and destruction Germany had to suffer. Then the German general replied that they should not be worried about Germany, because they would make it better than before.

The mayor of the city called us to the town's cemetery, and he gave a speech to the dead. He called them to wake up and rise because after all those years of occupation, we were all now free. I remember all of us there, crying like small children.

In the end, the Sacred Company was dissolved on September 15, 1945, and we created the New Army, since during the occupation there was no Greek Army. I became a four-star general and retired as a leader of the Greek Army.

I met my wife in the United States while I was studying for the army. I knew her family from Naxos, and we met again in Washington, DC. After the end of the war, she returned to Greece to take care of her family's property. In 1955, we got married. We have a daughter who is an archaeologist, and we also have a grandson.

Sidney Owen Kenrick

WARWICK, ENGLAND

My name is Sidney Owen Kenrick, and I was born in Birkenhead on September 3, 1917. I had two brothers and one sister. I went to Park High School and left when I was sixteen and took a job as a postboy for Buchanan's Flour Mills in Liverpool. I delivered mail to various corn merchants. Eventually, I was given a job in the sales department. One year, my girlfriend and I walked across Wales, using youth hostels.

When war broke out on my birthday in 1939, I tried to enlist. I went to the naval recruiting office. When I got my call, I went back to the office and said, "Look, I don't want to be a conscript. I volunteered on the third." I told my girlfriend that I was joining the Royal Marines. She started to knit me a nice blue, heavy pullover. When I got to Portsmouth, I discovered that they were all in khakis. So I wrote her to tell her I wanted a khaki one instead.

I was sent to Portsmouth in early December 1939. I joined the Nineteenth Squad there. I was there for a fortnight, and I got leave over Christmas. I was in a marine uniform then. Next time I went, I was in an officer's uniform.

It was a rough time because all the other newly appointed officers had a three-month course to prepare them, but I was just thrown into the deep end. I was given charge of the Thirteenth Platoon in B Company, under Major Phillips. The battalion formed on April 1. The next month, we were put on a twenty-four-hour notice to go on an operation. We weren't told where we were going. We were only told to take care not to upset the natives. It turned out to be a takeover of Iceland. We set sail up the North Sea in two cruisers, and it was a rough passage; there was a gale blowing. Only some of the chaps had ever been to sea before. There was a great deal of seasickness. The Icelanders were pleased to see us. Denmark had just been taken over by the Germans, and they were worried.

Together with the Company Major, we were fifteen platoons. We set up a camp in the cowshed. There were three marines to a stall. We worked in the night and slept at daytime—it was the only way we'd be warm enough to sleep. We spent three weeks putting up positions. The company was given the task of going to the Germany embassy to ensure that the staff were taken prisoner. But the ambassador wasn't there. One of the chaps that went with Major Cutler said, "There's smoke coming out of that window, sir!" So they broke the door down and found the ambassador's wife and daughter burning papers in the bath. We stopped that. Then they found the ambassador elsewhere. He was at a hotel with a girlfriend, and they found out which room he was in, and, being a gentleman, Major Cutler said, "Stand back—we'll wait until he's finished before we arrest him." Of course, they arrested him and took him back to England, and he became a prisoner of war. We were able to control the island, and had we not done that, then the North Atlantic convoys bringing food and munitions from America and Canada wouldn't have been able to work. So the people of England would probably have starved.

We returned to England after a few weeks. Three months later, we were on orders. This time we were going to Dakar because General de Gaulle had persuaded Churchill that the people of West Africa would be delighted if he appeared. That would mean that quite a big portion of Africa would be on our side. We marched through Liverpool with our pith helmets on. Everybody knew we were going somewhere sunny.

It wasn't until we were halfway across the Atlantic that we learned exactly what we were going to do. We left Liverpool in July 1940.

We got to Dakar in August, ahead of our tremendous fleet of several cruisers and lots of destroyers. The theory was that we would land there and the Vichy French would realize that we were a very strong force and there was no point in them not allowing General de Gaulle to take over. Unfortunately, his ideas weren't right. They sent a boat in, and they were fired on and came back. There was a thick fog, so the French could not see this armada of armed ships that we had outside. After about two days, they decided that General de Gaulle was not going to be welcome in that area, and so the operation was canceled. We went to Freetown, Sierra Leone.

Two of the battalions went to England, and two remained in Freetown, ready to deal with a possible attack on the Cape Verde Islands. One of my jobs there was to censor letters the lads had written. We couldn't write home and say, "I am now in Freetown." Each letter had to be censored by an officer to make sure that they hadn't disclosed where we were.

One of the amazing things that happened was that my father was in the merchant navy, and I recognized his ship coming into port. He used to trade down that route. He was surprised to find me there, and I was surprised to see him. I spent the night on his ship. He went and sailed down the west coast of Africa. About a fortnight later, they came back. My father was welcomed into the officer's mess by the colonel, and he had a good night. The next day, his ship sailed from Freetown. He stood on the deck and waved to me, and I waved to him. That was the last time I saw him. His ship was bombed by German aircraft just short of Ireland. He was one of the unfortunate seven who were killed.

After six months, we went to Gibraltar. We formed a rugby team there and challenged the army to a match. We thought that because they were tough lads, they were going to beat us. But we managed to beat them. Some of our chaps were suffering badly from malaria, but they got sorted out. We spent some time putting up barbed-wire fences on the slopes of Gibraltar, in case the Germans or the Spaniards decided to have a go. I was made a captain, second-in-command of B Company. On the way back, we took four Free French nurses onto the ship. The French of the various officers improved considerably.

I got married in a hurry on December 4, 1941. I was due to be married on a Saturday, but I was told on the previous Monday that we were going on an operation. I had to ring up my fiancée and say, "Can we get married on a Thursday?" So she scurried around, and we managed to get ourselves organized. We went to Edinburgh for a short honeymoon. On the Saturday morning, I rang up the battalion and said, "Am I due back?" And they said, "No, you're all right. We canceled the operations." They were always canceling operations.

I was appointed CO of a beach group gathering in Hampshire. I spent probably a year retraining them and loading ships. Putting out beach roadways, being able to use landing craft. In 1943, the beach groups were disbanded because they were too small for the D-Day landings. I was transferred, and I was reduced back to captain. We did landing craft training. We learned about calculating, dead reckoning, et cetera. Shortly after that, I was drafted to HMS *James Cook*, which was in Scotland. After a three-week course, I was retained there as an officer. I was in Scotland during D-Day. My wife was with me. We managed to find some digs up in Scotland, and my son was also there. I got the signal to report in as soon as I could.

We got to Glasgow during Fair Week and returned to Liverpool and set sail. Many people I trained were at D-Day. Some were killed, some got back. But we spent our time training how to navigate and how to land troops. That was my contribution to the war effort.

At the end of July 1944, after the invasion had taken place, I was assigned to HMS *Prince Baldwin*, which was a Dutch ship that'd been taken over by the Royal Navy. A fellow captain was in charge of the flotilla that worked from HMS *Princess Beatrix*. We sailed down to the Mediterranean. Our job was to land the first battalion of the American Special Forces on the two islands that were in a position to threaten the main landing in the South of France. We did a few exercises in Corsica. The Americans would be towed toward the shore in rubber boats. When we got to within a mile of the shore, we released them, and they paddled their way quietly and landed.

I was sent to Valletta, Malta, in 1945. We were told to await orders. The only order we got was to send three landing craft north of Italy to help bypass the Germans. They came back and joined us again. Four or five months passed, and we decided to tell somebody that we were there. We took a trip across Italy in a van and went to the headquarters, just short of Naples. We introduced ourselves, and they said that they'd been looking for us. The next day, we got orders to get back to England.

The lads were sent to harvest, because they were desperately short of labor on the farms. In due course, we were given orders to land in Flensburg, Germany, where we tried to control the Germans trying to get across from Sweden. After four weeks, we returned to England. I was discharged in December 1945, and I was granted the war service rank of major.

I went back to the firm that I had worked for and managed a small mill in Darby. I was soon made the manager for five counties. From then on, I progressed in the company. I became the general manager of a bakery and eventually one of five regional sales managers for the whole country. From there, I was promoted to the area director of the Midlands RHM Bakeries. I was made a member of the Order of the British Empire for my services to agriculture and the food industry. And that's it.

I try to keep busy. I've got children who come and look after me now and again. I play bridge. I'm a member of an organization for professional businessmen who've retired. I'm a member of the Methodist Church in Warwick. On the sixtieth anniversary of the landing in the South of France, I went there with two daughters and a granddaughter. The Americans and the French were there; I was the only British officer. And we had a tremendous time. One of the amazing things was that youngsters, teenagers came around and shook us all by the hand and said, "Thank you for what you did." We were presented with a certificate by the mayor, whose surname was Napoleon!

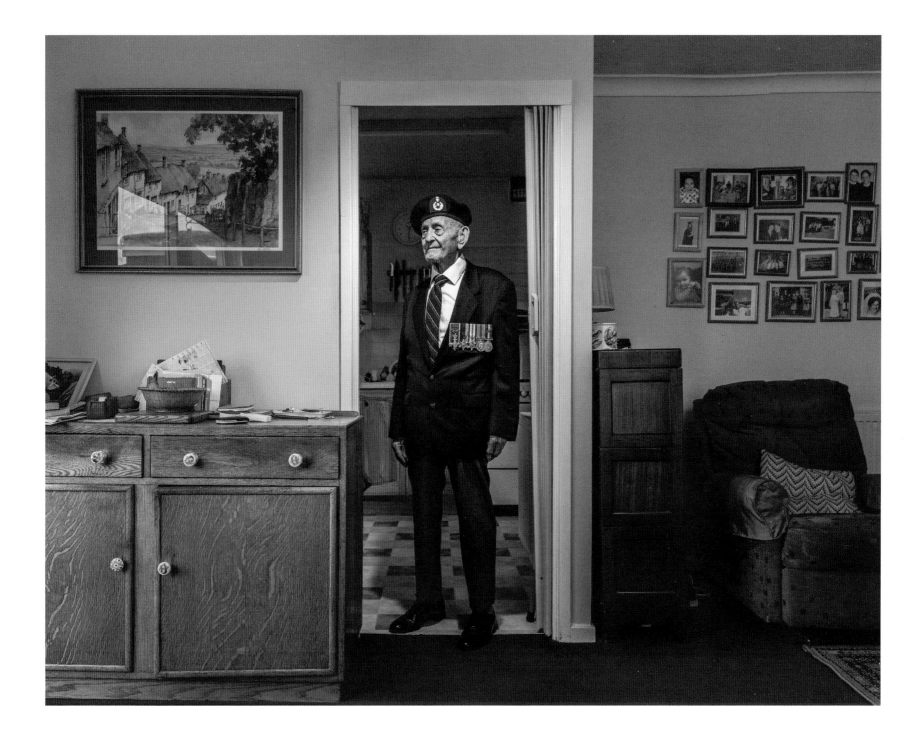

Harold Dinzes

PASSAIC, NEW JERSEY, UNITED STATES

My name is Harold Dinzes. I was born December 24, 1916, in the back of the old Opera House on East Thirty-Sixth Street in New York City. I was raised in Brooklyn. We lived on New Jersey Avenue, in East New York. My father built office partitions; then, the Depression hit. I was fifteen. My father went to work for my uncle, for practically nothing, so he could keep food on the table. One Sunday, I was over at a friend's house in Clifton, New Jersey, and we had the radio on, and we heard the announcement that the attack on Pearl Harbor had happened. Both of us got into the car and ran it to New York. I don't know why, but we went there. Everybody was up in a dither.

In June 1942, my number got drafted. I was sent to Fort Belvoir, Virginia, to the engineering school. I was interested in explosives. I took a liking to the instructor and paid attention to what was going on. Eventually, I got the chance to go to officer candidate school and took it. Before I knew it, I was a second lieutenant.

When I first got into the service, I was in the 169th Combat Battalion, and all of a sudden, they changed everything around and created the air force. My outfit became the 164th Aviation Battalion. I started teaching about demolitions and booby traps. I went all over the country to different forts, camps, teaching and learning. Because I was good at what I was doing with explosives, I gave lectures to all the officers who were way up in the line, including, once, a general. I like to believe that because of the lectures, I saved an awful lot of lives on our side.

I was stationed at an airfield in Tallahassee and was going with a girl from the Florida State College for Women. One night, we were out on a date, and she started crying. I said, "What's up?" She said, "You're going overseas." I said, "What are you talking about? I didn't hear a damned thing. How did you find out?" And she said, "You know, what's-his-name's girlfriend, she works in the offices at the base." Sure enough, we shipped out within a couple of months. They boxed up our equipment and sent us to the West Coast. This was 1943.

We boarded the ship at San Francisco, if I'm not mistaken, and sailed across the Pacific in about three weeks, unescorted. Japanese subs were all over the place, but we didn't use evasive tactics—we just went as fast as we could. On the way there, they told us that we were going to New Guinea. There must have been, I'm guessing, eight thousand troops aboard that ship, and I bet maybe ten people on the whole ship knew where New Guinea was. I happened to know because I had always been interested in faraway places and read about them. I lectured on where we were going, but it was impossible to tell these guys that we were going to the jungle, because all they could think about was exotic hula girls. They were sadly disillusioned when we got to Milne Bay.

The jungle came right out to the waterline. I got off the ship and stepped on land, and there was a native there, standing with his bow and arrow, his spear. He looked at me, I looked at him, and it was like we were from different worlds. I had studied the books they gave us on the language, pidgin English. I still have the books. He was shaking like a leaf. I asked him, "Where is your house? Where do you live?" And he looked at me like: Where the hell did I come from? From Mars.

We got put to work helping with the airfields. At the time, I had about 166 men underneath me, and I had to keep them fed with the rations from the service, as well as stuff we were getting from Australia. We never starved to death, but it wasn't the kind of food you'd like to eat. To enhance the meals, we would do some fishing. With hand grenades. The fish would float up, and the natives would tell you which ones you could eat. Soon, the fighting was going our way.

The Japanese had some very high-class marines who had seen previous combat, but they had to pull them out because we had the Australians there, who were also very good fighters. From that point on, it was the Japanese backing off from island to island. I can't praise the Australians enough for the fighting that they did. Once, when the Japanese marines were coming through the jungle, every one of our available men, whether sick or wounded, dying, it didn't make any difference, went up on the line. The Japanese came across one of the airfields, and we had all our guns lined up, shooting with no obstruction whatsoever. And they kept charging across. The massacre was so great, we buried six hundred men in a common grave, with a bulldozer. We couldn't take the time and give them the courtesy of a proper burial, because after one day in the jungle, everything started to rot and pop apart. Six hundred in one common grave.

Even after that, there were still Japanese in the jungle. There would be enemy fire, and we'd get there and wouldn't know where they were. I got sick and tired of it, so one day I requisitioned two fifty-caliber antiaircraft guns on mounts. Bullets that would take your arm off if they hit you. And we put them in the jungle and opened up, sprayed the place to hell. I didn't care who we killed. I never knew whether the Japanese were in there or not, but we didn't get bothered too much after that. We also sometimes sent the natives out as scouts, to find someone to interrogate, and they would bring back heads. I told them that I couldn't talk to a head—I had to get

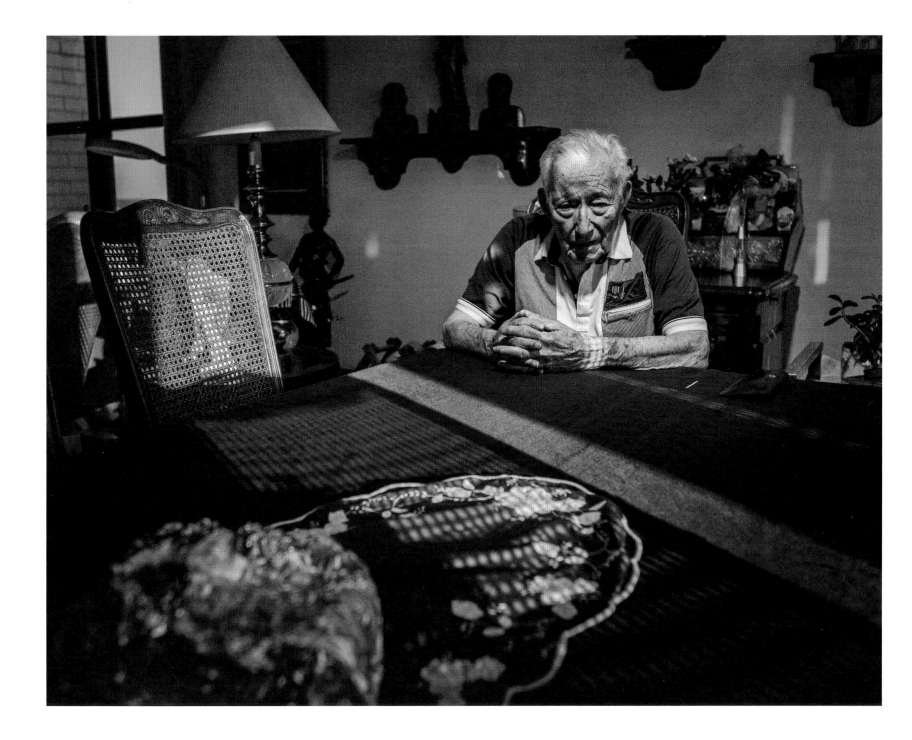

some information. When the first Japanese POWs came in, we put them to work. There were so few who gave themselves up. It was so uncommon, people actually showed up from hundreds of miles away to see one. They just never gave up. There would still be soldiers out there, refusing to stop, decades after the war, some of them.

Anyway, there was a demand for aviation engineers in different places because we needed airfields badly. I got alerted. We didn't know where we were going to go. You got an alert, you have so much time to load up, get your equipment ready. They sent us off in convoy, on a ten-thousand-ton steamer. We went up the coast to Manila, and I'll never forget when we got to the harbor, which was a deep-sea harbor where ships could come right up to the land. The whole bay was scattered with blown-up ships. The captain of our ship was an old Dutchman who had been a navy man; he'd been called back to service. He threaded that ship through there like he was driving an automobile. I stood on the bridge and watched him maneuver the ship into the bay, and I thought he was going to blow us the hell up. He got us in safely.

There, the Japanese had taken bodies, dead animals, refuse and thrown it all in the reservoir. They knew what they were doing. It would occupy nine or ten people to take care of a single person in a hospital. Not just wounded, but sick. The diseases that were going around, people were dropping like flies. Everybody in my outfit had malaria, myself included. The pill for it tasted horrible. An order had come down to stand there while my men swallowed it. I'd line the guys up and give them the pill and make sure they took it. But a guy would swallow it and the moment you'd turn around, he'd spit the damned thing out.

We had filtration systems set up. But it was so hot. They'd tell you not to drink the water. When you're dying of thirst, and there's so much of it…

Eventually, I got injured and got an infection in my ankle. I couldn't get it fixed where I was, so I found an outfit nearby that had an army doctor. An overweight man in his forties. I asked what he was doing there. He had volunteered. The bone was beginning to stick out of my foot. He gave me a concoction he himself had created, and it worked. He put a bandage over it and told me to keep my foot dry. But the minute I stepped out of the tent, there was water waist deep. You couldn't keep dry.

When the war was ending, I was at a field hospital. I had my bed on the veranda outside because there was no room inside. There was a medical captain to my right and an eighteen-year-old from a Filipino combat outfit that had been fighting against the Japanese. The kid came running up to where we were one day, saying, "Captain, they just said on the radio they dropped a bomb equal to fifteen thousand tons of TNT." I said, "Get the hell out of here. Go back to whatever you were doing and don't come bothering me like that." When I used TNT in the service, the most I ever used was ten or twenty pounds at a time. To blow up a bridge. To mine something. Set traps. This was an unheard-of amount. He ran away, then he came back and said, "Sir, they're saying it all over again on the radio." So I went there. I didn't know what the hell an atom bomb was. I couldn't conceive of anything that powerful. Nothing like that existed. It couldn't be. But it was, of course.

The day when we thought that was going to be the end of it, one of our ships full of ammo blew up in the harbor. The guys were going crazy, thinking we were being attacked. Bullets bouncing off the embankment. We got under our beds. I was praying, thinking,

"It's a hell of a time to get killed," you know. Finally, the MPs got control of what was going on. They took the weapons and got everything calmed down.

About six months later, everybody started going home. They prioritized people by how much combat they'd seen. I was in the Philippines for almost two years. This was MacArthur's Manila.

One day, I got a call from the officer in charge, and he told me to get dressed because I was being considered for promotion. I had no nice clothes—I'd been out in the field. I dug into my duffel bag and found an old uniform, put it on, and went there. Everybody was dressed clean as a whistle. I was sweating like a pig. I was nervous as hell. I hadn't seen that much brass since I got out of the States. All of a sudden, we're at attention and a two-star general walks into the room. He tells us to be seated. "Don't worry, the guy you're going to see is not that bad. He's a nice fellow." He put us at ease. Because my name started with a *D*, I was one of the first guys called. The general was sitting in the middle of them. He asked me some questions, which were so basic that a kid in high school could have passed. He was smart as a whip. And he says, "That'll do, Captain." He was telling me I got promoted. Right there.

I was also put in for an award by a commanding officer. He put me in for the Bronze Star, without my knowing it, and I got it. The army works in mysterious ways. I am now ninety-five years of age. I still have trouble with my injury. I'm a disabled vet. The army has taken care of me, with the problems I've had since. I've got stories. I could tell stories till I'm blue in the face.

Pingching Chen

HONG KONG, CHINA

I was born in 1918 in Putian, Fujian Province, China. When I was thirteen years old, I went to Amoy to study maritime navigation at Jimei Navigation Academy. I then went to Shanghai for an apprenticeship on board a Chinese mission ship.

I was four months into my apprenticeship when the Japanese started bombing China. I was deeply moved and angry. I applied to be a pilot with the Chinese Air Force; I was assigned to train with the Twelfth Chinese Air Force Division.

In 1941, the Kuomintang government secretly asked for American support; Americans would train Chinese pilots for an elite American-Chinese air force unit. Retired US Air Force officer Claire Lee Chennault ran the program, and he arranged for us to train at Dale Mabry Army Airfield in Tallahassee, Florida, and at the Arizona Thunderbird aviation school in Phoenix. Naturally, we felt a little insulted because we'd already had our training and didn't need to go over everything again.

To our bemusement, when we reached the base we found out that our American instructor had announced to the press that we were well-trained pilots, and it seemed like the American public was surprised. You see, in the 1940s, many Americans regarded "brown men" and "yellow men" as third-class citizens. So General Chennault, with good intentions, wanted to dispel the notion that the Chinese were inferior people. He earned our respect for his effort. He was a good leader.

I graduated from the training unit in 1942 and returned to China. We then carried out a mission to deliver planes to Chengdu, Sichuan Province. I was

in the last group of six pilots and the youngest one. It was raining. About two hours in, the squadron leader suddenly dove through the clouds and down to the ground, from about one thousand feet. I was ordered to force land. Luckily, I could see a dry riverbed and force landed there. My head pounded against the instrument panel. My legs felt like they broke. I felt numb. But there was no damage to the plane. Two Chinese soldiers came over to the crash site, thinking I was Japanese, but as soon as I spoke to them in Mandarin, they lowered their guns, and they quickly got me out. I still don't understand why I was ordered to force land my plane. But I couldn't question or discuss the decision of any commanding officer.

After that incident, I was unimpressed with the Chinese Air Force. How could they fight the Japanese with such inferior attitude and unity?

On March 7, 1943, I was asked to report to the Fourteenth Air Force, the Chinese-American Composite Wing. We were later known as the Flying Tigers, and we flew the Curtiss P-40 Warhawk. I was assigned to the Seventy-Fifth Squadron, based in Liling in Hunan Province. The Japanese were based in Hankou, Hubei Province, with over one hundred fighters to attack us.

The Japanese were crafty and strategic. Via small transport aircrafts, they managed to drop "Letters of Challenge" at our air bases. The letters basically said, "If you have guts, meet us tomorrow morning, 9:30 a.m., about the river." But General Chennault sent more experienced American pilots to face the Japanese in those challenges, and for every plane downed on our side, they shot down three Japanese.

When the Japanese challenged us a third time, General Chennault ordered us not to take up the challenge. That day, we were all ordered back to Kunming Air Base. All the pilots were angry, as it gave the

impression to the Japanese that we had chickened out. When we arrived in Kunming, the fighters from Guilin pilots also came back. The next morning, forty Japanese planes attacked Kunming. I think they must have been surprised that more than fifty pilots had returned to defend Kunming. General Chennault once again had been wise and could see through the Japanese intentions. Again, we were shortsighted, for he was proving himself a great leader.

Yunnan Province was an important target for the Japanese because Kunming Air Base is the terminus for the "Hump Route," the only military materiel supply line from Assam, in India. It was an important source of external support for the Chinese war effort. The Japanese had wanted to cut this strategic supply line, but realized they could not attack Yunnan Province from Burma, so they changed their base from Hanoi to Haiphong in Vietnam, which had a rail connection to Kunming. They started to concentrate their air force, navy, and army there.

On October 10, 1943, we decided to embark on a preemptive strike to bomb the Japanese navy and their infrastructure at the harbor. My mission was to escort the big B-24 bombers. During the past five missions, fifteen unescorted bombers had been downed. This time round, we had learned our lessons. The bombers had to be escorted. We went with forty planes: twenty-one B-24 bombers, seventeen P-40 fighters, and two P-38 fighters. After we finished bombing the harbor, we headed back to Kunming.

When we flew over northeast Hanoi, we engaged in an air battle with more than thirty Japanese planes. I managed to hit one Japanese fighter, but it did not go down. Soon after, my plane was hit by the artillery. A fragmented bullet hit me on my right shoulder. I did not feel pain at first, but it became increasingly pronounced. About ten minutes later, white smoke

appeared from the back of my plane. I realized I had no choice but to bail out.

I parachuted out and landed on a big tree. I lost consciousness for some time, and when I woke up, my body was in pain. I walked along a dried-out creek, then I stepped into a pile of green leaves and fell into a hole. Even after fifty years, I still have recurring nightmares about falling in that hole. For the next couple of days, I would follow the creek.

On the sixth day, I was extremely weak and very tired. I'd had no proper food and water for six days. I was resting and sleeping in a field, when suddenly I saw a naked old man with long hair wearing grass and animal skin. I was afraid he could kill me, so I pretended to have a gun, partially showing him my empty holster. I think he was scared too, but he motioned me to come with him. After walking for more than an hour, we got to a cottage, a grass house. I went around the house to check if anything seemed suspicious. By the time I was done checking and wanted to thank the old man, he was already gone. A woman opened the door, and I gestured that I wanted to eat. She cooked me a big bowl of rice. After eating, I fell asleep. I awoke to the sound of a rifle recharge. It was a French Army officer. I felt relieved—they were our allies. I showed him my jacket with the Chinese-American insignia.

From the cottage, we headed to the French headquarters. On the way there, we bumped into a Japanese soldier. I was very nervous. I tried to hide myself, but I had no hat, and my face was covered in blood. The kind French officer assured me not to worry. He told me not to run away and just keep quiet. I spent a night at the French station and some nights at their hospital. After six days, I was told I would be transferred to the Japanese. My heart sank; I strongly protested. The French officer apologized, explaining that they were subjected to give any prisoners to the Japanese, since they were technically located on Japanese territory. I accepted the reality, as there was nothing I could do. I was transferred to a Japanese hospital.

The Japanese only sent Vietnamese medical officers to attend to me. After I got little better, I was sent to an airport, where I met an American pilot from the Seventy-Sixth Squadron. He was captured at the Port of Hanoi. We were flown from Hanoi to Nanjing.

There we were placed in a military prison, in a small cell, three stories underground. Each meal was a bowl of rice mixed with earth. After four days, they sent me to the hospital to operate on the bullet wound on my shoulder. But two days later, it got worse. There was a bad smell—the wound got infected. It seemed they had operated without applying any medicine. I learned later that they had treated others similarly, leaving them to rot to death. It was a dirty policy.

I was transferred to an American concentration camp in Jiangwan, Shanghai. There were 850 prisoners of war there from Wake Island in the South Pacific, captured by the Japanese. The Japanese thought I was American, so I was sent there as well.

I was already very weak when I got there. On the sixth day, I was so motionless, they thought I was dead. They were prepared to bury me but found I was still warm. The American doctors gave me a blood transfusion. It felt like an out-of-body experience. I remember seeing a bright light and seeing my own body from a corner of the room. I learned later from others with similar experiences that I had probably briefly died but was resurrected. The American doctor and assistant said I was lucky to have survived; usually those with a blood level below 32 percent would not. My blood level was 28 percent. Finally, after three weeks, the Japanese asked me if I was American or Chinese. I said I was Chinese. The next day, they sent me to a Chinese war prison in Nanjing.

Unlike in the concentration camps, we were managed by Chinese officers under Japanese supervision. As a pilot, I was well taken care of. The prisoners grew to respect me because of my defiance to the Japanese. The Japanese threatened to punish the entire batch of prisoners whenever I undermined them, but I stood my ground. My fellow prisoners understood this code of honor.

Those working outside in the field would sometimes hide wild rats, cats, and vegetables in their clothes and sneak back to cook. Sometimes, the Japanese would ask the prisoners to bury dead horses, so the prisoners would also sneak in horse meat. I was assigned a helper because I was too weak sometimes to even put my clothes on. We also had Taiwanese nurses who were helping me, risking their own life.

On August 22, 1945, the high officer informed me and some others to prepare to meet Japanese officers the next morning. When morning came, the head of the Japanese army saw us and bowed silently for about ten minutes. I thought they were going to kill us. But, to my surprise, he told us we would be released. He told us to place our hands near our hearts on the way out. This symbolized a no-revenge pact. The Japanese officers did not want us to haunt them in spirit after we died. Just like that, we were released.

Eventually, I was given honorary medals and a $50,000 reward—I was credited for downing a Japanese plane. But at that time, $50,000 was of little value. I exhausted the money quickly.

I chose to move to Hong Kong in 1963. I married and became a merchant with a small business. I have nothing else to wish for. I am blessed with a good family. I am lucky to have such a beautiful and understanding wife. I am ninety-eight years old. I am ready to go. I was born in China, and I am Chinese—so when I die, I will also be Chinese in spirit.

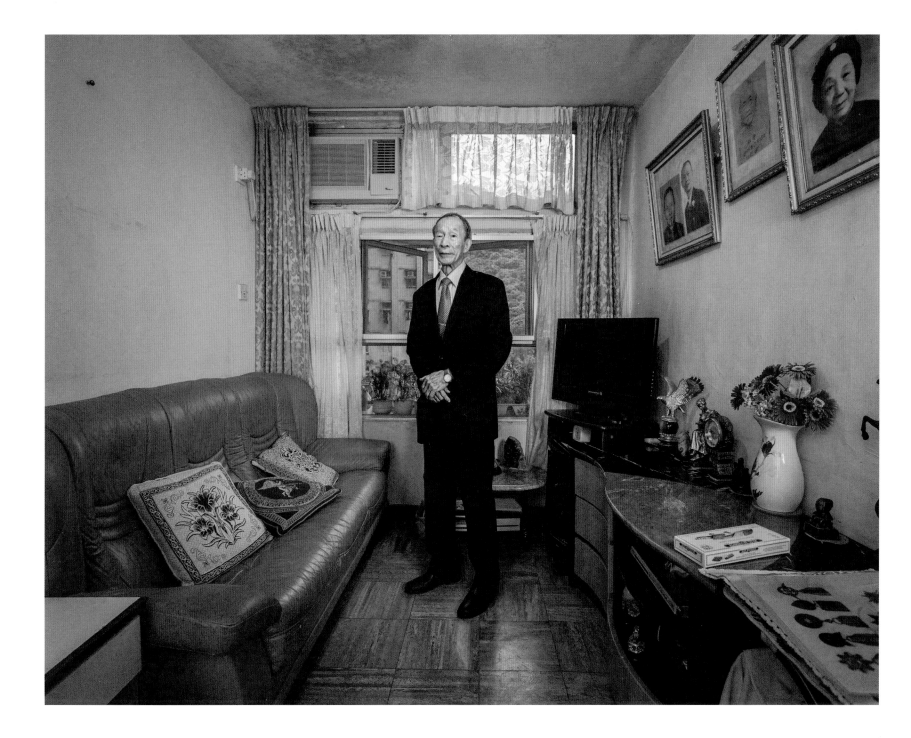

Ichiro Sudai

TAKAYAMA, JAPAN

Ichiro Sudai is my name. I had a very happy childhood and had very good scores in school. I was always getting awards from education committees. I was selected to be the vice president of the Student Committee. Those were very good days for me.

I remember that the quality of paper decreased in wartime. There was a lack of materials. So the awards were all very thin, on very small sheets of paper.

I was in the army for only two years. When I joined, I didn't think Japan would win. But I couldn't say this because I would have been punished. In June 1945, I was selected for a special team of 180 people from a pool of 5,000 candidates. I trained in Chiba city to dive into the sea and signal where the planes needed to dive to attack ships. We lacked enough planes, and each plane only held one person. I would dive with a flag. I had an oxygen tank on my back. The war finished before I ever had to do any of this.

Everyone was brainwashed then. I didn't feel afraid to die. If I did, it would have been with my colleagues. Of course, I was afraid of dying alone. But I was okay dying in solidarity. And at the time, there weren't many luxury foods available, either. Only rice. Everybody was hungry. They would always talk about being hungry.

Colleagues would have to bring the bones to the family after the bodies were incinerated. One colleague was given lots of food by one of the families he returned the remains to. He came back to tell us about it, and everyone was saying, "Go to hell—we had no food!"

The kamikazes were very proud of their duty. They felt as though they were much better than other parts of the military. There was a lot of pride. Lots of jealousy. Before deploying in kamikaze planes, of course, the pilots would be afraid and lose sleep. It was forbidden to tell your family that you would go. But I made a promise I would tell, and I did so with a postcard. Normally Japanese handwriting goes top-down. I hid the message inside the writing.

After they were notified of their duty, kamikaze pilots would have small farewell parties. We exchanged sake and drank. On one side of a table were the kamikazes and on the other were people of a higher position, who were not seen often. It was a respectful, farewell sake. But toward the end of the war, we didn't have sake available. We only had water.

With the kamikaze pilots, they didn't return the bones. We cut our hair and our nails and put them in an envelope or a small bag with a message, and this was given to our families when we died. Our families would receive a white box with these contents.

On August 15, 1945, there was an announcement that everybody had to go to the grounds and change their clothes. We listened to the radio. I couldn't hear what was being said. But I could tell it wasn't very good news. When I found out we had lost, I was very happy. I had made my peace with the idea of death, that it would be my destiny as a pilot.

After the war, there were no factories where I lived. Very few jobs. But there was a lot of forest area. I worked there cutting down trees for two or three years.

Then a cousin told me about a medicine company that was hiring. I worked there for thirty-five years and retired at age sixty-one. I studied woodworking and gardening. I worked on temples and shrines. I was a volunteer fireman until 1978. I lived for my hobbies. I wrote poetry and grew flowers. I've made more than thirty gardens. I also used to run a lot. I still have a very strong body. I go to the mountains in spring and fall and pick flowers and mushrooms.

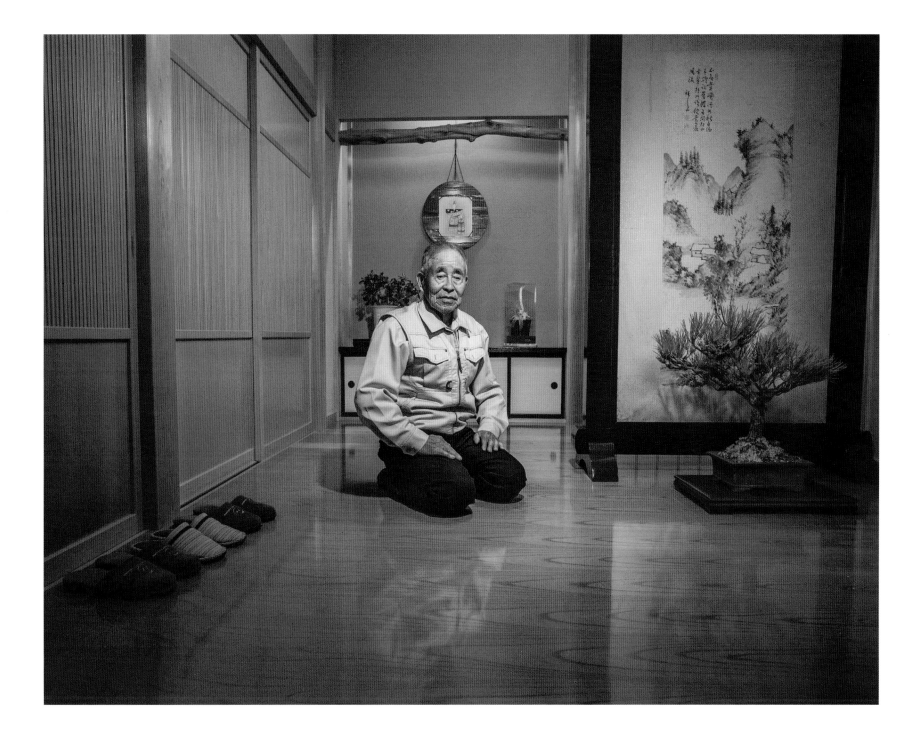

Lakshman Singh

POOTH KHURD, INDIA

My name is Lakshman Singh, and I was born June 2, 1914, in the village of Pooth Khurd, Delhi. As a child, I wasn't very interested in going to school. India had a poor education system. I spent most of my childhood and formative years working on my family farm, where we grew wheat, rice, sugarcane, and various vegetables.

Time has faded my memory, but I believe that I joined the Indian Army in 1942. I enlisted in Lal Qila, Delhi. As I grew, I realized that our family's farming business wasn't very lucrative. As a primary breadwinner in my household, I told my family that I would join the military because it was offering good salaries. I wanted to join the army to serve my country and support my family.

After enlisting, I was sent to Bareilly for basic training. I went through formalities such as a medical checkup and physical conditioning test. I passed both with flying colors. In training, we learned combat and how to operate vehicles and weaponry. Bareilly is where I honed my skill as a grenade specialist.

Once we graduated, we were sent to Manipur, India, then deployed to Burma, which Japan had seized from the Allied Forces during a contentious battle in the region. The main thing I noticed in Burma was the narrow roads. This meant that air transport was a major factor in our infantries' efforts.

Recalling the circumstances to the best of my ability, I served three tours in Burma. After each tour, we were allowed to have a rest for one to two months. We deserved it after the carnage we had gone through.

During most of my stay in Burma, pairs of soldiers in my infantry operated in tandem. If one of us slept, the other soldier kept surveillance. We alternated throughout the day and night. We had to be on constant alert, because the Japanese forces were highly dangerous. They were masters of stealth.

I can recall an incident where Japanese soldiers threw a few hand grenades at my company and killed dozens of soldiers. Because I was also a grenade specialist, my British superiors asked me to do the same thing back to them. Which I did.

As if this constant paranoia wasn't bad enough, our army couldn't even provide us with consistent meals. There was a painful famine among British Indian troops. They had deployed us but made no arrangements to feed us! We had to use our survival instincts and ingenuity to find food for ourselves from day to day. We marched through Burma, very hungry, engaging in constant combat.

I can recall that one time another soldier and I saw two Japanese soldiers in a bunker, one of whom had a machine gun. We killed the soldier with the gun in his hand, and then the other Japanese soldier fled in fear. We took the machine gun and went back to camp.

Along with being a grenade specialist, I was something of a medical assistant in my infantry. When my fellow soldiers were shot, I was one of the first on the scene with first aid. We had a firm border between our camp and the Japanese soldiers' territory, usually the Chindwin River. For those shot within the "safe zone," I would provide help. My job was to clean their wounds, help mend them, and then keep them safe until they were able to be escorted to an army hospital.

Little did I know, I would soon need my own medical treatment. The Japanese soldiers had an awful tactic of gutting us Indian soldiers, then dumping our bodies in the river. The aforementioned scarcity of food made water a paramount resource. We were constantly ingesting the water, but we soon realized the decaying bodies had contaminated it. On my last tour in Burma, I fell ill, along with many of my fellow soldiers. I ended up in a hospital camp for Allied soldiers, where I spent the rest of the war.

Even though I was on the sidelines, I was kept well abreast of the proceedings. After the Battle of the Sittang Bend, Japan's stronghold of Burma was significantly weakened. Ten thousand–plus soldiers died from their side. A couple of weeks later, the atomic bombs dropped, and the Japanese quickly surrendered.

After we won the war, my senior officers announced that anyone who had died or had serious injuries would be compensated by the British government. We didn't get anything from them, though. The only pension came later from the Indian government. After the war, we were sent back to India. Because I was still sick, one of my family members brought me back home to Pooth Khurd from the camp in Bareilly.

When I regained my health, I renewed my love of agriculture on the family farm, where I worked for more than sixty years. During the 1950s, I had three children, two daughters and one son.

My health hasn't allowed me to stay as involved in the farm as I once was. On January 24, 2015, my only son passed away. My son's death has made me feel terrible. The pain hurts me tremendously, but the rest of my family helps me and lets me know how much they love me.

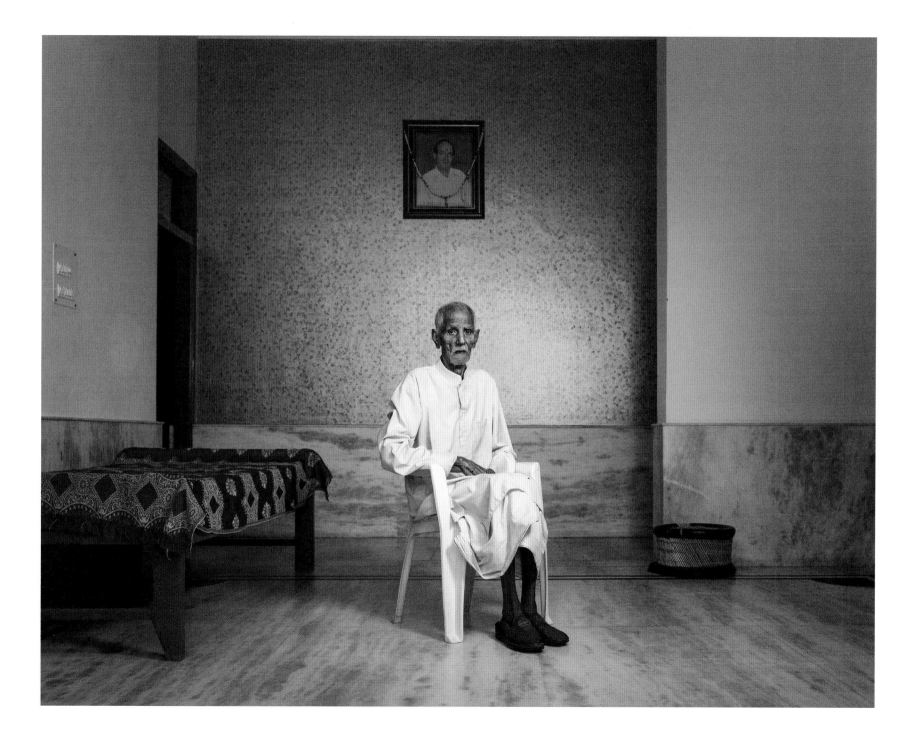

Alistair Cormack

ABERDEEN, SCOTLAND

My name is Alistair Cormack. I was born on the second of March, 1921. My parents had a hair salon, and they were both hairdressers. When my father died, I was only eleven years old, so it was very difficult growing up until I joined the RAF in 1940. The war had begun already in 1939, but I was part of a new regiment of defense. We all had wanted to join the Scottish regiment, but since we weren't allowed to do that, we had to make our own way. So I volunteered for the RAF, one of two other Highland divisions. I went to Blackpool for training and progressed from there. I was made a corporal a couple of years after and then a sergeant following that. I first got my training on aircraft guns, all sorts of different ones, like Brownings. I even finished training on charging up a Bofors forty-millimeter gun and taking down an aircraft—enemy, of course. So when I went into action, real action, I landed in Normandy and fought there for about three months, from June to about August.

When the war had first started, I was attending a cycling event. I was a member of the cycling club, and we would always compete on Sundays. We had just finished a race that day when it was announced that war had been declared. So we left Aberdeen to go to Blackpool for training. We were all spread out between villages, houses, and small hotels. We were there for about three weeks, and we did all of our training on the promenade. It was basic training: marching up and down, training on different weapons, and this sort of thing. Nothing very serious at that point until RAF regiments were formed.

Our RAF regiments were formed when Churchill suggested that Britain have a defense of its own and leave professional soldiers to do the job that they were employed for, rather than hang around the air force. So there were a whole lot of regiments made up, and each squadron had 180 members, as far as I can recollect. They compiled these regiments with what you could call volunteers. "You, you, and you," they'd say, until 180 of us were picked. We were allocated to an airfield in mid-England, near Nottingham. We took various training courses like commando, jumping off of boats, and that sort of thing. It was always leading to something that would be useful when we went into action.

During the evacuation at Dunkirk, a lot of soldiers lost their lives. There were actually fleets that saved a lot of lives, though; they were small sailing crafts leaving from the south of England. They came and rescued them. So after this, a rumor started that the Germans would move over the tunnel and invade Britain. The rumors never materialized, but we still made preparations to return to France.

We had a lot of false alarms before we actually went into action in Normandy. Everything was done under a certain amount of secrecy. You didn't know everything that was going on until you learned it was real and near. We knew that something was going to happen, but nobody knew exactly what. We soon discovered that we would be leaving soon. We didn't know which exact day; some thought it would be the fifth, while others thought it to be the sixth of June, 1944. So when we left Southampton, we left in a tunnel of convoy vessels all the way to Normandy, and we came into contact with E-boats from Germany. We bombed a couple of their boats and a couple of their aircraft. And they sunk one of ours. The LCT * that I was on was bombed, destroying our landing gear for

the ramps. So when we first got close to the beaches, we didn't go right in, because we couldn't. We had to go through maybe two feet of seaweed to make our way onto the beach. All of the landings were prepared for water, so they had to be dismantled on shore. Our engines were sealed off also as a temporary measure until we were on shore. A few of our members were killed. There were more who lost their lives as well, all buried at sea. I hear that there was a memorial service for them. One of my colleagues I kept in touch with from England told me about it.

After Normandy, we went up into Belgium, then Holland, and then finally to a place called Eindhoven, in Holland. We were based there until the war ended. In Eindhoven, we were defending an airfield once when a supplies raid was made. Our gun placement was credited for taking one of the two aircraft down. Unfortunately, one of our chaps was killed in the raid. There were quite a few others killed along the airfields, but only one in our particular squad. But that's how it all finished off. The war was finished. I forgot the actual date of termination, but there was a lot of celebration during that time.

* Landing craft, tank

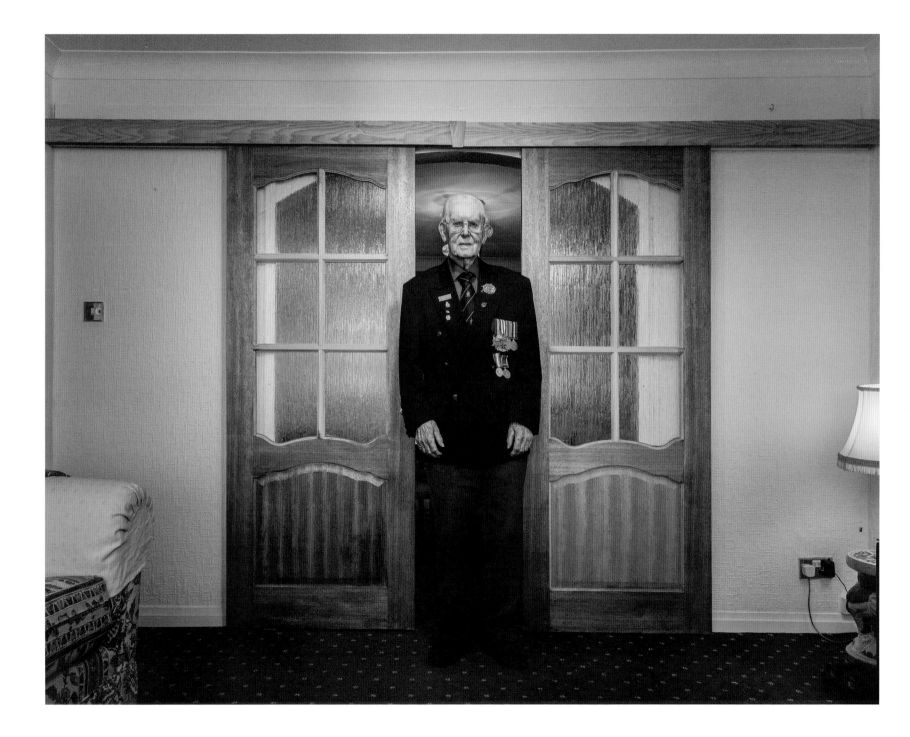

J. P. Jayasekara

KANDY, SRI LANKA

My name is J. P. Jayasekara; I was born on the twenty-first of April in 1921 in Teldeniya, Sri Lanka. Sri Lanka back then was known as Ceylon, and we were a colony under the British Empire. After the outbreak of World War II, so many British troops came and established their camps here. I joined the civil defense in 1941 once I finished school. At that time, the purpose of the civil defense was to aid as a service for casualties, attending to victims of the war. And from there, I joined the army—the Ceylon Signal Corps.

When Hitler attacked Poland and the Japanese sank two of Great Britain's most powerful battleships, the HMS *Repulse* and the HMS *Prince of Wales*, near Singapore, Great Britain was quite shaken up. The British appealed to all the Commonwealth countries for help.

Ceylon was a poor country with no money to give, but we were able to provide the manpower. Forty thousand youths were recruited from Ceylon: some of them were sent to the Middle East, some to Singapore; some served in Burma, and others joined Ceylon's naval reserve. Most of the men were still schoolboys at the time.

On Easter Sunday, April 5, 1942, at 7:00 a.m., we heard cricket noises. Or at least, we thought that they were crickets. They turned out to be gunshots. We all ran out of our barracks and saw Japanese planes coming at us. They were coming in groups of four, bombing and shooting at us. First, people panicked, but then our artillery started working, and we all scrambled into action. That was the day they attacked the harbor of Colombo. The fighting went on for a couple of hours, and a lot of people died on both ends.

It was a tragic day for Colombo and all Ceylon. After that, the capital became a dead city. All the schools closed, and colleges moved inland. There was not even a place to have a cup of tea.

After that, I was reassigned to Trincomalee, where I was still part of the Ceylon Signal Corps. My job involved operating wireless radios and being responsible for communications between the navy and army bases. That was in 1943. During that time, more and more British soldiers were coming and putting up bases all over the island and digging trenches—from Colombo to Trincomalee, from Trincomalee to Kandy; they were laying down underground cables for communication.

At the same time, the British established the South East Asia Command unit, and Lord Louis Mountbatten had arrived in Colombo. He was a member of the royal family and was made the supreme elite commander of Southeast Asia. Recruitment centers were opening all over the place. Their advertisements said, "Join the Army and see the World," to attract the youth.

In March 1942, Sir Geoffrey Layton was summoned to oversee the defense of the civilians. There were a lot of things done to defend the civilians during air raids. Underground shelters were built, fire brigades were organized, and many people were recruited for first aid purposes. Every time the coast guard would sight Japanese planes, it would inform the central command and activate alarms. The marketing department was reorganized; food items were rationed, and coupon books were issued to the people. Co-operative stores were also opened throughout the island, where people drew their rations without any difficulty.

"Looting is punishable by death"
"Black marketers will be jailed"
"Grow more food"
"Growers are winners"

These were some of the slogans written on parapet walls; they were better than the election posters of today.

The British did a lot of things at that time, and they looked after the affairs of civilians well. I was fulfilling my duties with the Signal Corps, where we had a phone, radio, wireless, and pigeons. A lot of messages between stations were coded.

For us, the remainder of the war went by quietly. There were a lot of foreign units brought from all over—American, British, Indian, South African, and Australian—that set up their camps on the island. There was one particularly interesting set of people, African Negroes, who had their mouths padlocked. They were man-eaters, and the British would put locks on their mouths.

The war ended with Japan unconditionally surrendering. When we heard the news, we were, of course, all very happy. But details from the bombings of Hiroshima and Nagasaki all shocked us. It shocked the entire world.

After the war ended, we had a lot of rolling stones. My family had a business—a bakery and a hotel—so I was lucky to have a job. Then I became interested in agriculture. I was always active in sports and still to this day take part in competitions in my age group: look at all the medals. I was also involved in social services and in the prevention of cruelty to animals. I also took part in some politics and was a village counselor for a while.

I got married and had one daughter. My wife has passed away already. Now I have grandchildren, so I stay active. I also wrote a book about the graves of the perished servicemen in Ceylon. I got the idea to do this because so many tourists come here to search for graves of their relatives but can't find any information. I did it for their benefit.

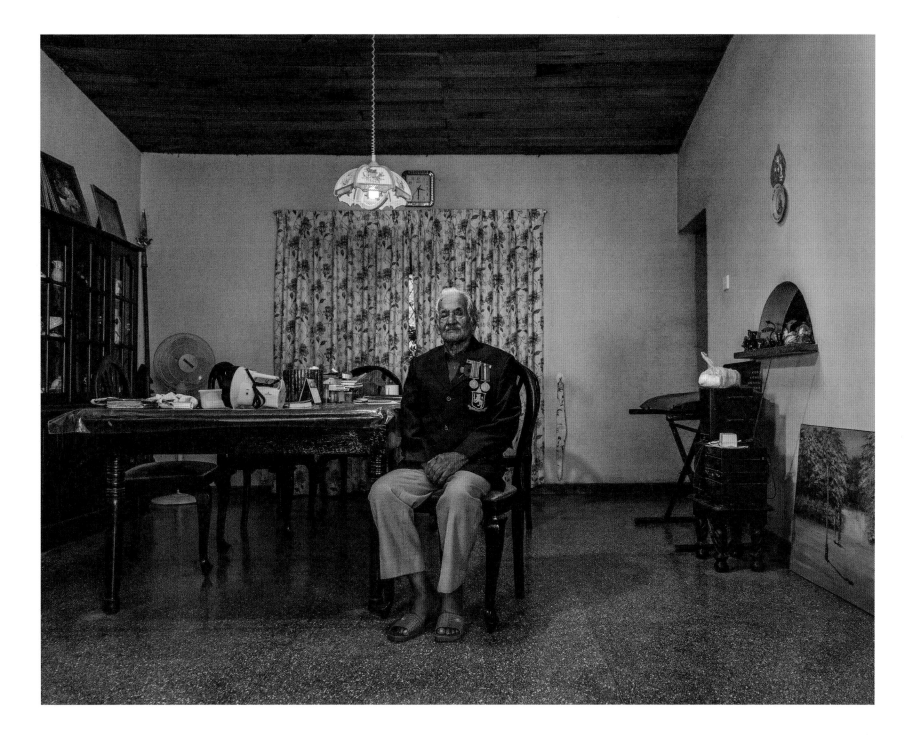

Alexei Georgiev

MOSCOW, RUSSIA

I am Alexei Vasilyevich. My last name was Priemyshev, which I inherited from my dad. But he went missing in 1937, and my family changed our last name to Georgiev. We didn't actually know what happened with my father—one day he just disappeared, and no one could ever tell us anything. It's a long story. My mom, and later myself, spent years trying to find a trace of him…but we found nothing. I never believed that my father could leave us like that, and the circumstances of his disappearance were very mysterious.

I grew up in Kirillov, where all my ancestors came from; it's in the Leningrad region. After Dad disappeared, my family was forced to relocate to Kirov, where my mom got a job in a garage. When the war broke out, the Germans were advancing very quickly, and we were evacuated, along with the others to the east. My family ended up in a village called Khalturin, and my mom got a job at the local school as a cleaner. I was studying in that same school. Life was poor, to say the least; we barely had anything to wear, and we were very happy when we had something substantial to eat. Nevertheless, the locals were understanding, and we felt welcomed. And when I look back on all those years, I still think that I had a happy childhood.

As the front line was moving eastward with the Nazis advancing, we had to move again. This time we got evacuated to a city called Gorky— it's called Nizhniy Novgorod now. My mom found a job in the hospital. I think she took some courses to become a nurse and began working in that hospital. I finished the eighth grade and started my technical education when I was fourteen years old. The war, meanwhile, changed its course, and we were kicking the Germans' ass.

In 1944, the hospital where my mom was working was ordered to be transformed into a field hospital and to be moved all the way to the Carpathian Mountains, to the front lines. So we were called to move as well. The trip took a whole month. On the way there, I saw total destruction: cities and villages turned into rubble, burned-out railway stations, true horror. By the time we got to the western Ukraine, I turned seventeen, which was the draft age. We arrived on December 5, 1944, and on that day, the hospital warden offered to enlist me as a hospital aide. He said to me, "Just stay with your mother, and after the victory is ours, I'll give you a good recommendation and send you to a medical school." But I said, "No, I want to go and fight." That was it. I went to the nearest recruiting station with my papers—it was in a town called Kolomyia—and enlisted in the Red Army. They gave me a gun right there, dammit! So there I was… a soldier. I already had gone through my army training and knew the basics—back then, it was part of the school program. So I was ready to go. My mom didn't argue with me; she understood that I was capable of making my own decisions.

I started my service right there, in the western Ukraine. The situation was complex—we didn't really know who our enemy was. First of all, most Ukrainians didn't want us there and didn't recognize us as their liberators. Our mission was called "giving a brotherly hand," meaning that we were freeing them from the Germans. In the meantime, we were just grabbing a part of their land, to be completely honest. So a lot of Ukrainians were fighting against us. They had partisans hiding all over the place, and the local people didn't exactly welcome us with open arms. And, of course, there were the Germans too, mostly the ones who didn't manage to escape.

It was nasty. Sometimes we would surround a small village, if we had information that Ukrainian insurgents were hiding there, and just shoot everything out. I was just following orders. But I never thought that I was doing anything wrong, never thought about dying myself. I never shot a person in front of me, only from far away. If I killed someone— that I'll never know. We arrested a lot of the people from the Ukrainian Insurgent Army and sent them to the concentration camps in Siberia. Of course, back then, we called them "correction camps."

I didn't really feel hate toward the Ukrainians or the Germans, but war was war. I feel like the people who were fighting there didn't care for their life as much. It came to that point.

We heard over the radio that Germany surrendered on May 8, 1945. I can't even explain how ecstatic and happy everyone felt—it was a real euphoria. We were shooting round after round into the sky. Well, Germany had surrendered, but the war didn't actually end. The fights with the Ukrainian partisans continued all the way into the 1950s. And the war with the Japanese was still going on, and a month or two after celebrating the victory over Germany, I found myself with my comrades on a train to Vladivostok, going to fight Japan.

The train ride was not luxurious, to say the least. Each car had about fifty people in it and just bunk beds. No sheets or anything. Couldn't sleep on those beds. It was a very, very long journey through the entire Soviet Union. Of course, we saw a great deal of destruction along the way, but also a lot of beautiful nature. I specifically remember Lake Baikal—it was as if someone had put a perfect piece of mirror onto the land, it was so still and gorgeous.

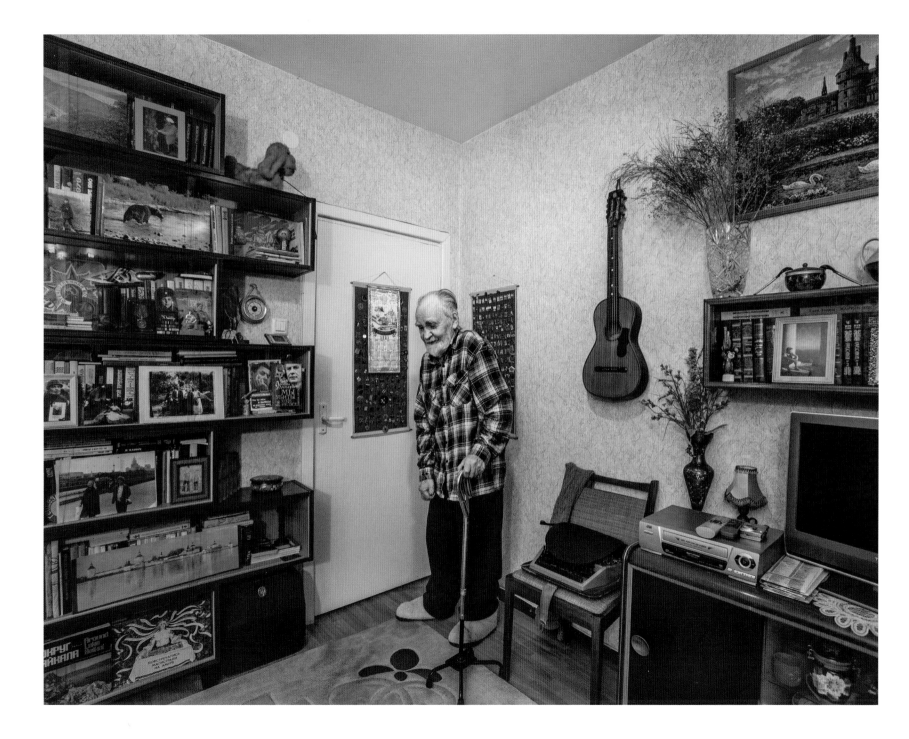

Once we arrived at Vladivostok, we boarded some boat and shipped to an undisclosed location. The trip took twenty days, and I found out what seasickness is in full. We went through some horrible storms, and I was more scared for my life on that ship than at any time during combat. Ironically, that boat then brought us back to Vladivostok because Japan had surrendered while we were at sea.

After arriving back to Vladivostok, I thought that I was going to be demobilized, as the war was over, and I didn't think there was anything else for me to do in the army. But no—I was sent to work at a POW camp in Kamchatka. Almost all the prisoners in my camp were Japanese. The Japanese were nothing like we were told and what we saw from those propaganda caricatures and posters—you know, where they would draw Japanese soldiers like some sort of short idiots with tiny eyes and crooked teeth. No, these guys were disciplined, tough, and well trained. Even as prisoners, they maintained their order and showed their pride. Mostly everyone got along—they worked all day long and tried to study Russian. They would surround me, holding their notepads and pencils, all smiling, and ask, pointing to a table or a chair, "What is that?" or "What is this?" and I'd tell them what's what. They all would nod and write it down. Funny people.

I served as a guard in Kamchatka for five years—two years over my term. Many of us back then overserved in the military for two or three years, some more. And none of us complained. I didn't hear a single person say a word to the higher-ups that they wanted to be demobbed. We all understood that we were there for a reason and that we would stay as long as our country needed us to stay.

I got back home in 1951. My mom didn't recognize me when she first saw me—I left a boy and returned a man. Shortly after returning home, I continued my education—I wanted to become a geologist at first. I knew that education was the key to life, and I spent seven years studying. The last two years were at the Moscow State University. Then I went into teaching and would go on numerous expeditions all around the Soviet Union. I got married, had a kid. After twenty-five years of hard work, I retired.

I took part in two victory parades. One of them was attended by Bill Clinton, by the way! He was up there, standing, looking at us marching through the Red Square. That was in 1995. Yes, I have things to reminisce about: I've traveled through the length and breadth of the USSR, been to all sixteen republics, and drunk vodka in each of them! I've always written poetry. It just comes to my mind, and sometimes I write it down. But I never considered myself a poet—it's too much of a title for me. I had a long and exciting life, and now, I often sit here in this room, browse through my photo albums, and proudly look back at all those years.

Alfred Martin

BELFAST, NORTHERN IRELAND

My name is Alfred Martin, and I was born in Finaghy, near Belfast, on March 26, 1920. I was educated at the local primary school, and then I went to secondary school in Lisburn. I passed my senior certificate in 1936. At that time, the world was in chaos in Northern Ireland and in Britain because of the King Edward VIII abdication crisis, as well as of Hitler's and Mussolini's desire to take over Europe. In 1938, at the time of the Munich Agreement, I made an application to join the Royal Air Force to fly on weekends. I signed up, but my mother indicated the dangers of flying and suggested that I cancel it. Therefore, I went the next day and canceled my joining notice.

In January 1939, things were still heading toward the war, and I felt very nationalistic, so I joined the Territorial Army Royal Engineers. In the Territorial unit, we were paid £5 a year, which is roughly equal to £100 today. The officer in charge was Maynard Sinclair, who later became the minister of finance in Northern Ireland. I was in the camp in June 1939, but after that, I continued my civilian job at an insurance company. I was away for company business when I received the telegram from my office on August 28, 1939, to immediately report to the TA. Thus, I took a bus and traveled to Kilroot.

I spent twenty months with the Royal Engineers, and our duties were looking after searchlights. We had nothing to do with aircraft, since we were strictly handling the searchlights to identify enemy ships. We performed our duty at Helen's Bay at Grey Point and then also at Kilroot. Later, in 1940, we looked after the searchlights in Magilligan. We all enjoyed our time at Magilligan, and it seemed like a summer camp, as there were beautiful beaches everywhere. There were about twenty of us just looking after ourselves. I returned to Grey Point, and in April 1941, I read that the Royal Air Force was looking for volunteers for an air crew. I applied because we were tired of doing very little. I was selected for the interview; however, I was told that I would do better as an observer instead of a pilot. The observer helps with the navigation. The role of a navigator was becoming increasingly important because of the lack of navigation aids within the continent. I agreed, but later on I wished that I had asked them to take me as a pilot. I would have liked to be a pilot; I think I was mechanical minded in many ways.

I was called up in May 1941, and the first place was in Shakespeare country, where we stayed at the Shakespeare Hotel for six weeks. Later, we stayed at the Grand Hotel in Scarborough, doing our initial training. From there, we found ourselves all aboard to Canada. At least, we thought we were going to Canada, but we ended up being dropped off at Iceland. We spent sixteen days in Iceland. It was summer, and we enjoyed swimming in a hot-water pool, which was very lovely. Suddenly, we were told to return to Reykjavik, and we were put on board the HMS *Wolfe*. So back we went toward Belfast and then toward Halifax, Canada. I was then stationed at Prince Edward Island for, like, five months, doing the navigation training all over the area. At Christmas 1941, we were declared okay as navigators, and we were then sent to Picton, Ontario. It was January, and it was really cold, which made it difficult standing up and firing machine guns, but we got through another three or four weeks before we were declared okay for bombing and gunnery. We were all promoted to sergeant and then sent to Boston. On return, I found out that I and five others had been commissioned.

This ended our training in Canada, and we returned to the UK, to Liverpool. From there, we went to various camps, including Harrogate and Oxford.

I remember one incident where we were flying back to Oxford from Scotland at nighttime, and we landed poorly somewhere in the middle of the night. I remember myself climbing out of the wing and onto a tree. I also remember hearing the rescue people looking for us and shouting, "We will find you." And they did find us. We were then put on medical beds. The next morning when we woke up, they put us on a train back to Oxford. Our landing speed was only sixty-eight knots, which was very slow, and I think that saved our lives. The only person injured that night was our pilot, who broke his wrist and was sent to the hospital. And we never saw him again.

Later, in September 1942, we did our first two raids on Hamburg and Düsseldorf. After that, the men of our crew were posted to Pocklington, and that was my station from September 1942 to April 1943. I did a number of operations there involving navigating bombing on targets. My role was to assist the navigator, helping the pilot target the enemy and press the button to drop the bombs. There were all sorts of fires burning on the ground, and we didn't have modern navigation aids. Once, we got hit with machine gun fire on our way back, but the pilot managed. A few minutes later, the pilot said that our engine was on fire. When they lifted up the escape hatch, we started dropping down through the hole. Unfortunately, due to the heavy wind, I had to disconnect my intercom. I had my parachute on my chest when I jumped from the edge of the door. It was five past four in the morning, and I was able to see my watch, but I didn't know where I was heading. After dropping out, I saw the tail of the aircraft pass over my head, and I pulled the ripcord and it opened beautifully. I was

drifting down at a very low level (I reckoned at about five thousand feet), and I thought it was very risky for the rest of the crew. Suddenly, the ground hit me, and I rolled over on my back. I stood up immediately and looked for a place to hide the parachute.

I walked all morning through the fields, and I didn't see people. I had to hide in the daytime to avoid people. So I hid between two hedges and sort of slept. Around 1:00 p.m., I heard some noise that I couldn't identify, and all of a sudden, a cow appeared. A little boy was riding the cow. He looked at me up and down, and then he stood back and saluted me. He went off, but it boosted my morale. I finally had to find a place to sleep through the night, as I was tired and miserable. I found a shed, and I lay down there while trying to get some sleep, but I had to get up every few minutes to keep myself warm by doing some exercise. It was the night of April 17, 1943, and it was a Sunday.

The morning came, and I moved on again, trying to look into some farmhouses for help but making sure that they had no phone connections. Finally, I was given a map and told to look for a train. I walked all evening until I got to a very small village. I saw a lady, to whom I said, "Could you help me?" The lady seemed frightened, but I managed to gain her confidence, and she led me up to the road. It was just getting dark (about nine o'clock), but she took me to a farmhouse and knocked at the door. It was opened, and I was told that I could stay the night.

There were notices that the people helping us would be shot, but I spent six weeks there with the farmer. I had to dye my hair, and whenever there was a search, they used to hide me under the straw in the barn. One evening, a couple came and took me away to the railway station, where we had to wait several hours for the train to Arras, France. I spent about five or six days at the check post in Arras.

We then took a train to Paris, and there were people in Paris waiting for us. They took us to a safe house, and two of us got to renew our cards, photographs, and identity cards.

I spent about five days there, and then we got a new guide, who took us to the railway station for a train to Bordeaux. When we reached the station, there were several men standing in a group, and one of them was my pilot. It was quite emotional as we both walked toward each other and patted each other's back. I also came to know about the other crew members. Two members were able to return to the UK (one was the navigator and the other was the wireless operator), two were taken prisoner, and one other was killed.

Anyway, we were taken on the train overnight to Bordeaux, and from there, we were again taken by train to Dax and later to the Spanish border. We were taken to meet a smuggler who used to take people over the border. We were taken through the River Bidasoa to San Sebastian, where we spent about five days. We then drove to Madrid, where we spent a few days in the embassy, and there we were able to send letters to our parents for the first time. Later, we were sent to Bristol on an aircraft from the air force base across the border, and we arrived in Bristol on June 20, 1943. From there, it was a trip all the way home to our air force station.

In February 1944, I completed the staff navigator course and became the instructor for staff navigator courses. The students were very lively, and it was quite fun. I was sent back to England in October 1945 and stayed there for a couple of months before I was discharged. Later, I returned to Belfast and took up the civilian job that I had in the insurance industry. I stayed there for over a year, and I considered moving to Canada.

Finally, I ended up joining Northern Insurance Company in Canada. When I resigned, I was the deputy manager for Ontario. I stayed for about twenty-one years in Canada. In 1952, I proposed to my wife, whom I had met back at home in 1943. We got married in December 1953 in Toronto. We had our honeymoon in New York. However, she was eager to return, and then I decided to also return and have my own business back at home.

My hobbies now include playing golf, gardening, and being connected with the armed forces. I am also vice president of the local Royal Engineers Association, and I am president of the Aircrew Association, Northern Ireland branch.

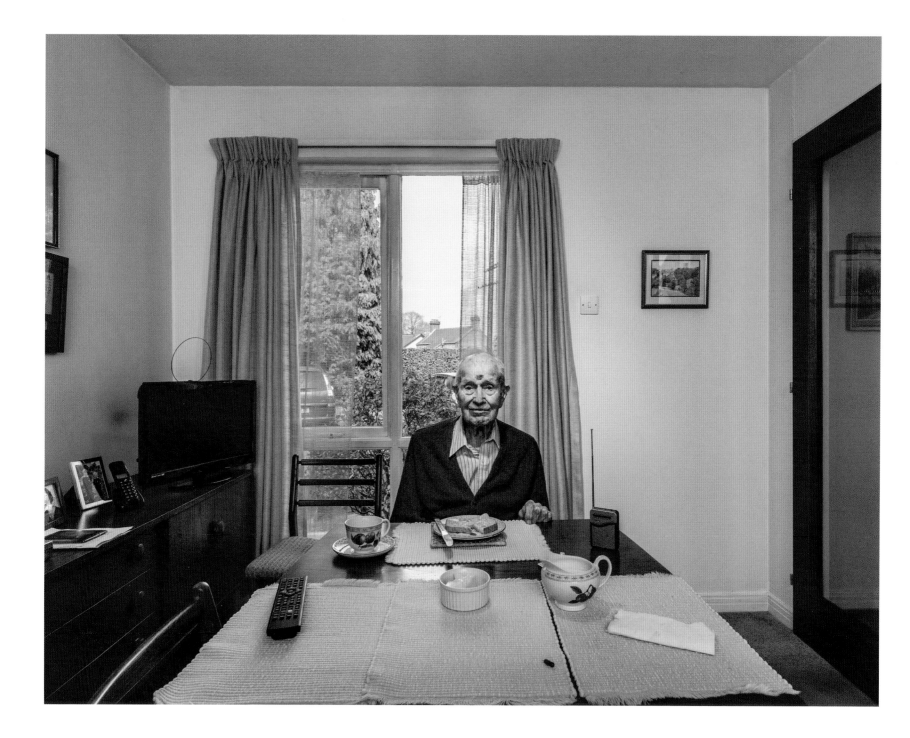

Uli John

FREUDENSTADT, GERMANY

I am Uli John. I was born on October 22, 1922, in southwest Germany. I had a peaceful childhood. I had a lot of fun around the village, with the boys and girls there. I lived on a farm. I loved the farmer's work. Sometimes my father hit me for getting in trouble.

In 1940, I finished high school. Then I was a volunteer for the army. I was sent to Czechoslovakia for training, then to Poland. I was stationed in these places in the war: in 1941, Poland. In 1942, I was in the Russian campaign, where I became ill and was sent back to Germany on recreational leave. I attended an officers' school in Berlin. In 1943, I went to France. In 1944, to Italy to the front against the Americans, in the fight for Rome. In the end of that year, I went to Belgium for the Ardennes offensive, and on December 31, I lost my left arm.

I got a letter: you must become a member of NSDAP.* I wrote a letter to my brother, who was also an officer in the war. He wrote me back: do not become a member of NSDAP, because we don't know how the war will end. This was the same year.

There was an order from the highest levels of the army, from maybe Hitler himself. It said that all the injured should be amputated, people with legs injured, arms injured, because it would be faster than being treated in a hospital, so that the wounded could rejoin the fight. So four weeks later, amputees would be at the front again. After an operation in 1945, I went back to Germany to the final fight against the Americans.

The soldiers on the front lines had no idea what was happening at home. We were told that we weren't

* National Socialist German Workers Party, i.e., the Nazi Party

going to war against America or against France. We were going to rescue the homeland. This was told to soldiers across the fronts because soldiers were often apolitical. Perhaps many of us were of good intention, doing wrong things.

I remember once, on Christmas Eve, in Russia, the soldiers were throwing presents they'd gotten from home to each other, across the lines. There was still gunfire, but it all went high, for show. The packages were full of sweets or cakes, small things sent over from home. Cigarettes, perhaps. A symbol for the holiday.

The last year of the war was a real mess. I was an officer, commanding my unit, and I did something forbidden: I dissolved it. I wrote everyone passes, for groups of two or three people, one weapon among them, so that they could get home. I could have been shot for this, but I did it because the war was ending and I felt that they needed to get home. Everyone made it back. I traveled with a bicycle and on foot from a French zone, which became an American zone at the end of the war, not far from Bavaria.

The village I returned to was occupied by the French first, and then by Americans. I had learned to speak French in school, so I was able to communicate. The mayor of my village had been imprisoned; he was a Nazi.

Before the war began, I had wanted to study French. But the year after the war, I studied forestry. They told me that I couldn't do it because I had only one arm. But I worked a year in the forest to show that I could, and then I was accepted and began my studies in Freiburg im Breiscau. I started my career as a woodsman, cutting down trees. I later became a teacher in the forestry school. I taught about construction of forest territories, hunting, shooting, sports, horn blowing, et cetera.

I was married in 1956. We had three children, all boys.

We established many contacts in foreign countries: France and Russia, the United States—other veterans of war, some through family members and forestry colleagues. I made some friends of former enemies. People who fought in the war and know what war really means.

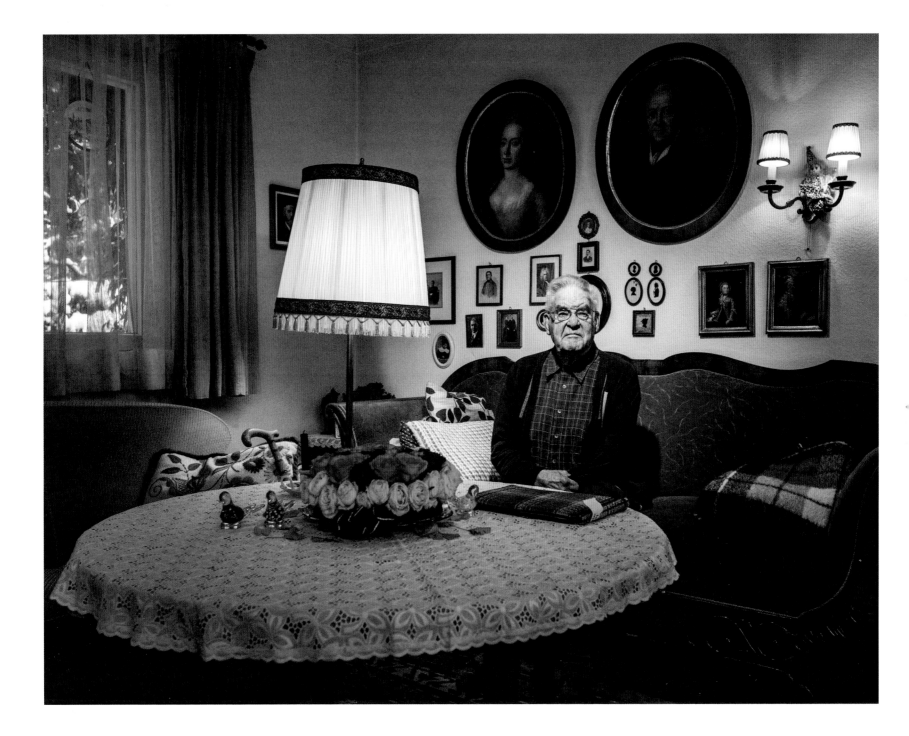

Anna Potapova

KHARKIV, UKRAINE

I was quite young when both of my parents died. I used to live with my elder brother and his wife, and I didn't get on particularly well with her. So when the war broke out, I told them that I would go to the front. Quite timely, I should say, because they were enlisting young girls of my age then. One of the officers wasn't quite sure about me, because there was nothing in particular that I could do. But I pleaded with them and told them that I was a nurse. There was a great turmoil in the beginning of the war, so they didn't go into detail and got me enlisted. They got us all packed into wagons, which had been earlier used for cattle. A propaganda officer got inside as well, and when the train was already in motion, we started to take the oath. It wasn't long before someone opened fire on us, and we were lucky to get through.

Our destination was the 189th Antiaircraft Artillery Battalion in western Ukraine, and when we finally got there, they gave us our first assignment, which was to dig trenches. I was fifteen then, and I spent two years on the front line. The Germans used to shell us from Messerschmitts and Heinkel He 111. When the bombing became too heavy, we would move to a different location. Sometimes we changed our positions as often as three or four times during the day. In fact, we moved quite a bit around the country—almost the whole western Ukraine, Bila Tserkva in central Ukraine, and even as far as Rostov, Russia. Once we were lodged in some village, and I remember a woman, the mistress of the house where I stayed, who was very kind to me and treated me to some homemade crackers.

In fact, I had several jobs during the war: a combat medic, an instrument technician on the anti-aircraft artillery unit, and a telephone operator. As an instrument technician, my task was to watch the gauge of some huge device and tell this information to our gunmen. You know, the bearing angle, the altitude, and the distance of the plane. This is how we managed to shoot down a lot of planes from the ground. There were ninety girls in my squad, and whenever a girl at the machine gun got killed, I would take her position. The device itself was tricky enough, because you had to watch it all the time almost without blinking in order not to miss a plane.

Once, the telephone line got torn, and the commander ordered me to fix it. I remember going out there all by myself, finding the damaged place, fixing it, and coming back. And there was another case when they sent me to the command post with an important message to deliver. I can't say that I was very scared. But it was already getting dark in the forest, and the birds stopped singing. I was walking through the quiet of the forest, thinking of my chances of being shot and repeating the name of the Lord quietly to myself, for it was the only prayer I knew. Somehow I managed to get to the command post and delivered the message. "Well done!" they said and asked me if I was afraid to return back to my location alone. Afraid? Who said anything of being afraid? Nothing like that!

My commander would always tell me to go straight to the shelter in case of shooting or an air raid. But how could I? When I saw so many wounded people, I couldn't do anything else but go out there and drag the wounded back to the trenches. The commander would curse me for that. I remember one wounded soldier with his guts falling out. He was pleading for help, and I tried my best to save him.

There were people among us who used to encourage others to desert from the front line. They spread all kinds of demoralizing rumors, saying that the war was as good as lost. I should say that I was pretty good at identifying these sorts of people. I would watch them closely and share this information with a special unit. Some people were even tried by a military tribunal. And I received an award for that.

Once, there was an air raid with plenty of Henschel planes. They started dropping the bombs, and I got buried under the ruins of our shelter. When they dug me out, I was shell-shocked. I guess it happened somewhere near Bila Tserkva. I was sent to a hospital straight away. When I came around, I found myself stammering badly. I even asked my doctor—the one who had a funny beard, just like biologist Michurin*—to give me some medicine that would make me fall asleep and never wake up again. "Darling," he told me, "how could you ask me for such a thing? You're so beautiful. Just wait and see. You'll get over it! You're in for getting married yet. I'm your doctor, and I promise that you'll be fine. You're a nurse yourself, so don't you worry!" And he gave me some medicine that was so bitter it almost made my eyes pop out! Later, in September, they sent me to Ryazhsk, in the Moscow region, where I fully recovered.

The war ended, and I decided to train as a nurse. I read in a newspaper about a medical college in Makhachkala, Dagestan. So I enrolled in that college and studied there for a year. I was a good student, and I think that I would have continued my studies there but for one accident. The thing was that I rented a room with one Armenian family. My landlady wrote a letter to her son Borya, who lived in Baku,

* The Russian biologist Ivan Michuran

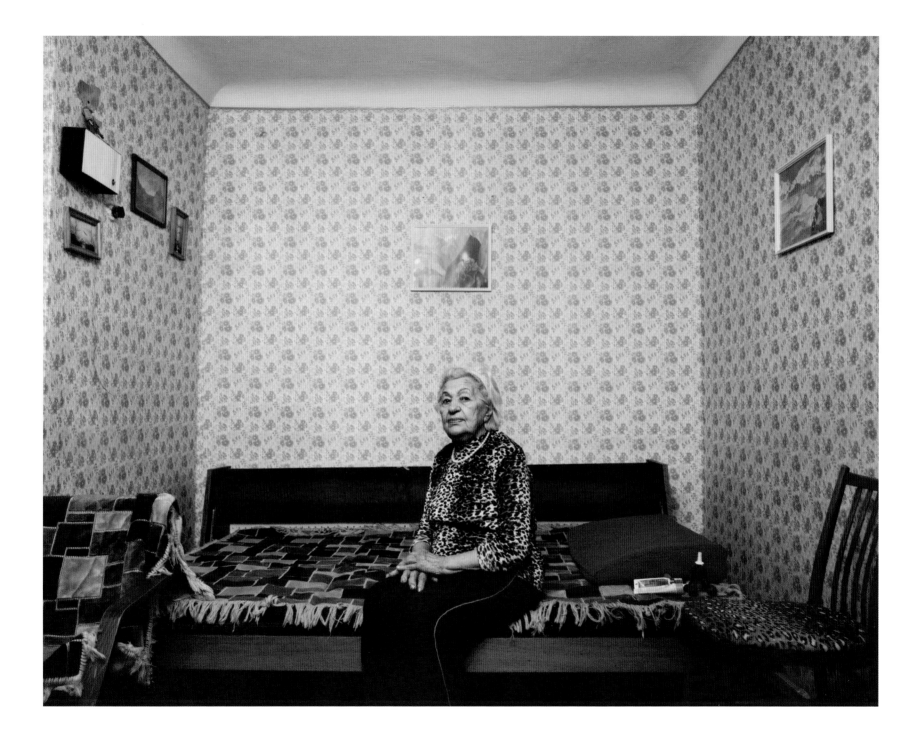

and told him that she had found a fiancée for him. I was out dancing the evening he came. I used to have a good dancing partner, a very handsome young man who would always pick me up and see me home after the dancing. So Borya came to the dancing club and made a great fight there, scaring away a lot of people. It was 11:00 p.m. when he finally came home, threatening us with a knife and shouting at his mother, blaming her for failing to prepare Ania—that is me—for his arrival. We couldn't sleep that night. In the morning, I came to college only to find the principal, who asked me to leave the city and stay somewhere for a while. So I returned to Ryazhsk and found a job as a nurse there. I never told this story to anyone.

There in Ryazhsk, I had a job in a military college that trained officers. I worked in the college canteen, checking the quality of food and tasting the meals. I looked lovely indeed in my snow-white uniform, with a nice headpiece in my hair. No wonder I had a lot of suitors! Some of them were really handsome. There was a pilot among them—a top-class navigator, to be more precise. He proved to be the most persistent of all. He would follow me wherever I went. But I didn't like him very much, and I didn't want to marry him. However, I could see that he really loved me a lot. I remember once that I saved up some money for a pair of new shoes and went to the shop. And guess what? I was about to pay for the shoes when he appeared as if out of nowhere and paid for the shoes himself! My landlord—I used to rent a room then—kept praising him. "You are so dear to him! No other man will take better care of you," he would always tell me. But the fact was, I didn't love him! However, some time later, our military division was to be transferred to Sakhalin, and I had a difficult choice to make. So finally I gave up and agreed to marry him.

On our way to Sakhalin, we spent nine days on board a ship. We all felt so sick that we could hardly move. Everybody except my husband. He was very healthy, so he took care of us all, bringing the food and taking away the waste. Besides, he did know a lot about planes. It wasn't a big deal for him to approach a top general or an admiral and ask all sorts of questions about planes. And those generals would ask our commander to quiet the insolent Potap. They used to call him this because of his surname: Potapov.

We spent six years at Sakhalin, altogether. When we first arrived there, it was barely habitable. There was nowhere to live, and everything was extremely expensive. Besides, there was deep snow everywhere, which made life even more difficult. At first, we stayed in some basement with a group of soldiers, having nothing to eat but canned pork. There was no running water, so my husband made an ice hole in the river and used to bring water in a small mug so that we could cook something to eat. I caught a bad cold then, with a terrible fever, which was even more dangerous because I was pregnant at that time. Soon, they gave us a separate room. When we first came there, it was entangled with all sorts of cables and wires, for our neighbor used to keep chickens there. Finally, six years later, my husband got discharged and started wondering where to go. Some clever people advised us to go to Ukraine. It was believed that one had more opportunities there. So we decided to take this advice.

When we arrived here, we were completely broke and with no place to live. My husband found a job at the Malyshev plant and worked tirelessly. He was a very good worker indeed and stood a good chance to get a nice flat. And he did. In fact, this is the same flat where I live now. As for me, I had an eventful social life then: dressmaking classes, volleyball, all sorts of things. I was the captain of the volleyball team. We had a lot of amateur clubs, a very good choir, dancing classes.

In the evenings, we used to leave our husbands at home, babysitting the children, and went dancing. It was a beautiful life, regardless of all the difficulties. Food was very expensive then. Milk, meat, apples—everything was expensive. However, we were young and full of energy, so nothing seemed too hard or too frightful.

Much time has passed. We are still at the same apartment. I have to take full care of my husband; he is almost disabled after having two strokes. Sometimes I wonder what would have happened to me if I didn't marry the man I never loved.

Dutch Holland

OTTAWA, CANADA

My name is Harold Edward Holland. I was born on August 31, 1922, in West Kildonan, in northwest Winnipeg. I was from a family of fourteen children: six boys and eight girls. As far back as I can remember, we spent our summer holidays on a farm in Saltcoats. It's in Saskatchewan, near Yorkton, which you've probably heard of. I went to standard public schools in Winnipeg and college much later in British Columbia, where I earned a degree in mechanical and aeronautical engineering.

When I heard that the war had broken out, I was working as an apprentice at the CNR* in Winnipeg. I knew I was the exact age for joining up, and I knew I was going to be conscripted, so I went and joined right away voluntarily. I didn't know what was going to happen, but I did what I needed to do. It was just around my eighteenth birthday in 1940.

I knew I wanted to be a pilot, but during my medical examination, I couldn't cross my eyes, so they told me I could never be in the air crew. You can't have depth perception if you can't cross your eyes, and as a fighter pilot, you have to have pretty good eyes. So they sent me to do guard duty. And guess what? During my guard duty that summer, I attached a bayonet to my rifle and spent hours putting it up to my eyes. By the time I finished guard duty two months later, I could cross my eyes as well as anyone. That allowed me to become air crew, so I continued my training and became a pilot.

I stayed in Canada, on the west coast, for about a year, continuing my training while defending the

* Canadian National Railway

country in case of a Japanese attack. But the Japanese never came, so I was sent to England. My time was easy there. I did nothing but chase girls. The British were expecting a German invasion at that time, and I sat on guard duty, waiting. The Germans never attacked, so I was then posted to Burma. My commanding officer called me and told me, "You're going to Asia. Burma." I didn't know where it was, but I thought it was a great idea. We traveled south from England, all around Africa by boat, and landed in India. I reported in and was sent onward to Burma, where I stayed for six months doing fighter pilot courses.

It was an interesting experience arriving there, because I had to cross a body of water to get into Burma, and then I was supposed to take a train. When I arrived at the railway station, it was just getting dark, and someone was supposed to meet me. I sat at that railway station by myself all night, listening to the tigers and lions howling nearby. It was frightening, but at eight o'clock the next morning, someone came to pick me up and took me to the base. I ended up at a training camp with four other people also just coming into Burma. We did exercises flying the Hurricane fighters that would be used in operations. I was there for about six months or so before, with the luck of the draw, I was posted to the RAF Number Eleven squadron. When I arrived, I reported to the squadron commander's tent and introduced myself as Harold Holland. The commanding officer said, "I have never known a Holland that wasn't called Dutch. Your name is Dutch." That was a long time ago, but I've been Dutch ever since.

The first night I arrived at the squadron, I had one of the best dinners I ever had during the war. Someone, a New Zealander, had gone out with his rifle and brought back a couple of dozen ducks. I think they

were a farmer's ducks, but we had a great dinner— the best during the war. From there on in, the food was lousy. But we ate better than the Japanese. They ate us, I was told. We were given poison to keep in case we were ever caught. I almost got captured by them once, and I remember thinking, "Oh God, I don't want to be a prisoner of war." But fortunately, I got out of that situation.

I spent the next three years initially training with Hurricanes and then fighting the Japanese on the Burma front. I was flying once when my engine failed. I was about a hundred miles into enemy territory when I saw my instruments indicate that the engine was starting to fail. So I flew a hundred miles back toward our lines. I didn't have many options on where to land. I was going to land in a lake that I saw, even though I had never learned to swim. I would have drowned landing if it hadn't been for a voice on the radio. Someone directed me to fly up a bit higher, over some trees, until I saw a swamp. With wheels retracted, I landed right at its edge. It was a frightening experience, but I got out of it without a scratch. I never found out who it was on the radio that told me where to land.

For two days and one night, I ran like hell from the Japanese. I was near the British lines, and several British soldiers from Nepal, the Gurkhas, helped me back to their camp. I had gone two days without any food before arriving there. It was just after supper, around nine o'clock. I went straight for the kitchen and found the cook. I think I slept for about two days after that. But I survived it and then returned to my squadron, hitchhiking back. It was a hell of a long way, but I eventually got back.

I remember one mission, when we were flying very low, about five hundred feet, when one of my boys suddenly said, "Oh, I see a target!" And immediately

he turned his craft over, stalling the airplane, and crashed, killing himself. That was a real shocker. I was leading this flight, leading him, and I didn't have a chance to say anything to him. That shook me quite a bit. It wasn't a valid target, but a derelict truck I had destroyed a few days before. I knew that as soon as I looked at it, but I didn't have a chance to tell him before he killed himself. He had been a good friend.

I was near the British Army another time, when we had to help them get supplies across a valley. They were stuck because at both valley ends, there were Japanese soldiers. They had guns and were shooting into the middle. To get the army through, I flew out from my squadron, into the middle of the valley, and set myself up as a target. It was a foolish thing to do, but while I was out and they were firing at me, the remainder of the army was able to sneak through. I had to do this several times because even though I told my team what I was going to do, they began shouting, "They're shooting at you! Get out of there!" They were so intent on watching me instead of looking for the Japanese gunners on the ground, I had to repeat my action two or three times before everyone passed through safely. So the British got through, and that's why I think I later got my Distinguished Flying Cross medal.

In March 1945, we stopped the Japanese, who, up to that point, had been advancing. We avoided the need for a huge battle and started driving them back with our support in the air.

Before the war was over, I was sent back to an army base in Vancouver to be demobilized. Once they discharged me, I went straight over to the University of British Columbia and signed up to become an engineer. I spent five years there, and one night, while on the bus heading home, I met my future wife.

When I met her, I was still in uniform, and I asked her for a date. We hit it off very well, and a year later we were married.

Once the war ended in 1945, I rejoined the Royal Canadian Air Force [RCAF] because they offered to pay for my university education. I was employed as both a pilot and an engineer, managing the maintenance of the aircraft. In 1955, I was sent to England on a course for guided missiles. I was one of the first people to get involved with this in Britain.

After retiring from the RCAF, I got a government job and went back to Burma. Burma had tractors and other equipment for their timber operations, but they were rusting away. No one in Burma knew how to fix them, plus they didn't have the necessary parts for them. I was brought over with a bunch of maintenance people to get all of this equipment back on the road. I developed a complete scale of tooling for maintaining the vehicles. I spent about three years there, managing and training young engineers and mechanics before then going to Tanzania on another project. I taught and trained mechanics there too before I came back to Canada.

I'm now involved with adult day programs with other veterans. Until the end of last year I used to recite "A Pilot's Prayer" at military ceremonies. I had the whole prayer memorized and would recite it at annual gatherings, such as the Battle of Britain parade. For a while, I was involved with the Air Force Museum. I also like to play golf…when there is no snow.

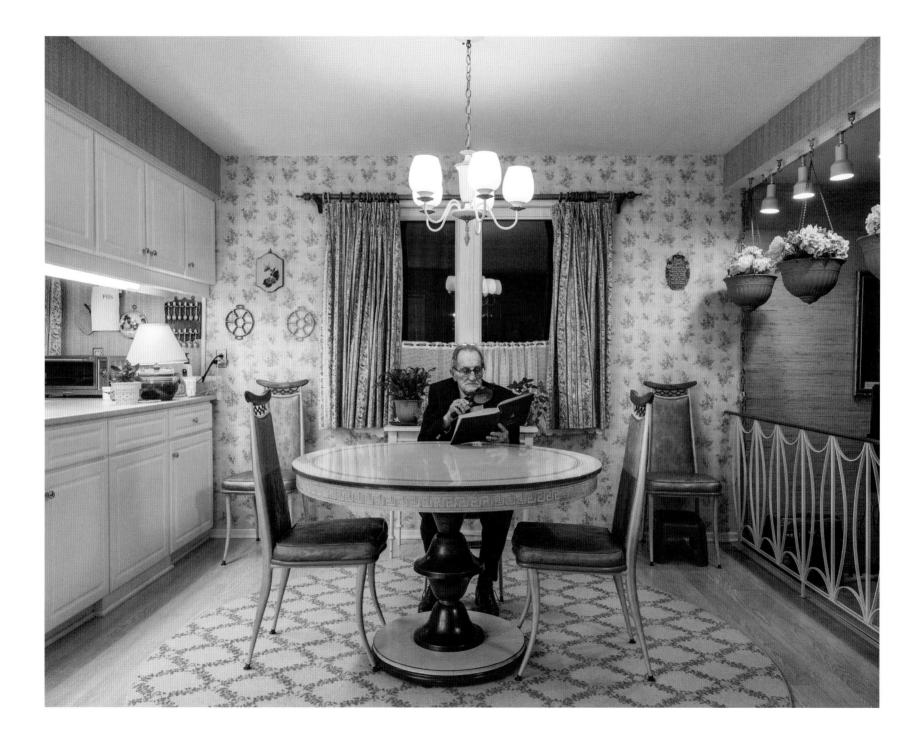

Sidney James Taylor

NORTON CANES, ENGLAND

My name is Sidney James Taylor, and I was born in Norton Canes, England, in 1920. I had a great experience as a child. I was in the Boy Scouts for a number of years.

When I left school, I got a job as an engineer with a vehicle manufacturer. In 1939, the possibility of war was becoming a reality. My father told me, "If I was you, I would join a good outfit, because you could be sent anywhere."

I took his advice and joined the Territorial Army. I started at a drill hall, doing manual work, such as erecting portable bridges. At that point, many were deployed to combat missions to Europe, but I was merely sent to another training camp. I stayed at that camp until early October 1939.

We traveled from Southampton to France, to Coutiches, a couple miles from where the Battle of the Frontiers in World War I took place. While we were there, we built pillboxes. Pillboxes were those ugly concrete structures that were used as fortifications along the defense line. We were there for several months. From Coutiches, we went toward the Maginot Line—essentially no-man's-land. We had a couple skirmishes there, but nothing serious.

We soon got word the Germans broke through France, and we were called to defend Dunkirk. Seventy miles out, we realized the Germans were already there. Our party was then sent southeast. Along the way, we were doing demolition, blowing up crossroads and bridges to keep them from advancing. Little did we know at the time how far they had already advanced.

On June 10, 1940, I can remember suddenly hearing tanks in the distance. We didn't have the proper ammunition to fight back, so our party jumped into the cornfields. We thought that was a decent hiding place, but the tanks were very tall, so the German soldiers still saw us. They swooped in, told us the war was over for us, and took us in as prisoners of war.

The Germans put us in trucks and drove us to Holland. We were then put in car barges and sent to a prisoner camp, Stalag XXA, in Poland. I grew sick and ended up in the hospital for a short time. I was at that stalag for four months, then sent to a second camp in Bromberg. At this stalag, we dug irrigation ditches and performed road repair. The Germans would gather us together and send us way out into the woods.

In the summer of 1943, I was moved to a farm in Marienburg, Poland (now called Malbork). I initially worked in the field. Once, I was using a tractor and forgot to put it back in the barn—I was almost shot over that. The Germans took me off that assignment and made me work in the office. Honestly, I figured sitting down was better than being in the field anyway.

While I was on the farm, I met a Japanese prisoner. He got a letter from his parents saying his wife had left him for another man. He kept telling me he had to escape the camp, presumably to go back and win her love. I told him I would escape with him. One day, we were out in the field doing work and scurried away from the rest of the prisoners. Apparently they didn't realize that we were gone until they did a head count on the truck. They eventually found us and shot us both, killing my friend.

In hindsight, it was a silly decision. Of the five thousand prisoners of that camp, only twenty-nine actually ended up escaping throughout the war. Those people had connections, and, being in a strange land, we had none.

Our time at the farm ended when the Germans suddenly decided to leave. I later realized the United States and Russia had invaded Poland; the Germans must have realized they would soon be ambushed.

It was an arduous journey through a Polish winter. There were twelve thousand of us prisoners marching along, locked in threes. We would walk twenty-five to thirty kilometers a day. Sometimes a prisoner would get too tired to march and fall by the wayside. We would pick them up and keep going. Eventually, the Germans just shot whoever fell by the wayside. They would beat and assault us at will. Four months later, we got to Dresden. There were only six thousand of us left.

While we were in Dresden, Allied forces bombed the city. The Germans fled and left us behind. The Yanks found us and wanted to send us straight home, but were too busy with combat. They first took us to Leipzig, then flew us to Brussels. Day by day, the forces would come in with Lancaster bombers and fly us home to Dunsfold. In Dunsfold, we were fed and given new uniforms.

We were then put on trains to Birmingham. I got to Birmingham at 1:00 a.m. My family was so excited to see me. It had been six months since we had last had any contact! My dad told me he was trying hard to get information on me but couldn't find anything.

After a short while, I went back into the army. I was sent to a civil settlement union. They wanted me to become reacclimated to society. After that, I was officially demobilized.

I didn't do anything for my first three years, but soon after, I took a job as a driver. I retired in 1965. I'm now active in my community and talk to the local regiment. I live on my own; sometimes my daughter visits. Considering my experience, I'm doing quite all right.

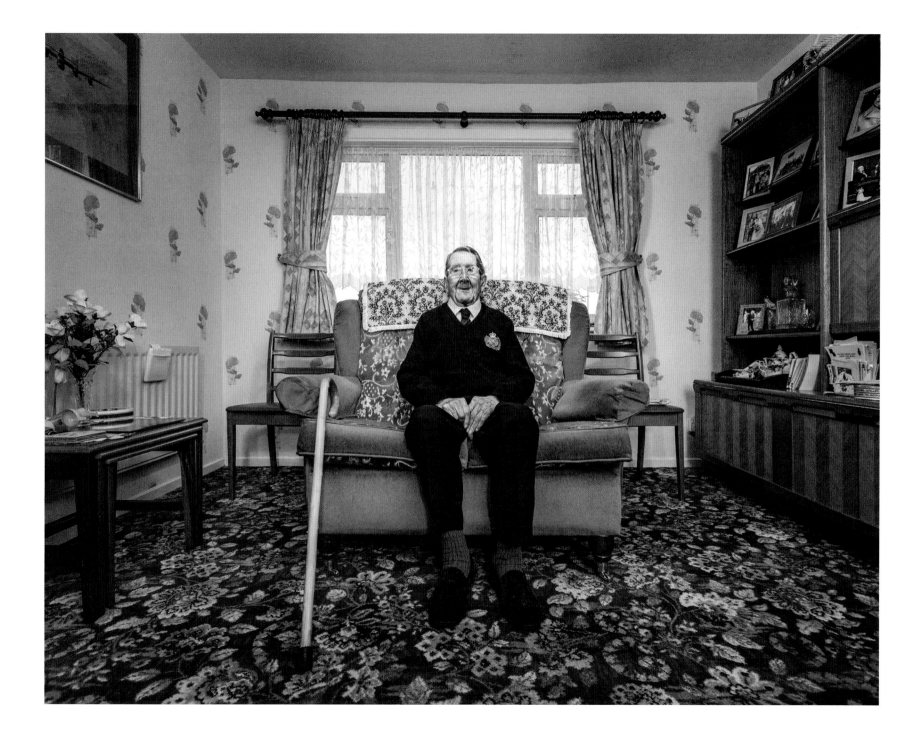

Jack J. Diamond

MIAMI, FLORIDA, UNITED STATES

My name is Jack Jerry Diamond, which is not my birth name. My birth name was Udell Moishe Diamond. I was born in Brooklyn, New York, on June 23, 1925. I grew up as a kid in Brooklyn, and then my dad bought a property on Long Island. He was building us a home outside of Huntington. My dad learned about the automobile business during World War I, when he was in the army. However, my father was told to enter the gasoline business, and he listened to this advice. He bought another property in Brooklyn at the entrance of the Brooklyn Bridge. He built a gas station on that property. Unfortunately, my father got killed by a drunk driver when I was only eight years old, on February 1, 1934. At that time, we were in Huntington. After his death, we moved back to our grandparents' home in Brooklyn. We also had family in Miami, Florida. I had an uncle in Miami, and he got us moved into his partner's apartment building on South Beach.

World War II started when I graduated from Miami Beach Senior High School. My uncle sent me to join the Riverside Military Academy in my senior year. I enlisted in the army before I turned eighteen. I ended up in the 106th Division, and we were stationed at Camp Atterbury, Indiana. We provided close support to the infantry. Our field position was on the front line. I spent a short time in a military school in Indiana, ranked as an army private. We left from New York on a ship known as *Aquitania* and landed in Scotland. We were stationed for some time in a small town outside England. Our division crossed the English Channel and landed in France, where we went to our first combat position in Belgium. And

BOOM! It was the time after D-Day, and there were not many Germans left in France, because the battle had moved to Germany.

The Battle of the Bulge was our first point of combat. That was happening in a small town called St. Vith in Belgium. Our division got wiped out by the Germans, practically all, and I became a German prisoner of war. We spent approximately nineteen days in combat, and the Battle of the Bulge was completely unexpected. Our division had no prior experience of any real combat. However, we destroyed all the evidence that the Germans could use against us before we got captured by them. I was a Jew, so I told them that I was a Jew and an American, so take me as I am. A person is a person, no matter what kind! There were two German armies: the Wehrmacht, who were trying to wipe out Jews, and then there was the SS, who operated under Adolf Hitler and the Nazi Party.

I was captured as a private first class, and it was during the coldest winter in Europe. I was wearing my galoshes, but my feet already got frozen, and it sucked! The Germans knew about my feet, and two of them took me to the hospital. But there was nothing the doctor could do, as I had no boots. However, there was a German officer who made sure that I didn't have to walk in the woods with other prisoners without putting on my galoshes. There was not enough food for the Germans themselves, so they gave us next to nothing to eat. All Americans were treated this way, not only the Jews. There were all types of prisoners there, but they segregated us. For instance, the Americans were in one part of the prison and the Canadians in another. I was never segregated on the basis of being a Jew, but a dogface will be a dogface, no matter what army he's in!

The US Army also sent a telegram to my home, stating that I went missing in action in Germany. The

telegram was received by my sister, who was thirteen at that time. She didn't want to upset my mother, because she was a widow. So my sister never told my mother that I was missing in action, and she kept it to herself. My mother came to know, however, when the army sent another telegram stating that I became a prisoner of war. At least she knew that I was alive. Later, we got transferred from the St. Vith 2A camp to another camp in East Germany. I stayed there the whole time, until the Russians came along, and that was several months later. I was freed from the camp by the Russians in May 1945. The Russians came through East Germany.

Ah! It was like moving from a German prison into a first-class hotel in Paris. But the food didn't get any better with the Russians. We stayed there and helped the Russians. A few Americans came later in combat trucks and took us back to America through France. Luckily, we got shipped back from France directly to—guess where—Miami Beach! I was stationed at a hotel about three blocks from my mother's apartment. My mother did know that I was a prisoner of war, from the communication sent through the American Army. However, she didn't know that I was back in Miami. So I went to visit her, but she wasn't in the apartment. She was visiting our relatives in New York. Later, she came back from New York quickly when I notified her that I was back in Miami.

We were examined by doctors as soon as we landed in America to identify what shape we were in. I must say that nobody was in good shape. I was then sent to New York on a leave. I was in the army until we dropped the bomb on Hiroshima, and then the war was over. I was discharged from the US Army at the Miami station. I didn't want to go someplace cold to continue my education, because of the memory of my frozen feet in the war. So I thought of Southern

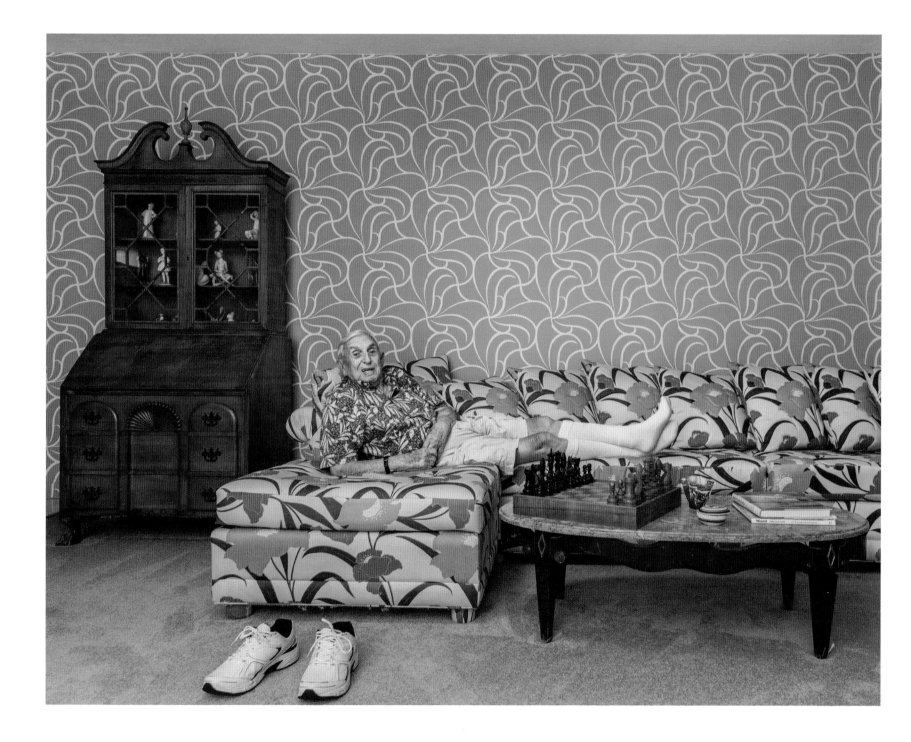

California, but that was about three thousand miles away from home. So I decided to earn a degree from the University of Miami in general education. After getting my degree, I knew that I wasn't going to move to the northern part of the United States. Therefore, I had to do something in Miami.

I loved the ocean, and there was a club, the Riviera Cabana Club, which had cabanas and a pool. I had a concession stand at the back of that club. I got into this beach stand business. I had another stand in a hotel in Miami Beach. At that time, my uncle was in the nightclub business, and he also had a liquor store. I ran his liquor store, and I learned that business as well. I also learned about the surfing business. I got my name registered in the local phone book as South Beach Surfers. I used to rent surfboards to the surfers at the beach. Apart from working in the food and entertainment business, I was also working at the dog track at night. I also used to give the beach weather report over the phone to people calling my surfing business. This was because sometimes it might be sunny in the town, while at the same time cloudy at the beach. I gave the best weather and surfing reports. No BS!

I got married to Julie on March 1, 1978. Julie is the love of my life, though she isn't my first wife. We didn't have any children together. But I had two children with my first wife, a boy and a girl. Julie has two kids too, and she had them from her own first marriage. I'm very involved in the American Ex-Prisoners of War organization. When I stopped working, I started volunteering at the age of sixty-two at the Miami VA hospital as a service officer. I helped people get compensation from being prisoners of war and for injuries they had during the war. In 2014, I had twenty-four thousand hours drawn for charity, and I was the volunteer of the year at the VA hospital.

Themistoklis Marinos

ATHENS, GREECE

My name is Themistoklis Marinos; my friends call me Themi. I was born in Zakynthos on February 8, 1917. My father was working for the cable and wireless company in Zakynthos, and we had a big family: four brothers and one sister. I finished my school in Zakynthos and then moved to Athens to study economics. To finance my studies, I was also working odd jobs. When the Italians attacked Greece, I was called to arms, and I stopped studying.

When the war was declared, we were very enthusiastic, and we were looking forward to fighting against the invaders. The Germans and Italians took over Greece, and I left for Crete, which was still free.

With no practical experience in the military, I took part in the Battle of Crete. The Germans attacked from the air on May 20, 1941. We fought alongside the British soldiers, and for a while, we thought that we weren't going to let Germans take over the island. But after ten days and a lot of casualties on both sides, Crete was surrendered.

I had to flee to Cairo, where I joined the Greek Army again. I was an officer in the department that was the official link between the Greek and the British Armies. When the British Army created the Office of Special Services in Palestine, I was transferred there. Thus, I became a member of the Special Operations executives, the department responsible for the creation of the Sacred Band: a new special forces regiment, which was entirely Greek.

During September 1942, before the Battle of El Alamein, the General Office formed a group of soldiers to sabotage the bridge of Gorgopotamos because the Germans were using it to supply weapons and provisions for the occupying troops. The group consisted entirely of British personnel and myself. I was the only Greek. It was one of the most important operations of the war for us because it managed to give hope to the Greek resistance.

And what an operation it was! Like I said, all the command was British, and I was the only Greek who took part in arranging and organizing the sabotage. We were parachuted into central Greece —around the Gorgopotamos River—in three groups and established connection with the local resistance and guerrillas. The viaduct itself was heavily guarded, and we couldn't just go there, put the explosives under the bridge, and walk away. It needed to be meticulously planned and perfectly executed.

Our operation began on the night of November 25, 1942. One of our groups cut the telephone lines, and almost at the same time, about one hundred people from the Greek resistance launched an attack on the garrison set up to guard the bridge. We were waiting for the signal to set the explosives under the base of the viaduct, but it wasn't coming. The attack on the fortresses was delayed and taking longer than we planned. Eventually, our command sent us anyway. There was a fear that Italians guarding the bridge would somehow call for reinforcements, and we wouldn't be able to complete the mission. There were a few explosions, and the mission was a success. All the people who took part in the operation survived—I think we had only a few wounded. Later, I found out that the reinforcement was on its way, and if we hadn't laid the charges in a timely manner, the mission would have failed.

I also have to note that this was the only battle where the Communist Greek resistance group ELAS would fight alongside the EDES, the National Republican Greek League. Later, these groups became enemies and clashed in the civil war.

After this incredible mission, our group stayed in the area to support and train various guerrilla groups. In July 1943, when the Allied invasion of Sicily was about to take place, we were organizing some operations to trick the Germans into believing that the landings were going to take place here in Greece. Great battles took place in the western part of Greece, and Germans were sending additional troops to strengthen their defenses there instead of sending them to Italy.

One of the most memorable fights was the one that took place in the mountains of Makrynoros. Our group stopped a whole armored division that was heading to Sicily to support the Italian army during the invasion and delayed them until it was too late. During the battle, I was calm and serene. In these cases, you don't feel or think about anything else other than how to succeed.

Already at that time, we were in confrontation with the Greek leftist resistance movements. They thought that we were working for the Germans, but we knew that they were getting help from the Soviet Union and wanted to establish a Communist regime in Greece. One time, I got caught by some partisans from the Greek People's Liberation Army. Aris Velouchiotis, the leader of ELAS, interrogated and tortured me himself for a whole night to make me claim that Fotios Zambaras, the leader of the opposite group, EDES, was cooperating with the Germans. He wanted me to say that so he could spread this false information. But I managed to escape. The moment I broke free was one of the happiest moments of my life.

At the end of 1943, I got back to Cairo. I was the instructor at the secret services department. We were training Greek soldiers undercover without informing the related official department. As a result, one day

our British superiors arrested us, and I had to prove to them that I was training Greeks to fight on the side of the Allied Forces. It got me into some trouble. Everyone was suspicious of everyone back then, and for good reason.

In April 1944, I was transferred to the general headquarters, located at Argostoli in Kefalonia. Through the Ionian Islands, the Germans were controlling one of the main entrances to the Peloponnesos and the Greek mainland, and our main goal was to kick them out of there.

In September 1944, we tried meeting the Germans for peace negotiations. The only condition was that we wouldn't attack each other during the day of the meeting. We agreed on the time and place, and when we met, we offered them to surrender unconditionally, and in exchange we would guarantee them a safe passage while they were vacating Greece. They refused and also said that once they concluded these talks, they would attack us immediately. They were upset that the British RAF bombed them the night before, even though we had agreed for a cease-fire on that night. Thankfully, nothing like that happened, and we went our separate ways.

But soon after that meeting, the Germans started retreating anyway. Not without a fight, but still… The Soviet Union was making a strong advance from the east, and the Italians by that time had become the enemies of the Germans. And the Bulgarians didn't have any power at all. On October 14, the British and Greek Armies liberated Athens. Greece was free at last!

I stayed on the island for two more months after the Germans left. We were there to take care of the civilians with the help of the Red Cross. Then we returned to Egypt in December 1944.

I came back to mainland Greece in the beginning of 1945. Greece was liberated from Germany, but the civil unrest was starting to boil over. The Communists wanted to take over. And soon, with the help of the newly created Communist governments in Bulgaria and Yugoslavia, the Greek Communists started a civil war. But that's a different story.

After the Greek civil war, I tried to work various jobs but then decided to finish my studies that had been interrupted by the war. So I enrolled at the London School of Economics for a master's degree. When I finished my postgraduate studies, I worked both in Greece and abroad for the World Bank, the United Nations, and for other organizations. I also got married to my wife, whom I met in Bulgaria, where she was a cipher officer. We have been married for thirty-six years now. I was using her services frequently, but it seems that I overused them! The most important thing that came out of this war was that I met my wife!

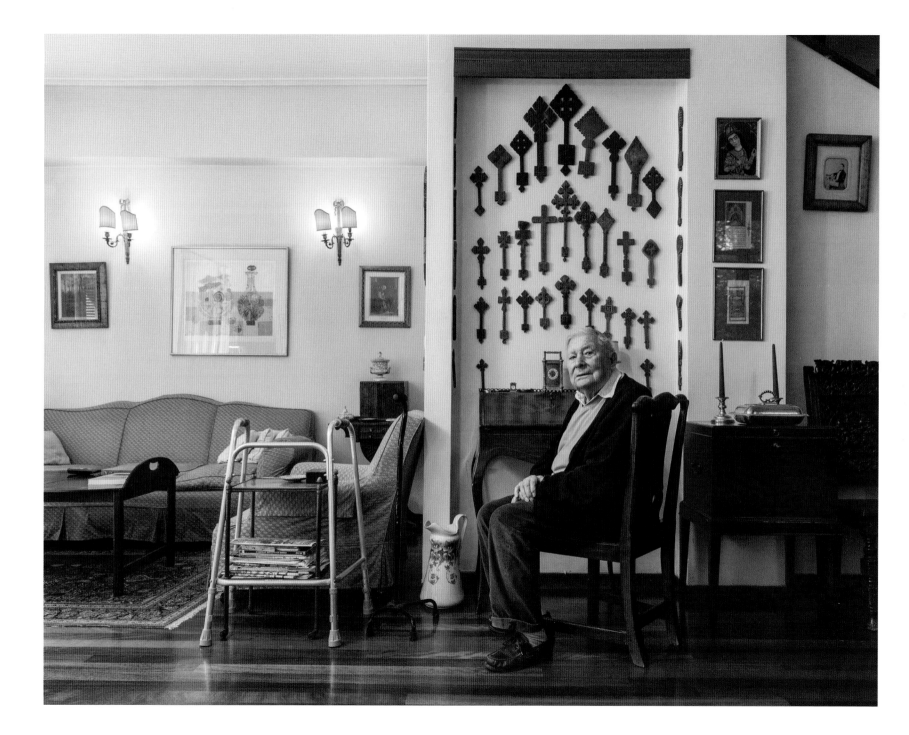

Robert Quint

PARIS, FRANCE

My name is Robert Quint. I was born in La Blanche on July 5, 1925.

I started school at four years old, in 1929, and I was there until 1936. After that, I worked for the government at SNCF* until 1942. After the Germans invaded, they soon were in the countryside. I didn't like seeing so many Germans everywhere. They were in the schools, in the shops, and in the houses. I saw Jewish people being sent away. I couldn't stand to see that, people herded like animals onto trains. It was a shock for me, so I decided to become part of the resistance.

It was forbidden to listen to the radio. There was a curfew, and everything was shut at night. They would publish photographs of those they had executed for the purpose of creating an atmosphere of terror. But I didn't care. I listened to the radio, to news from London and General de Gaulle. News from the resistance.

They gave us tickets for food rations, but sometimes they were fake tickets. People were starving. I wanted to fight against that. But we had to be careful because the French police didn't have any choice but to collaborate with the Germans. It was very dangerous for us.

The Germans would use the trains to send supplies. My purpose with the resistance movement was to work very slowly and to make mistakes. Sabotage. We had time cards for work, and I used to burn them. We counterfeited our own, so they would think we worked longer hours than we did. Once, we wanted to put the French flag on the roof of the central station. I was the skinniest boy on the whole crew. I went to the roof to do it, but they saw me, and we had to escape.

The president of the SNCF was killed by the Germans on March 13, 1942. This motivated some of the employees to join the resistance. Mostly, I sabotaged trains. I stole repair equipment. I did this alone. The resistance group was instrumental in making sure it went smoothly. But I want to say the truth here. For me, it was normal to do this. It wasn't to be heroic; it was a desire for a return to normality. There were little actions every day, little problems created on every train in Paris. For example, we put an old part on a train to stop it for a few weeks. Anything to slow the Germans down and to starve them of resources. Some of us had collections of train parts in our homes. I was very lucky to not get caught.

The station was the first place the Americans bombed to disable the transport lines in 1942. When the Germans withdrew in January 1945, SNCF fixed the rail systems within two weeks or so. This was to help the American, British, and French forces advance.

By May, the war was over. I tried to become a pilot for the army. It was my passion because of all the time I had spent watching planes. I was refused because I was too weak. I was too small, malnourished from the war. So I began my life. There was freedom. I went to the bars, I danced. I played football. It felt like a second birth when the Germans left France. I had a beautiful youth after. Later, I met my wonderful wife, and I made my life here, in La Blanche—now I'm happy. I've lived in this same house since 1931.

* The French national railway company

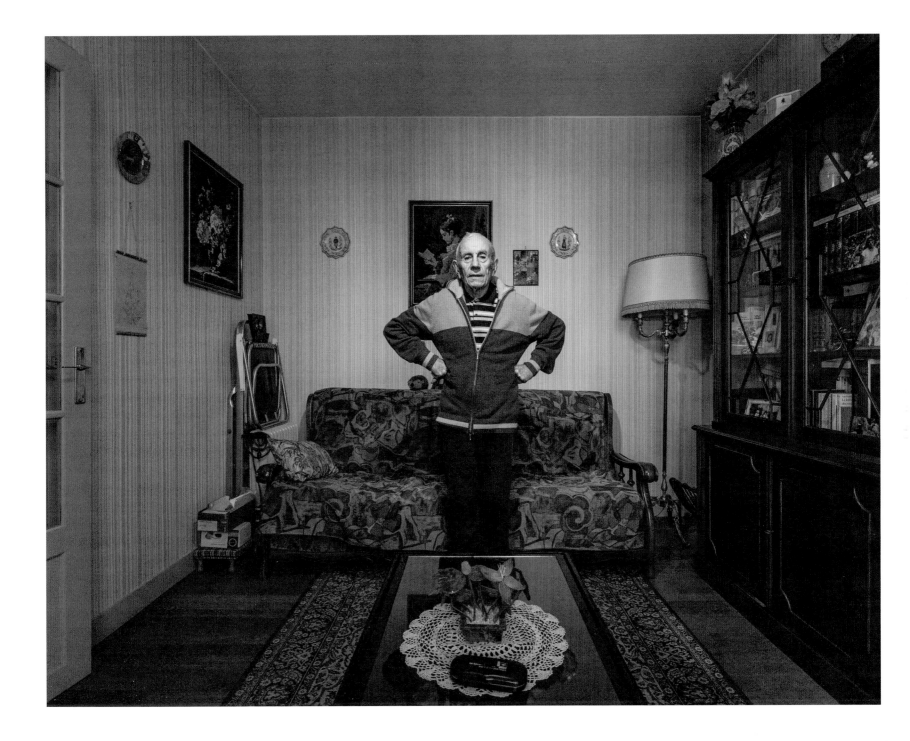

Thomas Blakey

NEW ORLEANS, LOUISIANA, UNITED STATES

My name is Thomas Blakey. I was born in Nacogdoches, Texas, on October 22, 1920. I was raised in Houston, Texas, and schooled there too. I went in the army early in 1942. I went from basic training in Mineral Wells, Texas, through jump school in Fort Bennett, Georgia, and went to England in the latter part of 1943. I joined the Eighty-Second Airborne Division in late 1943.

England was a fun place to be—we did a lot of training there. We did a number of practice jumps during training. We knew we were going to Europe someplace, sometime. The weather was lousy in 1943 and 1944; it was a bad winter, a lot of snow and quite cold, and that had some bad dealings with our training, but we made it work. Everybody was doing about the best they could, and it worked out well in the end. We were a very good outfit. We were sharp. Everybody wanted to make this jump into Europe.

There was only two ways home: a bad wound or a trip through France and Germany. Nobody wanted a bad wound, but everyone wanted the trip through France and Germany. We didn't know when it was gonna happen, but we figured it was gonna happen in spring of 1944 someplace, and it did.

We trained until D-Day came along. The original date for D-Day was June 5. We loaded planes on June 4. Some were in the air on the way to France when they were called back and put away for twenty-four hours.

Everyone went to the station, and it was a down feeling. Nobody felt good about it. Weather was bad. We didn't know how long it was gonna be bad. There we were sitting on the bus, waiting to go again.

It was very bad morale, but we made it through the night, made it through the next day, and that evening we got back in the planes and started off.

We didn't know if we were gonna make it or not because the weather was not that good again, but we made it all the way to France. At that point, the front had gone through the beaches, but it wasn't quite through where we were.

When we jumped, it was about 1:00 a.m. in the morning of June 6. It was raining. Everybody was cold and wet. I would guess the temperature was in the low fifties, midforties. But we made that work, too. We went to where we were supposed to be, which was ten miles from where we were dropped. Our mission was to secure this one bridge over the Merderet River. We got to the bridge early daylight, and it was full of Germans.

The thing that affected me the most was this little man, a German fellow I shot. I saw him standing from far away and aimed right at his chest. I couldn't see above his chest to his face, so I couldn't tell if he was a young man or an old man. But it didn't make any difference. The Germans moved closer, and I pulled the trigger. He leaned back, threw his hands in the air, and dropped his rifle. There I knew, I killed him.

In a couple of days, he showed up in my mind for a few seconds. I was afraid that some of my guys would think I was a coward. In fact, I couldn't find a reason to tell anyone about it. And I haven't, for years. The little man kept coming back and haunting me.

I was mad for no reason; I was critical of my family. I did things to them that I shouldn't have done. Because of that little man.

Anyway, we cleaned those Germans out and took this little bridge. And we held that bridge for four days. In that period, we had five hundred casualties. No MIA or POWs, only wounded or dead. But we kept that bridge, and therefore we kept the Germans from getting to the back of Utah Beach and the back of Omaha Beach with their tanks.

We went from there through little towns and secured the road going from Cherbourg to Paris. We cut that road to keep Cherbourg from being reinforced with new German troops. The Fourth Division was on the other side of the peninsula, going up to take Cherbourg, and we were there to make sure no German was leaving or coming.

In July, General Lewis H. Brereton took over the airborne troops in Europe. I was pulled out of the Eighty-Second and went to his staff, and I spent the rest of the war on General Brereton's staff. We followed the Eighty-Second and then the 101st a great deal.

One of the most shocking moments of that time was this prison camp we took over. It was a German prison camp called Wöbbelin. And there were a lot—a lot—of dead people stacked up like corn. The people who came out of those huts were just skeletons with skin hanging from them. At that moment I knew: This is why we're here. This why we need to end this war. But I was just shocked, couldn't say a word.

My mates did what they could for these poor people. Medics would take it over. The people needed to be medicated and had to have their strength built back up with food. But we had to move farther. We went on.

I had no sympathy for the German soldiers, even though we knew they were young like we were and were doing the same thing for their country, but that didn't make any difference. We had seen some massacres up to that time, and we had no problems killing Germans. After we saw Wöbbelin, we had even less problems with it. We took a lot of German forces. We didn't let them misbehave.

After we were in Normandy for thirty-some-odd days, we were sent back to England to get reequipped

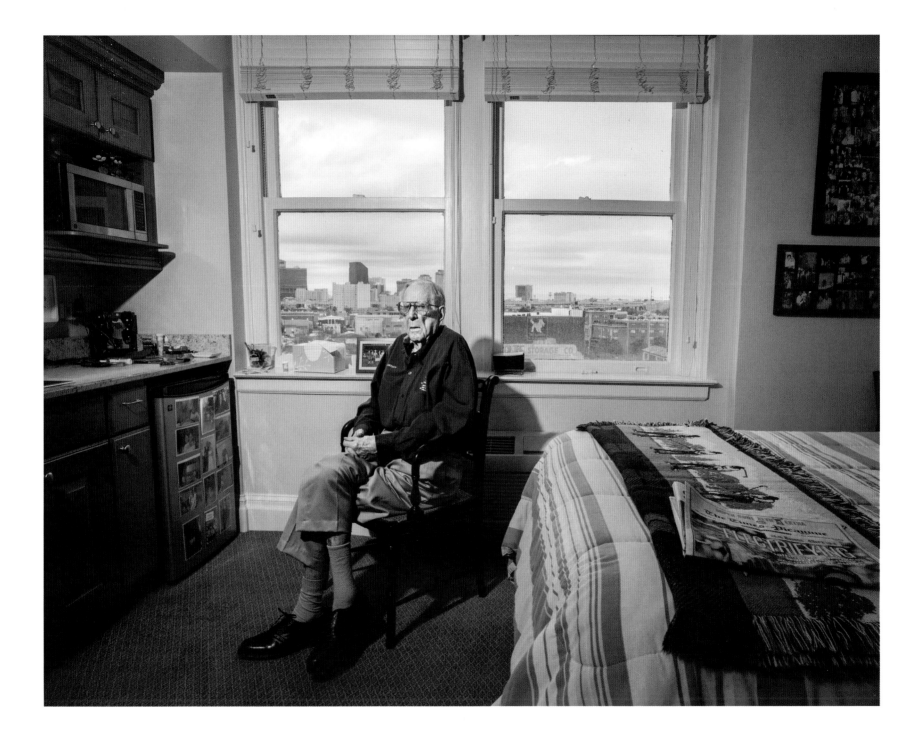

and refitted with men. Then we went to Holland on September 17, 1944. We were moving and shooting. I took part in Operation Market Garden, Battle of Ardennes,* and a bunch of small fights. It was cold, snow, ice, and death. During the Battle of the Bulge, I got called up to go to Paris with General Brereton and stayed there till the end of the war.

In the beginning of May 1945, General Brereton's aide Major Joe Givens called us on the phone and told us Germany had surrendered. Champagne flowed freely, everyone was celebrating. It was finally over.

I was aware of the fact that all of us might wind up going to Japan. Somebody had to go. There weren't enough over there to take it. With time, I got to know what their plans would have been if we did a land invasion. And it was supposed be a great occupation. They were going to use five airborne divisions to go in there.

And every Japanese person on the island would be an enemy. Six-year-old kids had a bamboo stick with a poisoned sharp point to stab in your leg. So that kid would be an enemy. I'm afraid if we'd had to take Japan, if they hadn't surrendered, we wouldn't have a living Japanese person on that island.

I was discharged in September 1945, and January 1946 I moved to New Orleans, Louisiana, to go into business for myself in oil. It was very successful. I did well, got married, had a house, and had children. Business was good. I moved to an office to Lafayette, Louisiana, and from there, I moved to an office in Houston, Texas, so I had three offices at one time.

I sold my business in 1975, so my wife and I traveled a lot, played a lot of golf, and spent time with our children. We went back to Europe several times. My wife had a stroke in 1988, and she passed away in 1994.

I went back to Normandy on June 6, 1994, for the fiftieth celebration of D-Day. I enjoyed that, came back, and ever since, I've been here in New Orleans. Ever since the D-Day Museum was opened on June 6, 2000, I've been a volunteer there. (Seven years later, several senators changed it from the D-Day Museum to the National WWII Museum.)

It has been astounding. We have a tremendous place now. We've expanded into a number of buildings, and we're still expanding. It's a wonderful place to be. I'm still working there. I've obtained close to thirteen thousand hours of volunteering, and I've enjoyed every day of it, and I'm still enjoying it. I'm doing what I can do—it's made my older life far more pleasant and fun.

But as long as I live, I wanna go to that bridge one more time, though I can't make any longtime arrangements anymore.

* The Battle of the Bulge

Shiro Arai

TOKYO, JAPAN

My name is Shiro Arai, and I was born on March 27, 1925. My hometown is Edosaki, which is in Inashiki District, Ibaraki Prefecture, Japan. I had a normal childhood, and I always used to get good scores at school.

We were five brothers and sisters, and my eldest brother had his own textile business. My brother's business was suffering from the export ban, so he had to give it up and become a policeman. I also moved to live with my brother and began studying in high school in Tokyo. At that time, the war was spreading around the globe rapidly. Therefore, the Japanese Army started accepting applications for the position of soldier from individuals eighteen years of age. The usual age for submitting an application for a soldier was twenty years. At that time, I was eighteen and a high school student, so I applied for the military academy. I passed my test and started my training as a soldier. At the military academy, I observed that not only me but also everyone else wanted to serve this country in World War II. We all worked really hard during the training period and wanted to join our fellow soldiers in the war zone as soon as possible. One day, we were all gathered at the academy, and our leader told us about the launch of a secret project by the emperor. I always wanted to be a pilot, so I thought that the secret project might include training for pilots. I decided to volunteer for this secret mission and got selected. About two hundred soldiers were chosen, and I was one of them. After our selection, we left the school, but we didn't know exactly where we were being taken or what this secret mission was about. I was really hoping that it would be related to flying. Soon, I realized that it wasn't. However, we left from the city called Tsuchiura, in Ibaraki Prefecture, and took a train to Yokosuka. After arriving in Yokosuka, we began naval training. The exercises and drills were quite simple and easier than the ones I had in the military academy. Then I finally found out that our secret mission was not all that I thought it was—I figured out it had something to do with motorboats. The boats we were practicing in were fairly small, and overall the operations seemed unambitious. However, the Japanese Army does not allow you to share your personal thoughts and opinions about any project or activity. Therefore, I kept my disappointment to myself.

Even though no one talked about it, Japan was losing the war. We were also not that mighty in industrial terms—we didn't even have enough power to build decent motors for those boats. They converted old truck engines to be used on these boats. The whole secret operation was that a boat was used to carry 250 kilograms of explosives, and we were supposed to sail it to the American ships and blow it up as close to the target as we possibly could.

Our training went on until November 1944. At our graduation, we were visited by a member of the emperor's family and one of the navy's top commanders. It was a memorable day for all of us. Each of us got honored by the emperor's relative and given a special sword engraved with the names of the navy's top officials. The hilt was also embossed with the sentence "Protect our country."

I was very happy to meet these people, and all my initial discontent disappeared. It felt that we served a purpose; we were about to embark on a mission blessed by the emperor himself. Everyone felt quite patriotic, and we honestly believed in our victory then.

After graduation, we were divided into four groups of fifty soldiers. The fifty members of my group were further divided into four subgroups, and each subgroup had its own leader. We were then sent to different locations in the boats with our leaders. At first, we didn't know where we were heading, but later we arrived in Sasebo, Nagasaki Prefecture. However, we were still in the deep sea at Sasebo when we started moving again along the coast of Korea and China. There were many American ships along the coast of China, and we didn't know where exactly we were headed, but we knew that it was north of Taiwan. We were moving a lot from one base to another and spent a few weeks at sea without any understanding of where we were going to end up and what our mission would be. Everything was under the seal of secrecy, which I understood. But I really wanted to be useful and finally see some action.

Eventually, we came to know that our destination was the city of Keelung. We all got off the boat and took a train toward the city to start building our base. The weather was good in Taiwan, and I was feeling content that finally I would be able to represent my country in an actual battle.

At first, I was mainly responsible for hiding the boats and building the base. It took us two months, from December 1944 to January 1945, to build the Japanese base in Taiwan. Every day, we used to perform rigorous exercises as part of our training. There were hot springs at a distance of six kilometers from the base, and we used to go there every weekend. Our boats were not yet deployed to the actual fight, so we were only practicing at the base.

At that time, the American soldiers were moving to the Philippines after destroying Okinawa. On their way back, they bombed our base and continued bombing for a few weeks. However, we didn't have

any casualties. One night, I was on a patrol duty on the beach, around our base, and an American plane flew by. Suddenly, the pilot started firing on the beach, and one bullet hit the sand two meters away from me. I ran away into the forest and was able to escape. However, I caught malaria later and suffered from it for the whole month. I was being treated at the army hospital in Taiwan.

Later, a leader of the Japanese Army from another city in Taiwan came to our base and announced the conclusion of World War II. As you know, Japan had to surrender. We all felt absolutely empty. We were ashamed to lose the war, and we were ashamed of the fact that we never took part in the missions we were trained for.

There were no boats to go back to Japan, so we stayed there until further notice. We started to grow vegetables, since we didn't know when we would be able to go back. We stayed there until December 1945. All of us were very disappointed, because we never thought that Japan would be defeated. At that time, our leaders also ordered us to throw our special swords in the sea so that the Chinese or American troops couldn't take them away from us. We had a fear of being captured by the Chinese or American troops. Thus, I believe that none of the two hundred soldiers were able to bring back their sword to Japan, and everybody threw theirs into the sea. Later, the Japanese Army gathered us all in the same place and boarded us on the American ship to go back to Japan. It took us only three days to reach Japan in the American ship. In contrast, it had taken us three weeks just to reach Taiwan in our boats from Japan.

The Americans took us to the port of Hiroshima, where I boarded the train back to my hometown. The Japanese Army provided us the transport fare and food. However, I got to know that my hometown was completely destroyed by the American bombing. Somehow, I also got to know that my family was in a safe place with my relatives in another city. On the other hand, my family knew that I had joined the secret mission of the army, and they thought that I was dead. Of course, they all were very happy to see me alive, since I was their only son who took part in the war. My elder brother was still working for the police, and my younger brother was a junior high school student. After coming back to my country, I graduated from the university in Japan and began working at a company in Ginza for three years. Later, I moved to the city of Fukuoka, where I stayed for three years and then moved to Osaka and stayed there for six years. Finally, I got back to Tokyo and stayed there until my retirement at sixty years of age.

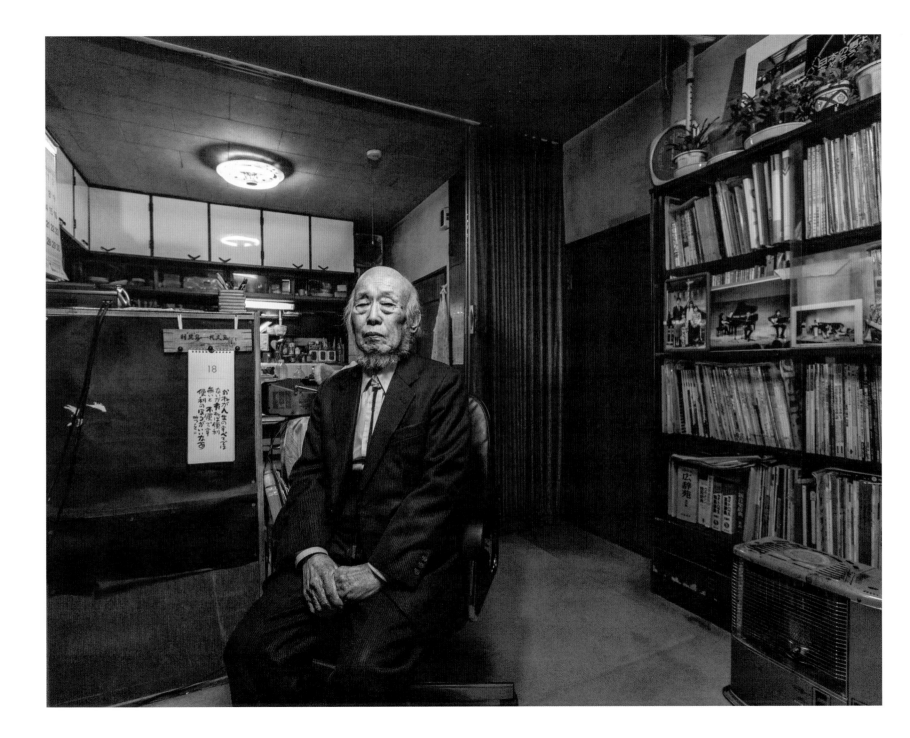

Alexey Svyatogorov

KHARKIV, UKRAINE

My name is Alexey Svyatogorov. I was born in 1925 in the Caucasus, as my father used to work there at that time. He was a civil engineer, and they would give him commissions in different parts of the country. So we traveled to Siberia, Ukraine, and many other places. I had two elder brothers—Anatoly, born in 1913, and Pyotr, born in 1917. We were in Luhansk in 1941 when the war broke out. My brothers were students at Dnipropetrovsk University of Civil Engineering then. As for me, I was at school.

Hardly had I finished ninth grade when our troops retreated and the Germans took Luhansk. It was in July 1942. The German vanguard detachments were the first to enter the city, followed by the Italians a couple of days later. So we had to discover what it was like to live under occupation. I remember that there was a girl, Lida Teppel, who was the secretary of the Komsomol unit in our school. At the beginning of the war, her father, who had a German background, was deported to Siberia, beyond the Ural Mountains. She must have held a grudge against the Soviet state because of that. In fact, when the Germans came, she immediately put on their uniform and an SS armband, a piece of red cloth with a swastika on it. Our family, together with other remaining citizens, was supposed to be evacuated, but my father had just undergone a serious surgery, and we had to stay put. He had cancer, and the doctors told us that he would die in about a month. And so it happened.

It was not long after my father's funeral that I got arrested. It was Lida who had betrayed us. They took us in November, and I was released only on February 14, 1943, when the Soviet troops finally took the city

back. When the Germans retreated, they blew up the prison, the former KGB building. The walls of the basement, where we were kept, were massive, so they made sure that the explosion was really strong, hoping that the prisoners, who were presumably working for the Soviet state, would die under the ruins. We were actually buried under the debris but, fortunately, rescued by our soldiers. When I finally got home that evening, my mother was so full of emotions that it took her some time to get the key into the keyhole. She had already lost all hope of ever seeing me alive.

My two brothers were at the front. They were supposed to be graduating from Dnipropetrovsk University, and they already had their diploma theses ready. Naturally, because of the war, everything was canceled, and they were drafted and deployed first to Kharkiv and from there to Moscow and from there to Nahabino, where there were camps organized by Kuybyshev Military Engineering Academy. There they studied for six or seven months to qualify as military engineers. After that, they both joined the troops that defended Moscow. As far as I remember, one of Anatoly's assignments was to blow up Krymsky Bridge in Moscow, and Pyotr had to blast some railroad bridge. Luckily, they both survived those assignments. Pyotr got into the Guards unit and was appointed deputy commander for military engineering, and Anatoly was a bridge builder in a different battalion. Pyotr was killed on March 23, 1942, near Moscow, and Anatoly survived. He marched all the way through to Germany until the Victory Day. Later, when the war with Japan began, he went there as well. Nothing ever happened to him, no wounds, no shell shock.

As for me, I was supposed to be drafted right after I was rescued from the ruins of the building, but I was too feeble and weak after the imprisonment. So they let me stay at home for some time and gain back

my strength. In March, however, I was already in the army, with the Fifth Motorized Infantry Brigade that came from Stalingrad and had a camp in Peredelsk, which is near Luhansk. I stayed with them during the whole summer training, and my mom came to see me sometimes. It was sheer luck that I and all the other young guys like me did have some training before we were sent to the front.

I was trained as a mortar gunner. My first battle was in Donbass, in a small town, Yama, which is now called Seversk. It was terrible but successful, and it certainly made a huge impression on us, especially on those of us who saw a dead soldier for the first time in their lives. That was a man called Okrainets, the commander of the battery. He would urge us to go faster, which wasn't an easy thing to do, since it was autumn already and it had started to rain. An eighty-two-millimeter mortar weighs around fifty-six kilos, and you and your partner have to drag it up the hill, and the wheels are all covered in mud! It happened so that Okrainets got killed. He was standing with his back turned to us when a stray bullet, a shell splinter, hit him in the chest and tore out his heart. It was extremely depressing for us. Nevertheless, we successfully marched through Slavyansk and took Kramatorsk. I think that it was September 5.

I took part in the liberation of Ukraine all the way from Luhansk to Izmayil. After Donbass, we headed for Nikopol and crossed the Dnieper there. The Nikopol beachhead was known as the cemetery of German tanks. There were as many as six rows of tanks stuck in the mud along eighty kilometers. We had to blow them up to get through. Then there were Ingulets and Belozerka, but it wasn't until late in the fall of 1943 that the infantry finally managed to clear the way for our motorized detachments and we could rush toward Zaporozhye. We had good German

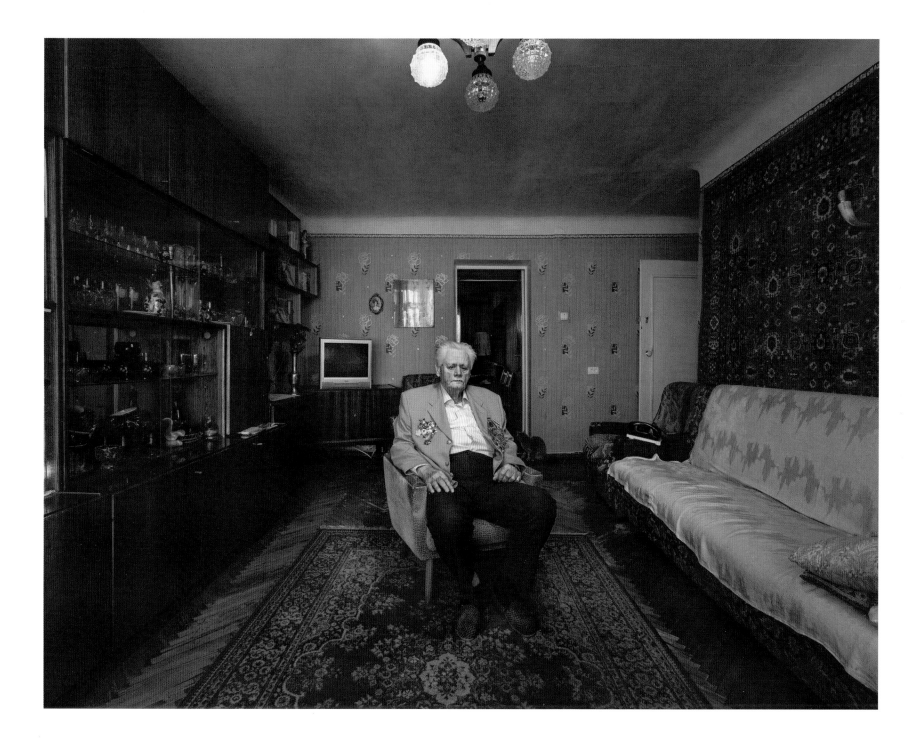

machines, brand-new two-axle Opel Blitzes, taken as trophies at Stalingrad. We drove those trucks across the whole of Europe.

In Izmayil, our Fifth Motorized Infantry Brigade, which had been an independent unit, had to join the Fifty-Seventh Army, with Nikolai Aleksandrovich Gagen as the commander in chief. Later, in Belgrade, we were renamed, and by the end of the war we were known as the Thirty-Second Guards mechanized brigade. There were as many as eight people in my brigade who were awarded the title of the Hero of the Soviet Union, the highest distinction in the country. As for me, I was also awarded the Order for Bravery, for liberating Kramatorsk, and many other medals as well.

Later, we were heading for Budapest when suddenly, 200–260 kilometers away from the city, we received the order to turn left. Who knows, maybe it was the thing that saved us, because all the major troops were directed to Budapest and the battles were quite severe there. We were sent to Pécs instead, moving in one big column. It was night, and I fell asleep. I had a dream that I was standing near the truck, disassembling my watch. Suddenly the mechanism fell out of my hands, but I managed to catch it just in time. I listened carefully and made sure that the watch was fine. I woke up and told the guys nearby that I was about to be either killed or wounded.

At that moment, the Germans decided to start a fight. By the time our trucks came closer, the battle was already in full swing. We stopped, and some of our guys jumped into a side ditch without waiting for the command to get to the ground and get the mortar ready for action. Not daring to jump after them, I was waiting, listening to the sound of bullets swishing over the truck. Suddenly I felt as if my head was torn away from my shoulders. I touched it,

making sure that it was fine, then turned around and felt an awful pain in my chest. I suddenly stopped being afraid of the bullets and jumped into the ditch. There the guys took off my shirt and saw that a shell splinter, the length of a finger, had gone through my clothes and got stuck in the chest, injuring the lung.

Funnily enough, it was the only shell that actually hit us. Besides me, its razor-sharp fragments also wounded Klushin, the commander of the battalion, and Suhachev. As for the latter, a tiny splinter, as small as a needle, got into the white of his eye. All they had to do was to take it out carefully, and that was it! Another man, Shcheposhkin, the platoon commander, wasn't wounded at all. A shell splinter got stuck in his pocket, which was luckily full of documents, money, and other stuff. So the guys in the medical unit brought me a mug of good Hungarian wine. When I drank it, I suddenly felt so light and easy! I even thought, "Why on earth should I go to some hospital?" After hospital, they could send you to any first unit, and I really hated the idea of having to join any detachment other than my own.

I was evacuated to a hospital in Timishoara. I had to wear a funny sort of a bra with a suction drain and a small jar. Since I didn't have to stay in bed all the time, I would put on my coat and my boots and sneak away to some restaurant, where I would place the jar directly on the table. However, I stayed in the hospital from November 1944 till March 1945, which gave me plenty of time to get to know all the ins and outs of its bureaucracy. So when I was about to be discharged, I asked the girl who was in charge of issuing references and sick leaves to give me a referral to my former unit. They gave me all the necessary papers, some money, clothes, and food supply, and I set off to catch my unit.

Our unit hardly ever failed a battle. Other troops would make a breakthrough for us, and our job was to use this opportunity and drive as fast as we could deep into the territory, trying to gain the rear of the enemy. We could cover several dozens, or even hundreds, of kilometers in one go, gaining lots of trophies, such as cars, trucks, and other equipment.

I remember how we entered Tatarbunary. It was a dark night, and our commander ordered us to switch on the headlights. Much to our surprise, the officers showed us the way through the whole town, taking us for the retreating German troops. That was unbelievable! The trucks were German, indeed, but our soldiers were sitting on them without even trying to conceal their identity!

Not long before the victory, we had a major breakthrough toward Graz. I remember that we were approaching the city when we saw the bright lights in the distance. We were sure that we were facing a head-on battle, the most dreadful thing that could happen to a motorized infantry unit. In this case, you're lucky if you manage to turn around and get everything ready for the fight. You can't imagine how surprised we were when we came closer and saw that those were not headlights but street lamps! We hadn't seen any since 1941!

One peculiar thing happened to us in a village near Graz. Our assignment was to take the city by storm, but we realized that there was nobody to fight with. Here and there, we met scattered German troops who told us that the war was *kaput*, meaning "over." They were completely dispirited and passive, sleeping in the streets, leaving their guns almost unattended. However, when one of our soldiers ran after some of them, trying to attack them, they turned around and shot him point-blank.

We were quartered at the outskirts of Graz. It was May 9, and we were planning to celebrate Kolya Astakhov's birthday. So we set the table, gathered some food and drinks. In fact, we had a lot of alcohol available then. Cognac, wine…There were two handicapped German soldiers staying in that house as well, and the Austrian woman, the landlady, took care of them. One of the Germans had been wounded near Odessa, and the other had lost one arm and one leg at Stalingrad. We switched on the radio and heard the Moscow news saying that the ninth of May was Victory Day. I can't describe to you the euphoria that overcame us. We were beside ourselves with joy, and we even invited those Germans to share our food and drinks, and memories about the war, of course. Several hours later, however, we had to move on, farther into the Alps, where some German units would not give up the fight. So we were in a war for another few days.

We stayed for some time in makeshift camps in the Austrian mountains, relaxing and enjoying the most beautiful landscapes I had ever seen.

After the war, I stayed in the army for another five years. It wasn't until 1948 that they could finally make a new draft. So we were sent to sergeants' school to receive additional training. There we spent two years and were finally promoted to the rank of sergeant. As a sergeant, I was in charge of a platoon, and I'm really proud of that.

In 1948, those guys who had been wounded at least once could finally leave the military service. If I had been wounded twice, I could have returned home as early as 1945. But I was hit only once, so I remained in the army. We were obliged to stay at the sergeants' school to train young soldiers who had been drafted after the war. It wasn't until two years later, in 1950, that we were finally discharged.

When I left the army, I went to live with my brother in Poltava. He was busy rebuilding airfields and roads destroyed during the war. In fact, Anatoly had been moving around the whole country, together with his family. He had built hundreds of airfields across the whole Soviet Union. Siberia, the Caucasus, Ukraine… you name it! Later he went on to build rocket launchers. Sometime in the sixties he came to Kharkiv, where he took part in the construction of the opera house. He died in 1999 here, in Kharkiv.

I followed my brother wherever he was commissioned. No sooner had I joined him in Poltava than they sent him to Novosibirsk. So I went there with him. There I finally finished my high school studies and received the certificate of secondary education. I entered Novosibirsk University of Civil Engineering, and I was finishing my first year of study when Anatoly was sent to Tbilisi, where he was to build another airfield. I followed him and got transferred to Tbilisi Polytechnic University, where I studied until 1953. It was the year that Stalin died, and I remember enormous crowds of people in the city commemorating the death of their compatriot. That was the time when I decided to move to Kharkiv and live there with my mother. We had some relatives here, my mother's sister, in fact. She had a big family, and my mother and I stayed at her place.

Since I hadn't yet obtained my university degree, I did a part-time evening course at Kharkiv University of Civil Engineering. After I finished my studies, I took various engineering positions there and was finally promoted to the head of the department that dealt with construction organization. Altogether I worked there for forty-one years and eventually retired in 1994. I still keep in touch with my coworkers. They do remember us veterans and help a lot indeed, even financially.

After the war, our lives became extremely busy, since a great many enterprises in Donbass had been destroyed during the war and had to be rebuilt. I was lucky to be at all the steel plants there, doing my bit to restore their industrial facilities and infrastructure. We did work hard at that time.

I got married and received an apartment. I had two children, a son and a daughter, but my daughter, Olga, died two years ago. Life does have its ups and downs.

Today many of my fellow soldiers are already either confined to their beds or can hardly move. Most of them have lost their eyesight. My eyesight is not great either. I can't read or write without a magnifying glass. I try to write by touch, but it's no good, as the lines keep getting on top of each other. This is how my wife, Valentina, and I live now, helping each other the best we can. We have a son, Mikhail, and a grandson, Misha. Misha works at the same factory where I worked. Recently his daughter, Dasha, my great-granddaughter, was born.

Pyotr Koshkin

ODINTSOVO, RUSSIA

My name is Pyotr Koshkin. I was born in Obolenki village, in the Mikhaylov district of the Ryazan region, on July 2, 1924. In 1939, my dad took the family to Likino, in the Moscow region. There, I went first to our local school and then to one in the neighboring village. However, in 1940, they introduced a tuition fee for high school. Our family had six kids, and we weren't rich, by any means. Dad used to work in a *kolkhoz*, which meant that we could hardly afford to pay for my education. So I had nothing to do but to enroll in a technical school. I received my cum laude degree in 1941 and started working at the aviation factory near the Aeroport subway station in Moscow.

One night, a policeman, accompanied by the officer and the head of the village council, came to our house and took me to the army. No questions asked, no military enlistment officers, no medical checkups, no documents—nothing! I wasn't the only guy captured this way. There were many of us around the same age. It was a real manhunt, rather than a normal draft.

First, we came to the Ershovo, Zvenigorod district, Moscow region, where we were busy building fortifications. Then, they gave us the uniform of the 44th Infantry Division, where I remained until November 28, 1942, training as a mine picker and placing land mines. On November 28, there was a massive air raid, and during a moment of silence between the bombings, our platoon commander sent me out to place some land mines. It was just at that moment that a new air raid began, and I was wounded in my left arm. They stitched and dressed the wound, and the next day I was summoned to the officers' dugout. They told me that according to the new decree of the National Defense Committee, I, together with fourteen other soldiers, would be released from military service, and we were to work at some plant in Moscow. I asked them to commission me back to the factory where I used to work, and so they did.

I showed up on December 1 and was immediately put to work. I was technically inclined and already had some experience, so I quickly gained the trust of my new supervisor. I used to train young workers and made samples of the manufactured parts. It was all young kids, fourteen or fifteen years of age. Many workers were evacuated to the east of the country, and a lot of people were sent to the front, so we had to train brand-new personnel. Most of the time, we were patching up Sturmovik IL-2, which was the battleplane most commonly used by our air force.

Sometime in late February or early March of 1942, we had a crash landing on our strip. The plane was pretty beat up; we could see trails of bullet holes in the fuselage. The pilot was in bad shape himself. His face and his hands were all badly damaged, and there was blood all over his uniform. But he jumped out of the cabin like nothing happened. He said that he wanted to talk to the main specialist, and all the guys pointed at me. The pilot didn't believe them at first, as I was a seventeen-year-old kid, quite short and skinny. So he found our senior foreman, and the latter pointed at me too, saying that there was nothing I couldn't do. So the pilot told me about his IL-2, which was the best of its kind, with bulletproof armor and four missiles. It could melt down a tank with only one strike. Besides, it had two bombs, 250 kilos each, and a large-caliber machine gun in the front part. However, it had no protection whatsoever in the rear, which meant that the German fighters could fly up close and destroy both the plane and the pilot. His regiment had lost sixty planes in a single battle near Moscow a few days before.

So the task was to make another cabin for a co-pilot and gunner. Two months later, the new modified plane was ready. In its very first battle, on May 1, it shot down two German fighters. From then on, our planes could not be brought down as easily. This helped boost the morale of our soldiers significantly.

I was awarded a medal for special merit. Later, we had a visit from Ministry of Defense specialists, and not long after that, they began mass-producing IL-2 planes with the second cabin, just like the one I designed.

After the war, I decided to stay in the military. I continued my study at the Murmansk Academy of Communications, specializing in wireless and radio. I stayed in the military for twenty-seven years, working on improving communication methods in the army.

In 1950, I got married to this great woman who's sitting here with me. Please meet my wife, Lydia. We had a baby boy in 1951 and named him Victor.

Now, we live in Odintsovo, near Moscow. I am really into gardening these days. I love to spend all my time in the backyard. I always remained devoted to the ideas of Lenin, Stalin, and Marx, and I'm still active in trying to spread the word of socialism. I give out leaflets and write for a local Communist paper.

I'm also active in veterans' affairs. I often meet with youngsters and tell them about the war. I also meet with veterans and reminisce about those days.

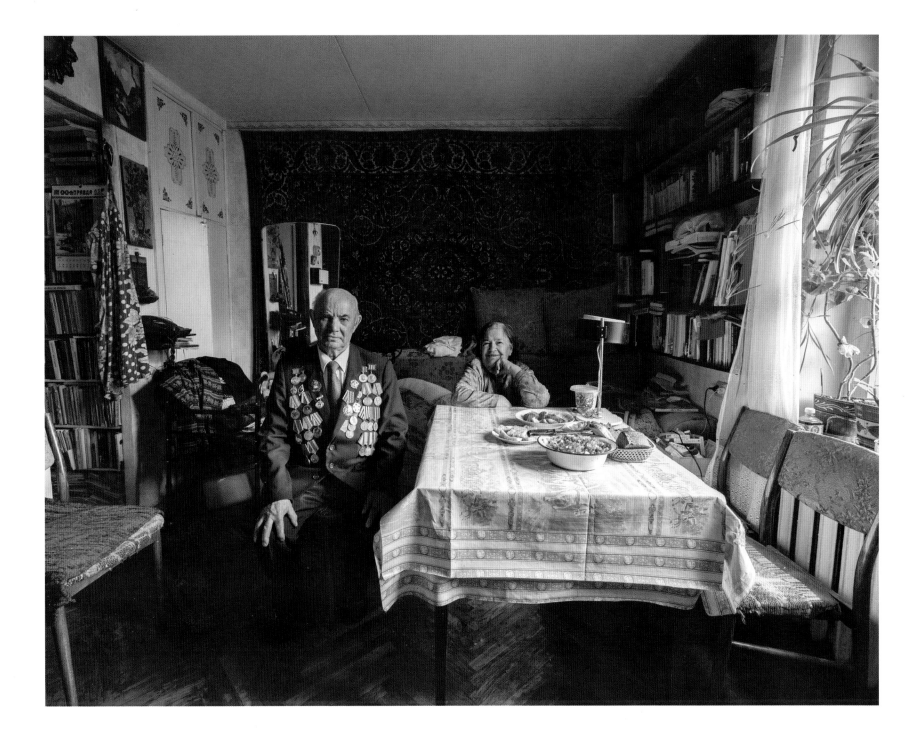

Luigi Bertolini

UDINE, ITALY

I was born on March 28, 1927, a few months after Charles Lindbergh flew across the Atlantic Ocean. I spent most of my childhood in northeastern Italy, in a small village just twenty kilometers from Udine. My parents worked on a farm. I attended a school where all the farm children went. It was never interesting to me. From an early age, my interest was in engineering.

I must say, I didn't care for the war. I didn't support either side, despite being Italian. I was interested in aviation. I was fascinated by how precise everything had to be to operate a machine as complex as an airplane.

There were a lot of air battles around Udine between Americans and Germans, Italians and Americans, between factions of the Italian Army. After September 8, 1943, Udine went under German administration, and we were bombed a lot, mainly by the Americans. I always got excited when a plane was shot down, so I could go explore it. I would rush over to the site of the crash and try to recover whatever parts I could. I would take them home, where I had a small workshop, where I dismantled and reassembled all the parts I found.

Italian partisans carried out some attacks in my village in 1944. They came to our house one night. I was frightened. They were suspicious of the German presence in the village. But the Germans stationed there were mostly engineering and construction staff, and worked on building runways in the surrounding areas. You see, this location is a convenient distance from Munich, Slovenia, and Monaco. They wanted to search the house. My father got into an argument with them because he didn't want guns in the house. They searched and didn't find much. My father once had a rifle—he was a hunter—but it had been confiscated by the Germans.

I found work as a mechanic in a nearby village. Two Germans ran the shop. One specialized in engines, and the other was a general smith. Three others worked for them. They were very kind to me and very keen to teach me. I helped German soldiers repair their trucks and tanks. I also worked on the airfield. I'm still thankful to them for setting the foundation for my future career. I was interested in the work, not the politics. The Germans were here, and we had to live with it. Many people understood that fighting them wasn't worth it. But, of course, many people also resisted. My brother worked with partisans, and I was unaware. He had a radio transmitter in the attic of our home, and no one knew.

In the spring of 1944, Todt, a German organization, began working on a project nearby. This organization basically existed to coordinate large engineering projects around Europe at that time. Of course, that late in the war, most of the projects were now dedicated to defending Germany. There were plenty of trucks and tanks, but there weren't enough people to work on them. So they asked the locals. People came from all around; there were so many, they had to build barracks. Even my brother worked for the Germans for four or five months. I remember some locals were displeased because their horses and cars were confiscated for transporting dirt and cement to build runways.

Some runways were already functioning in full, in Gemona and Risano, some other villages around Udine. Usually German planes took off in the evening to bomb around Bologna, in central Italy. They would return, having to land at night or early in the morning, when it was extremely difficult to see the runway. There were many incidents when bombers crashed after missing the runway. Lots of German pilots died that way.

By autumn of 1944, the Americans attacked so often and intensely that German troops began to withdraw. Construction stopped. They just left everything behind—empty runways, abandoned mines, construction sites.

One night, American planes bombed our area. I stood on the roof to watch it. One of the trains on the railway exploded. I think it was carrying tanks or some sort of heavy machinery. This was fun for me, because of the explosion and the fireworks, the flare from the blast. That's what it was for me at the time, a kind of entertainment and excitement. I had no idea what war really was; I didn't understand the scale of what was happening. I never thought that the Wehrmacht occupying our village was a bad thing. I was always fascinated by their technology, and I didn't mind working with them for the sake of playing and studying these machines.

A year after the war ended, I joined the army and went into aviation mechanics. I passed the tests with flying colors. After that, I attended a mechanical design school. Times weren't easy for my father's farm. We needed machines to farm more efficiently. I wanted to learn how to design them.

I almost emigrated to the United States because I couldn't find work. There was a committee interviewing people who wanted to work in America. They asked me what my profession was. I told them I was a mechanic. I was asked to show them my hands. I hadn't worked for several weeks, and my hands were clean. They thought I was lying, and I didn't get to go.

I worked hard all my life on things I truly love. I am proud of my family, my faith—I'm a Catholic—and last but not least, I am proud of my craft.

Urszula Hoffmann

POZNAŃ, POLAND

My name is Urszula Hoffmann. I was born on June 15, 1922, in Poznań, Poland. When I was young, I was homeschooled. I really wanted to go to school, where there were other children, and eventually, my parents allowed me to attend one with my sister, Elizaveta. At the time, we all lived in a three-bedroom apartment on Wiankowa Street, in one of the houses the Germans had left behind after World War I. But my mother wanted to move to a bigger place, so we moved into a six-bedroom apartment on Ogrodowa, where I began middle school. The war started in my fourth year.

At the time, I was part of the Związek Harcerstwa Polskiego Polish scouts organization. We were mostly older kids, even some who finished school already and were attending university. One of them was Irena Petri—a girl who took the lead and helped organize the scouts. Once the war started, we decided to take boys into our circle. Then, some of our members brought their friends. It was important that we could trust everyone in attendance.

We were a group of thirty scouts. We called ourselves the Beavers, and we soon integrated into the Gray Ranks—the underground resistance. We had decided to name ourselves the Beavers because we gathered every week near the river, in a small town near Poznań called Luboń. We would build a small camp near the river each week, and when we returned it would be destroyed. We couldn't figure out who was doing this—it was such a desolate place—but we soon realized it was the beavers. So we took the name.

The functions of our organization were broad. During the occupation, children weren't able to have a basic Polish education, so we would go to houses and teach the school program. And we tutored one another as well—geography, history, writing, literature. No one wanted to learn mathematics, because it was just such an awful subject. We were hoping that the war would end soon, and we could go on with our normal studies. We also taught some foreign languages, including Russian, because many of us understood that sooner or later the Russians would come. We organized small celebrations of Polish holidays as well; all of these were banned.

The funny thing is that we moved our headquarters across the street from the Imperial Castle in Poznań; in the same building was the office of the Poznań Gauleiter, Arthur Karl Greiser, who was responsible for overseeing the German occupation of Poland. His office was on the second floor, and we were on the first floor. We were very brave back then.

Before the war, my father worked in a company that sold coal. During the occupation, the Germans took control of the company, and a man named Erich Steffen was appointed director. He left my father employed there, but soon they began to send Polish men to labor camps in Germany. My father managed to escape this fate by agreeing to become house help for the new director.

In 1940, the Polish resistance was becoming more organized. Our group, which was already part of the Gray Ranks, began reporting to Armia Krajowa, which was the primary resistance force at the time. Our functions soon varied from underground parcel and mail delivery to sabotage. We were young and very reckless, and some of us were caught and killed. The Germans didn't tolerate or spare anyone they suspected of taking part in any resistance. Some, like myself, were lucky to survive. We had a simple phrase in the Gray Ranks: "Today, Tomorrow, and the Day After." Today meant the fight for Poland's independence. Tomorrow meant the liberation of Poland from any occupants. The Day After stood for rebuilding the country to its former glory.

At the end of the war, we moved to the basement of a house in one of the Poznań neighborhoods, called Górczyn. The Russians were coming through Poland at the time. I remember them knocking at our door and very uncomfortably asking for some coffee.

In January 1945, I returned to my house here. The condition of the place we were staying in had become intolerable. My house had also been destroyed and was without heat and water, but my father used his connections to bring in a firm to help us restore some parts to the house to make it livable again.

I started work at a print company—one of the few around here with a printing press. I wanted to continue my education, but most of the schools had been destroyed. I occupied myself with work. The following summer, I intended to study French philology. But sometimes things don't turn out the way you plan. I had gone on vacation with some friends, where I met a professor of the Merchant Academy. He persuaded me to switch my interest to the academy he taught at, so I did. In February 1946, I continued my studies there. In 1948, I finished my education, something I had been dreaming of for so long. I started to work and teach at the University of Economics in Poznań.

Later, I became the secretary of the world organization of Armia Krajowa and kept in touch with many of the people I knew through the war. In fact, I saw some of them at my ninetieth birthday. With some people, you share something so precious that you want them to stay in your life forever, cherishing it.

Shiv Dagar

NEW DELHI, INDIA

My name is Shiv Dagar, and I was born in Samaspur, Khalsa, Delhi, in 1923. As a child, my parents wanted me to go to school, but I wasn't interested in wasting my time with our poor education system. I spent most of my youth living a relatively normal, fun life.

When I was eighteen, I traveled to Nagpur, India, to visit my older brother Hathi Singh, who was in the Jat regiment. He strongly encouraged me to join the army, so I enlisted and began basic training in Nagpur.

The British conditioned us. We learned how to use pistols, steam guns, and various artillery. They fed us well, but it was not a pleasant experience. I felt that for all the hard work we did, the Britishers underpaid us, and my current pension from the Indian government pretty much confirms that.

The British officers would beat us for every little mistake and never grant us a leave. Some soldiers would be in camp for a year before they were allowed to go home. The treatment was awful, but it was to be expected of people in power. The British controlled us.

I graduated from training in two years. Right before we were to be deployed, our senior command gave us alcohol and fired us up about killing all our enemies. The British also told us if we were successful, they would leave our country and grant us our independence. That evening, we were all very motivated for combat, but once we started traveling, the nerves set in. With every mile closer to our destination, the possibility of being killed seeped into our minds.

We traveled from Nagpur to Lahore via train and then proceeded in vehicles toward the Afghani border. Throughout Afghanistan we had to travel on foot and were attacked multiple times by local tribesmen.

Afghanistan was not taking part in the war, since it pronounced neutrality after the blitzkrieg, but it had economic and political ties with Germany. And neither the British nor the Soviets trusted the Afghani government, so we had a small military presence there. But the local tribes didn't want us on their land, so locals would constantly attack us. Not only did we spend our waking hours battling them, they would invade our confines during the night and gut us or drop hand grenades in our camp as we slept. I wanted badly to go back home.

We were mainly stationed around the Indian-Afghani border. It was hard for us to find water to even bathe or stay hydrated. Our camp was in the mountains, about seven miles from civilization. The terrain of the mountain made using vehicles impossible, so we had to walk everywhere. We would ride donkeys into town to get water or food, but sometimes the Pathan soldiers would kill the donkeys, leaving us without nourishment. Our camp would go two or three days without even eating.

The Pathan insurgents hid behind stones in the sandy mountains, firing at us from a distance. We couldn't always see them, but they could surely see us. They would even cut our telephone lines so we couldn't communicate. They would kill us, then steal our ammunition. I can remember entire twenty-five- or thirty-man platoons being murdered by the Pathan, who would steal all their weapons and artillery.

Once, I was in a group of five soldiers patrolling the area. It was dark, but we still saw the Pathan coming to attack us. We shot at them, and they scurried away. They must have only had knives, because they didn't shoot back.

Also, they would kidnap our platoon members. I remember once, we received a message that a local tribe wanted ammunition, and if we didn't give it to them, the tribe would kill our comrade. We negotiated for two months before they finally released him. Upon his return, he told us about his terrible ordeal. He said that he was barely fed and often beaten.

The British would only send us Sikhs and Hindus out on the dangerous missions. I felt that they were scared of the tribesmen. They would escort us occasionally, but if the terrain was too risky, we were sent out alone. When we were transferring to other areas in the mountains, we would never know exactly where we were going. The British would tell the senior command, and we would simply follow them through the mountains. When they stopped, we realized that we were at our new destination.

After three long years, we returned to Bareilly in 1947. Over half of our platoon was dead at the hands of the Pathan soldiers. Fourteen other people from my home village enlisted with me, and I was the only one who survived. The commanding officers told us we could continue on in the army or be discharged and go home. I immediately decided to retire.

After a couple more months, we were finally free from the British rule. I started a farming business with my three brothers. We evenly split our 150 hectares of land and ran our own businesses.

I was married in 1951. I had two sons, and now, I have three grandsons. When I left for the army, our family was in dire shape. Because of the efforts of my brothers and me, our family is now quite prosperous. We made a nice living, and now, my oldest son takes care of me. The war was a frightening experience. I can remember so many moments of hoping to be home, and luckily I got that wish and have lived a full life.

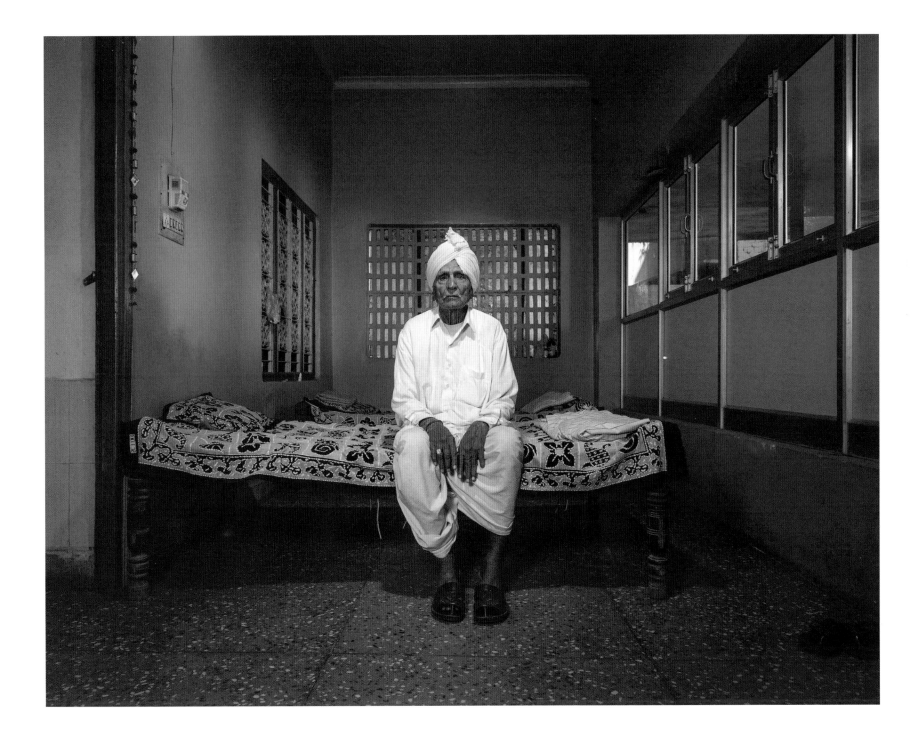

Agostino Floretti

UDINE, ITALY

My name is Agostino Floretti. I was born on August 21, 1920. I joined the army on February 15, 1940. On February 25, I was sent to Albania, to Pukë, which is a small mountain village. We began weapons training and mountain training. On October 28, 1940, we went to war with Greece.

We arrested a Greek soldier at the border. I was charged with escorting the POW. Eight of us at his back with rifles. I got the feeling that he was trying to escape, so I threw a grenade at his shoulder. It still had the pin in it—I was trying to scare him—but the terrain was rocky, and the pin got knocked out and it went off. I don't want to tell everything, because it's quite harsh, an ugly image I still remember. We no longer had a prisoner.

A few days after that incident, it started snowing. When we reached the river, we had to build a bridge. Before that, there were some fights, but nothing substantial until we reached the mountains and the Greeks returned and encircled us. We had to withdraw. On the way back to Albania, we suffered. We were angry and thirsty, freezing. Fortunately, there were relatively few deaths. After we crossed back over the border, we received food and shelter, and our situation improved. We started to dig trenches, but the Greek counterattack was very strong, so we had to withdraw again and again. We quickly became dispirited. On January 8, 1941, I was wounded in the leg by a mortar shell. It went through my leg, just missing any bone or major blood vessels.

When I heard more shooting, I moved in the opposite direction. I found a hole with two soldiers who were relaying data to direct fire at the Greeks.

They told me the route to reach a Red Cross truck nearby. I was lucky when I reached the road because a truck was passing right at that moment, and I was picked up. But just before we reached the field hospital, two English planes bombed the area and shot at the tent. Two Italian doctors died, as well as four people in the tent. We left immediately and drove two more hours to a bigger hospital. After fourteen days, a German transport plane flew us back to Italy. I was put up in another hospital, and it was nice to sleep in a real bed with sheets. And food—they gave me a sandwich with mortadella, which was really fantastic. After thirty-five days, I was sent home for two weeks' leave.

After that, I returned to my battalion, and we were sent to Yugoslavia. We formed the Julia Division, to go to Russia. After Greece, the division had been nearly destroyed. We had to start over.

I was sent to Tricesimo and became a driver for the Cividale Battalion. In August 1942, we departed for Izium, Ukraine. From there, we traveled to the Don River. I was in charge of driving the truck, which was loaded with hospital supplies. I was lucky, because I didn't have to march—this journey was about 280 kilometers.

We reached Saprina, Russia, where there was a command center. We were immediately attacked by two Russian fighter planes, but a German Messerschmitt plane counterattacked and destroyed them.

I was stationed ten kilometers from the river. I was surprised to see how the other alpine soldiers created their refuges. To escape the winter cold, they'd dig big holes in the ground and sleep there.

Until the real beginning of the Russian winter, it was okay. We mostly spent time digging the holes we stayed in. We had the principal bunker, where we ate, slept, cooked, and washed. And there were windows, so we could see the river. Machine guns were set up in case the Russians came. Had everything continued as it was, without confrontations, we were sure that we could survive there for five years, easily.

On December 4, 1942, we got the order to move west because the Russians had broken through the defensive line and destroyed three Allied divisions. They had over a thousand tanks and half as many heavy artillery guns. They had waited for the rivers to freeze over so that they could cross with tanks.

The Julia Division was ordered to repair the front line, but the tanks were already within three hundred kilometers of the area under German-Italian control. We were unprepared, untrained for that terrain. We had no tanks, just trucks and riflemen. Our equipment was left over from World War I. They were unstoppable. Our artillery just bounced off. We could sometimes disable their capability to move, but never their capability to shoot. The division was almost immediately destroyed.

Eventually, we received the order to withdraw, but we had to march because we had no real transport. The German troops were motorized, so they withdrew first, leaving us to act as a buffer.

From the day they ordered us to leave the bunkers until the end of the withdrawal, we walked 870 kilometers. We slept only in the open air, despite the freezing temperatures. We were able to eat only what we could find. Everyone was thinking, "I hope God will send me a bullet, because I can't stand this anymore." Those who couldn't walk anymore, we laid them on the field, and when the Russian tanks arrived, they were crushed. Soldiers were going crazy. People died continuously. The road back was littered with frozen bodies. I rarely talk about the events I lived through, because it's still strange to me that it happened—it's something incredible.

Jaroslaw Ferdinand Wietlicki

ŚRODA WIELKOPOLSKA, POLAND

My name is Jaroslaw Ferdinand Wietlicki, and I was born on October 8, 1925, in Wejherowo. When I was a toddler, the whole family moved to Brwinów, which is near Warsaw, where my father worked as a teacher at the local agricultural school. Later on, I studied at the primary school there and also took part in the Polish scout organization.

In 1939, I enrolled in a grammar school in Pruszków, which is also near Warsaw. While I was getting ready for my exams to enter the grammar school, I heard some alarming news about the war, which had started on September 1, 1939. I was too young to understand the real meaning of this. Of course, I heard our teachers and other people talking a lot about the coming war, but I couldn't really imagine it. It was only later, on the night of the twelfth to the thirteenth of September, that I finally understood what it was all about, when I saw a real battle between the Polish and the German troops.

I saw the Polish troops retreating. It wasn't a panic flight at all. The German army was far too strong for them to resist. After one of the German air raids, I saw holes in the ground five meters in diameter! I was really proud of the bravery of our soldiers. I saw a Polish officer who was wounded in his leg. He couldn't walk anymore, but despite this, he kept shooting at the approaching enemy, and he even managed to kill two Germans. Then he crawled into a hiding place in some basement, but the Germans found him there and shot him dead, which wasn't a very common thing in the beginning of the war. In situations like this, the Germans preferred to take prisoners. But not that time.

Back in May 1939, the citizens of Brwinów had bought a machine gun cart. They gave it to the Polish army, and it was standing on the market square. In the beginning of September, right before the German attack, I heard one of the officers say to the local people, "It was a good job that you bought that machine gun cart! Now, it's going to protect you!" And they did make good use of it to defend our town against the enemy.

The Germans took Brwinów on September 13, 1939. They surrounded the house we used to live in and told everybody to come out. Fortunately, my aunt was staying with us at that time. She was a German-language teacher, so she could explain that the house was not a military unit but an agricultural school. I think that this saved our lives because they were definitely about to shoot us. Besides, they noticed our school flag, which featured a peasant with a plough. They understood that it was a school indeed and allowed us to return to the building.

One hundred twenty Polish soldiers were killed on that memorable night. The Polish Red Cross gathered the bodies and buried them at the local cemetery. The wounded officer who was shot in the basement where he was hiding, we buried him near that very building, together with those two Germans he had killed.

In the evening of September 13, I walked the same way as the retreating Polish troops and found four short rifles with full ammunition belts. I understood that those were Polish weapons and that they must be hidden somewhere. I didn't think much of the consequences. So I found a good hiding place in the attic of an abandoned building, although it turned out later that the Germans had arranged their headquarters in that building. However, they never searched the attic, so the rifles were safe there.

I was a Polish scout then. During the war we were known as the Gray Ranks [Szare Szeregi]. However, I was willing to join the real armed forces. The father of one of my friends was a lieutenant colonel in the Polish Army, and he knew about my aspiration. So he advised me to go straight to the Union of Armed Struggle and then to Armia Krajowa. He also gave me a good reference, without which I couldn't have gotten there.

In 1940, I started attending a clandestine school to finish my secondary education. Some courageous teachers continued their work regardless of the new rule that prohibited teaching in Polish. The same applied to my father, who had taught wine making in the local agricultural school before the war. Since he was now deprived of his job, he decided to earn his living by making home-distilled spirits. I remember taking those huge bottles of homemade alcohol to Warsaw, where we sold them to a couple of restaurants. We didn't earn a lot, but at least it was something. In 1943, Father fell badly ill, so my mother and I had to continue his business until the end of the war.

Needless to say, life was pretty hard during the war. We were constantly short of money. From time to time, my father received some grain from his school, and Mother used it to make brown bread. It was a great moment when once a week we weighed this bread and divided it among the members of our family. There were five kids, and since I was the eldest, I was in charge of dividing it. Besides that, we used to grow pumpkins on a patch of land near the school, so we could cook a lean soup with this pumpkin. It was delicious, especially when our mother added some milk. In fact, we ate so much pumpkin that I couldn't bear the sight of it for several years after the war. But during the war, we were happy to have any food whatsoever.

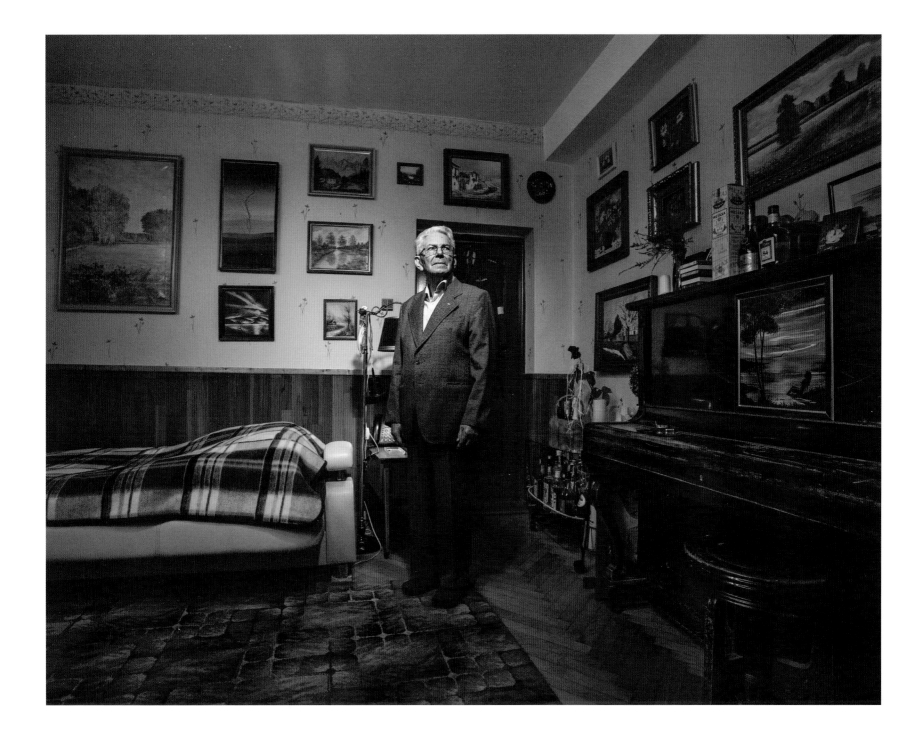

My mother managed to keep some hens that gave us eggs. She also tried to keep a pig, but it proved to be impossible to find enough food for it. Besides the pumpkin, we also managed to grow some vegetables—you know, carrots, parsley…But it was very scant, indeed.

Heating was another great problem. We had furnaces, but there was no coal because it was all taken away by the Germans. So I either stole some coal from them or went with my dad to a nearby field to cut some willow. But this wood was very bad for heating, of course.

In 1942, I finally joined the Union of Armed Struggle and did a course in communication. During the following two years, together with my mates, I had to watch the movement of the German troops and transmit this information. I became really well versed in their symbols and codes. I believe that this job also developed my observation skills. The training course was far from easy. One assignment was to disassemble a pistol and then assemble it again. It wasn't difficult in daylight, but we had to do it in pitch darkness. And we did it!

After a year of training, I became a member of the communications service. My major responsibility in the communications service was to transmit information. For example, important information would be written on a sheet of paper, encoded, of course. I would leave this note somewhere near a tree or a bench, and another AK member would already be watching me from a hiding place. He couldn't approach me straight away, of course. Only when I was far away would he come up to this bench and take the note. The information was very well encoded, so nobody but a trained person would be able to read it.

In autumn of 1942, we found out that the German troops were marching toward Podkowa Leśna. So I was sent there, together with another mate, to transmit this information. We came there and left everything with a Jewish family. Unfortunately, we spent a bit more time there than we had to, because when we left the house, we found ourselves surrounded by the Germans. I got scared because I had a notebook with some codes in my pocket. What a fool I was to take it with me! The Germans frisked us, but apparently, they were looking specifically for weapons. Luckily, we didn't have any. I, for one, never carried any arms at all. So, having found nothing, they let us go. We found out later that they didn't hurt the Jewish family, either. The master of the house was quite well-off, so they just enjoyed his hospitality a bit and most probably took a handsome bribe.

I remained with the local AK unit until the first half of 1944. On August 1, the Warsaw Uprising began, and I found myself in Warsaw on that day. Most of my relatives, including my grandfather, lived there. In fact, one month before the uprising, we were told to shuttle all the weapons from Brwinów to Podkowa Leśna. So we understood that something was about to happen, but none of us knew what exactly that would be. We all hoped for some massive breakthrough, though.

As we found out later, after the beginning of the uprising, Armia Krajowa was planning to announce a massive draft, and all the AK units were supposed to pull in toward Warsaw. However, it turned out that the eastern units were not able to join the fight, because they had all their arms taken by the approaching Soviet Army. The same thing happened to the southern AK units. As for our unit, we didn't rush to Warsaw, although it wasn't that far away. Our commander, Lieutenant Colonel Zigmunt Marszewski, refused to send us—young boys with almost no weapons—to a place where we would certainly be killed.

So we remained in Podkowa Leśna, watching the well-equipped Polish troops march toward Warsaw. We met them, and I gave them some grenades, which I had found in the beginning of the war, hoping that they would make better use of them.

Later I found out that a Pole working for Hilfspolizei, or the so-called Blue Police, reported to the Germans that a Polish military unit was staying in Podkowa Leśna. Surrounded by the Germans, the Polish soldiers hid in a barn, and when the enemies entered the barn, they threw those grenades that I had given to them. However, the Germans had already closed the door, so the explosion took place inside the barn. All the people rushed outside from the back door, trying to save their lives in a nearby grove. The Germans opened machine-gun fire, and everybody was killed. They say that one wounded soldier managed to escape, but this information was not confirmed. Either way, the high command of Armia Krajowa found out about the incident and made sure that the Polish *polizei* who had betrayed our soldiers was put on trial for treason and executed.

After the Warsaw Uprising, the Germans signed an agreement, according to which AK members were considered soldiers, so they were not to be taken to concentration camps but rather to be treated as prisoners of war. Moreover, they promised to establish hospitals for the wounded. One such hospital was organized in the same school building in Brwinów, where I used to live. So I worked in that hospital as an assistant, transporting the wounded soldiers from other hospitals to Brwinów. Once, I was carrying a stretcher with a soldier who was wounded in his lungs. I slipped on something, and the soldier fell to the ground. We put him back quickly on the stretcher and rushed to the hospital. I was very afraid that he

might develop internal bleeding because of this fall, but luckily everything turned out fine. I was very happy about that, because if he had died because of my stupid action, I don't know how I would have lived with that burden.

There was another unpleasant situation connected with that hospital. I used to have a girlfriend, Barbara. Once we were strolling near the hospital where we both worked. Suddenly, we heard some Germans shouting something to us. We didn't know what they wanted from us, so we got scared and took to our heels. We ran into some abandoned building, and it appeared that we had no choice but to jump from a window. Barbara was afraid to jump, but I persuaded her to do it. And she did. But that was an unlucky jump for her, since she ended up with an open fracture of two bones of her leg. To make it worse, I suddenly realized that the German soldiers had already given up looking for us and were going in a different direction. I carried Barbara to the hospital. Unfortunately, the break didn't heal well, and she remained handicapped for the rest of her life. I still feel guilty for ruining her life. She managed to get married after the war, but her husband wasn't a very good guy. Her life was very difficult. I will never stop blaming myself for persuading her to jump out that window.

I continued working in that hospital from the second half of 1944 until the very end of the war. We tried to cheer up the wounded by arranging some parties, reciting poems, celebrating Christmas, of course.

In January 1945, the high command of Armia Krajowa officially declared the suspension of its activity, and everybody was allowed to serve our country in any way they wanted to make it a free, independent, and democratic state. However, for me, the war was not over yet, because in March 1945, I was arrested by NKVD. Surprisingly enough, I can't remember how much time I spent in captivity. The only thing I remember were two guys, Sasha and Misha, who "took care" of me. Once, I asked Misha if he had a mother. "Sure," he answered. Then I asked him again, "Imagine you were arrested like me now, and your mom knew that you didn't do any harm, that you were totally innocent. What would she think about those people who kept you in prison? Huh? Now, listen what my mom would think of you!" He got furious and started shouting at me. Nevertheless, I think that conversation saved my life. After that time, they treated me a bit differently and finally released me.

When I was still in the NKVD prison, they asked me if I wanted to join the pro-Communist Polish Army. Naturally I couldn't say anything else but yes. When I was released, I went straight to General Florian Siwicki, who was responsible for recruitment. I told him that I was too young, and I had exams to take in August in order to get my secondary education certificate. I pleaded with him to let me go. Eventually, when I came the next morning, he gave me an official note that allowed me to go home.

In August 1945, I passed my exams and received the so-called minor certificate of secondary education. I only asked them to release me from Latin. We didn't have a course in Latin at that clandestine Polish school. So now my certificate of secondary education has a note saying specifically that I didn't sit an exam in Latin.

After the war, I found a job as a teacher at a vocational college in Radzymin, but in 1955, I was fired. The first reason was that one of my students smeared a portrait of Stalin with ink. Besides, some students asked me if they could go to church for confession. I told them that in our country it was not prohibited to go to church, so anybody could attend a church service if they wanted to. And on the very next Sunday, the whole class appeared in church. Finally, it was revealed that I had served in Armia Krajowa. So they blamed me for perverting the youth and exerting a bad influence on them, and I lost my job.

I moved to the Poznań province and found a job at a technical school. Everything was good until the Polish Communist agents found me there. They approached the headmaster and told him that I had a bad reference as a teacher.

This crazy hunt continued until 1970. During all this time, I was constantly interrogated by various agents. Only in 1970, one of them told me that Armia Krajowa was already becoming history. He also added that I had been very smart to avoid all sorts of bold statements, so nobody could find a good reason to accuse me of anything.

I was really lucky to survive that long war from its very beginning in September 1939 until its very end. Thank God for that! Yes, I had some small wounds and injuries, but it doesn't count. Now every time I come to church, I always talk to God and thank him for sparing my life.

Ioanna Koutsoudaki & Rena Valyraki

CHANIA, GREECE

My name is Ioanna, and I was born on July 8, 1933, in Chania, Greece. My older sister, Rena, was born on September 8, 1926. We sisters had a wonderful childhood. Our parents were loving, giving people who always did the best they could to provide for us. We had a big house and a beautiful garden.

Our life was carefree until the war started. The Germans were tyrants who were rapidly invading Europe. It was pretty clear that Crete was in line to be invaded by the Germans, especially after they occupied mainland Greece. At that time, our family leased our house to the British consulate. The British were here to protect us, as well as a lot of soldiers from New Zealand and Australia. Still, we all felt very uneasy about the possibility of war.

In May 1941, my father took us to a village north of Chania, trying to find a safer place to live. Soon, the German invasion began. There was heavy fighting, and the British soldiers fought for our island like it was their own. Still, the Germans won, and Crete was under occupation. We remember the first day of the battle. We were playing in the yard, when out of nowhere, a plane appeared right over our heads. We saw a German pilot pointing his gun at us. Our mom ran out of the house and dragged us inside. That plane was flying so low, we can still remember the expression on the pilot's face.

Later, when we returned to Chania, it was already governed by the German administration. One day, my mother walked me through our neighborhood. I saw our home and ran to go inside, but saw a strange man on the porch. I was very confused. My mother quickly grabbed me and told me that it was no longer our house.

The Nazi commanders were living there now. Thinking that it was British property, they took it over and made it their residence. We were afraid to say a word, so, of course, my family didn't even try to tell them that it was our house. We moved to our aunt's house and stayed there.

Thus began the terrible, terrible times. Our childhood innocence was stolen by this worldwide conflict I had no understanding of. Germans would patrol through the town, banging on doors and screaming. My aunt had covered all her windows with dark materials and paint so they couldn't see inside. Our parents would hold us tight during these contentious moments, protecting us with their very lives. My family had already lost their home—the last thing we needed was to lose each other too.

The family had a rice factory that the Germans pillaged, stealing all the food. They even had the audacity to barge into my aunt's home and taunt us, saying, "The war isn't over; we'll be back one day." And giving my parents a key to their own factory.

I had a friend in a Jewish family a couple of homes over, and I remember one morning my father telling me that the Nazis had taken them for prosecution. I never saw them again.

It was a never-ending terror until the British Army came back into our town in 1945. We were relieved that the Nazi threat was being neutralized. The battle over Crete began again. Only now, our liberators were trying to kick our occupants out. And they eventually succeeded.

The Nazis occupied one part of town, and the British had another. We didn't hear many gunfights, but I vividly remember a British soldier banging on our door one day. Rena opened the door, and he was huge. He told us that there were many Nazis chasing him, and he just needed a glass of water. My family happily gave him something to drink.

Once the British Army kicked the Germans out, the war was finally over! We were liberated, and things could go somewhat back to normal. On their way out of town, the Germans burned everything they could. I can recall seeing clouds of smoke billowing off in the distance.

We returned to our family house in 1947. It wasn't in very good shape. The young soldiers hadn't been very respectful of our home. It was dirty and had minor structural damage. Both forces left behind things that we decided to keep and store in the basement as a memorial. The British left a "British Consulate" sign, and the Germans left a drum. I guess that there wasn't much time to play songs once the British were coming.

We later turned the home into a hotel. One time, a German guy visited Chania and stayed with us. Once, I saw him walking around the hotel and checking everything out, looking at things and inspecting doorknobs, windows, frames, et cetera. I was curious as to why he was so interested in the details of our place. So he turned to me and said that he had stayed here during the war. I asked him why he hadn't told me before, and he said that he wasn't sure at first. Had we known, I'm not sure that we would've let him stay. The Germans did a number on our town.

After the liberation, we kept in touch with the British soldiers whom we remembered. We got their names, and every time the town had an anniversary celebration, they were free to stay with us as our personal guests. We greatly appreciated them for their work in liberating us from the German rule.

These days, we still run our hotel. Our parents have passed on, but their memory lives on through us and our historical hotel.

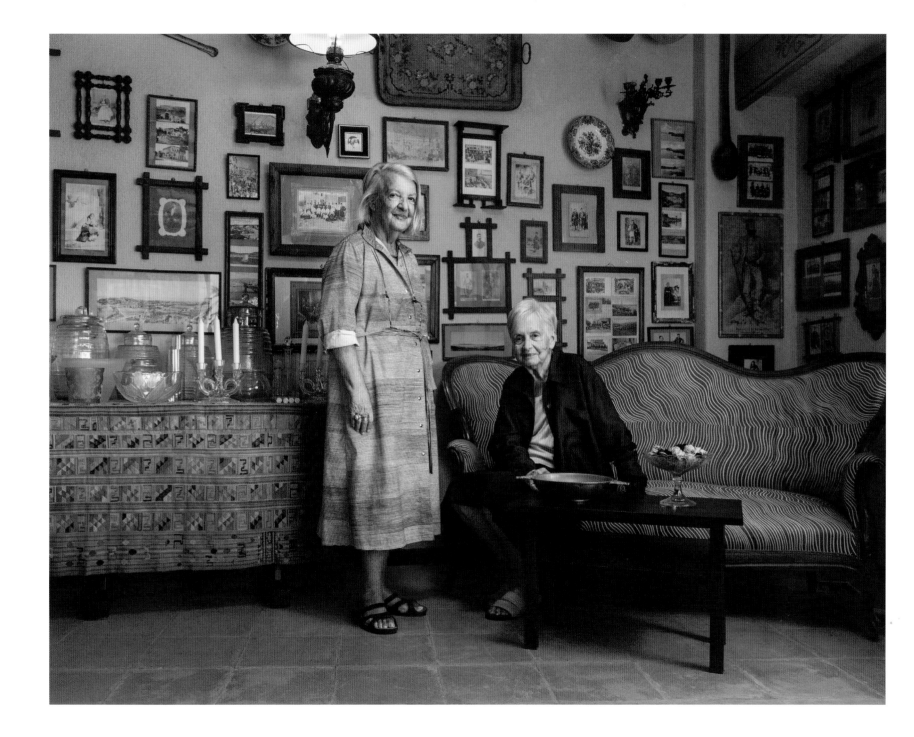

Yvliang Ye

I was born in March 1922 in Beijing. My ancestral home is in Fuzhou city of Fujian Province. My grandfather was a *jinshi* in the former Qing dynasty, which meant that he was an advanced scholar who passed the triennial court exam, a very high honor. But after the Nationalists took power and the Qing dynasty collapsed, my dad lost his job and the family moved to Beijing, where I was born and went to primary school and middle school.

When the Marco Polo Bridge incident happened on July 7, 1937, I happened to be on the way to Nanjing. I left Beijing on the sixth of July and arrived in Nanjing on the eighth. I had an uncle there, and we were afraid that the war would come to Nanjing too, so together with the wife of my uncle, I fled to Fuzhou, my ancestral home.

In Fuzhou, I continued to go to school. The Sino-Japanese war had already started. The leader of the Republic of China, Chiang Kai-shek, announced that all Chinese men, no matter how old or young, living in north China or south China, must fight the Japanese. I was too young to join the army, but we had military training as part of the school program and propaganda lessons, where they would prepare us to fight the Japanese in the near future.

I stayed in Fuzhou for one semester before I was able to get in touch with my family in Beijing, which was then called Beiping. They sent money to me and asked me to go back to Beiping. After I received the money, I went to Tianjin first by ship, and after that, I needed to take the train to Beiping. The Japanese Army already occupied Beiping and Tianjin, and when I was trying to get on the train, it was very crowded, so I clung to the door of the train. A Jap was trying to get on the train, and I didn't make way for him. He gave me a hard kick and got himself on the train. I wanted to fight back but was stopped by a Chinese man, who told to me: "He is Japanese. He can kill you and receive no punishment. This is the world of the Japanese now." So I endured this humiliation and have always borne a grudge against the Japs since then.

After I came back to Beiping, I continued my education. My classmates all hated the Japanese but didn't dare talk about it in public. I had a relative who was a member of the underground resistance, which was basically a secret, unofficial organization of volunteers for assassinating Japanese and local traitors. As we talked a lot about the anti-Japanese movement, he sensed strong sentiment in me and asked, "Would you dare to join the resistance?" I said, "I would." That's how it all started.

The underground resistance started in Tianjin, and our organization in Beiping originated from that movement in Tianjin. Originally, I was responsible for communication and investigation. Later, I took part in assassinations. After joining the organization, I had only one contact, Li Zhenying, who was the leader of the Beiping underground. We called him the "principal." He was kind of my mentor, teaching me how to do investigations and gather information on collaborators. Later, he also taught me how to use weapons, bringing a real gun to teach me how to assemble and clean it, how to aim for and shoot targets.

My first assignment was to investigate the president of the chamber of commerce. His nephew was my classmate, so I used this connection to visit his place and came to know how to get to his home, when he went to work and got off work. After I'd collected all the information, I passed it to Li Zhenying. Together with another killer, Li Zhenying planned the assassination and scheduled a day. On that day, when the chamber president drove away from his home, they shot at the car twice. However, when the news was published in a newspaper, we found out that the bullets missed him but hit his wife. We killed the wrong person.

Another assassination was targeted at Shu Zhuanghuai in Beiping, who lived very near to me. He was the director for the department of public works. The responsibilities of this department included building barracks, trenches, et cetera. His daughter was my schoolmate in primary school. I was asked to find out where he lived. After my investigation, Li Zhenying brought another two killers to carry out the assassination. As soon as Shu Zhuanghuai came out of his car at the gate of his house, they shot him. The traitor was shot in his eye but wasn't killed at the scene. He died afterward in the hospital.

We also attempted to kill Yoshiko Kawashima, and that was my first assassination assignment. It was on her birthday. Yoshiko Kawashima was a Japanese spy and a puppet of the Imperial government. She was a Chinese princess, but had been brought up in Japan and was collaborating with them. She was going to celebrate her birthday in Xinxin Grand Theatre. She had booked all the seats upstairs. Tickets for seats downstairs were still being sold. That day, Li Zhenying led me there to kill Yoshiko Kawashima. I followed Li Zhenying, and we bought tickets in the front row, from where we could turn back and see what would happen upstairs. The opera that day was quite famous and was played by Yan Jupeng and his daughter. Yan Jupeng's daughter was Yan Huizhu. That was her first time on stage, so there was a big buzz about this and many people in the audience.

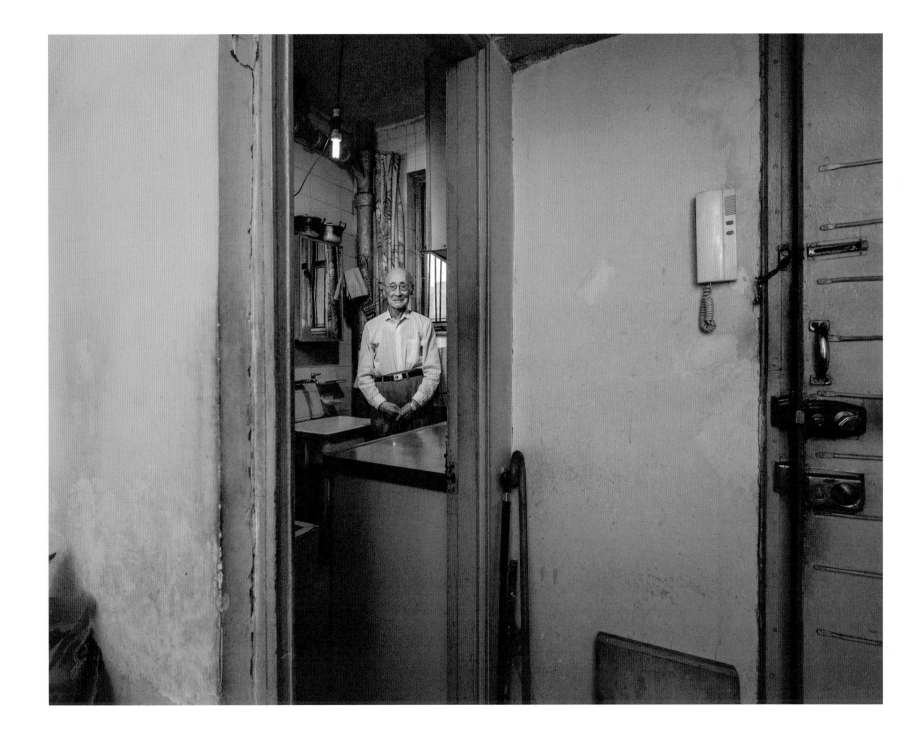

We waited. The opera had started, but Yoshiko Kawashima hadn't arrived. Later, we heard some noises, turned back, and saw her and her posse settling down. She was upstairs and sat in the middle. She was wearing men's clothes: a long gown and a Mandarin jacket, a pair of shades. We had to wait for a while, because it was too crowded. Then we heard some commotion again, turned back, and realized that she was gone. We rushed outside, but she was already in her car driving away. We failed.

On the seventh of July 1940, the Japanese celebrated the third anniversary of the Marco Polo Bridge incident. They set up a stage at the Altar of Land and Grain in Zhongshan Park to make speeches, and a lot of people went there to listen. The event was cochaired by Wu Juchi and his deputy editor in chief, Chen. Wu Juchi was the editor in chief of *Xinmin Bao* newspaper, which was an official newspaper for the Japanese puppet regime. And we decided to kill them.

This assassination was very significant. Li Zhenying brought Feng Yunxiu, Liu Yongkang, and me. We were in the crowd listening to the speech. When the speaker was condemning anti-Japanese armies and people, one of our guys was getting really worked up and wanted to shoot him right on the stage. Li Zhenying quieted him down and said, "We can't take action here. There are too many people around, and among them traitors, spies, special agents, policemen, and plainclothes police…It's too dangerous to shoot here."

Later, when the ceremony ended and the crowd was dispersing, we followed Wu Juchi and Chen. They went to a restaurant at Qianmen Wai, so we waited outside. After a while, Wu Juchi came out. Li Zhenying and Feng Yunxiu followed him outside to the South Xinhua Road. And all of a sudden, there was a funeral procession passing by, playing horns, gongs,

and drums. This was a perfect distraction, and Feng Yunxiu rode his bicycle toward him and shot Wu Juchi in the head twice. He was instantly dead. Then they ran away. The policemen came immediately. The whole city was searching for the killer. Meanwhile, I was still waiting for Chen with Liu Yongkang. Li Zhenying sent someone to inform us of the search and tell us to abort the mission. So we left, and Chen was not killed. This assassination caused a great sensation, and none of us got caught.

Soon, we were planning another mission: to assassinate a newly appointed officer in the general office of construction, Yu Dachun. Liu Yongkang and I were assigned to execute the mission. Our investigator gave us his exact location at Fengsheng Hutong and the time he would be arriving. We were both on bicycles; Liu Yongkang was in front and I was behind. Liu approached him first and shot him from behind. I was following and was supposed to make sure he was dead. But he wasn't—when I approached him, he was lying down, bleeding out but still mumbling something. So I shot him. And I killed him.

Immediately after this assassination, the military police launched a large-scale search. Liu Yongkang was arrested. As he had the list of members on him, our underground organization was almost fully exposed. All members were arrested, including our leader, Li Zhenying. When the Japanese military police came to my door to arrest me, my family had no idea I was part of the resistance. I hadn't told them.

After the trial in the Japanese court, I received my sentence: life in prison. I was sent to a prison specially set up to hold anti-Japanese and resistance people, under the supervision of the Japanese Army but administered by Chinese. The prison wasn't well armed like Japan's, so to prevent us from running

away, each of us had chains on our feet. We had to walk and sleep with those chains on—they never came off.

In the beginning of my sentence, the food wasn't bad. But around January 1942, after the Pearl Harbor incident, Japan started war with the United States. The Japanese needed more food for soldiers. At that time, outside the prison, rice was for the Japanese, while Chinese could have only wheat flour. In the prison, we didn't have wheat flour but ate steamed corn bread. Afterward, we even ran out of corn flour and started to eat sorghum flour, bran, and potatoes. Many prisoners died of malnutrition or hunger. I was luckier; my family lived in Beiping, so they could send food to me.

Since I was sentenced for life, there was nothing for me to be afraid of. The Japanese translator came to talk with us on behalf of Japan and told me that we shouldn't argue with the prison guards and fight against Japan. I told the translator, "You're wrong. You invaded our country, sent forces to China, and transported resources back to your own country. You're invaders." We didn't reach any conclusion in the end. I remember, a Chinese guard beside us said to me: "Are you crazy? If he came back and told others, you might be shot by them." I answered, "I'm not afraid of him. I'm not afraid of death now." However, nothing happened after that.

The most difficult period in the prison was when I got ill. I was sick for thirty-five days. I got typhoid and had a severe fever. I recovered naturally, but almost died. It was tough in prison. Food was getting worse. Finally, on the fifteenth of August, 1945, Japan surrendered unconditionally. After I knew that China won the war, I was so happy that I jumped up. We broke the chains on our feet, dashed outward but were stopped by the guns of Japanese soldiers. So we came

back and waited inside the prison. While we were waiting, we were treated better. People outside were sending food to us. We didn't have to eat bran or potatoes anymore. We got better food, like steamed corn or millet bread. People from some patriotic organizations also sent some dishes to us. Some traitors also sent something in order to please us.

On September 3, I was released. On the tenth of October, the surrender ceremony in north China was held in front of the Hall of Supreme Harmony of the Forbidden City. Commander Sun Lianzhong accepted the surrender of Nemoto Hiroshi, the Japanese commander in north China. I attended the ceremony and was sitting behind Sun Lianzhong.

After being released, I worked in the Beiping Guard for one year. Then I came back to Fuzhou and worked in the tax bureau for another year. After that, the finance ministry transferred me to the financial management bureau in Wuhan. When the Communists occupied Wuhan, I didn't leave my position but was reemployed by the Communists. All of us in the financial management bureau were transferred to a financial management department in the People's Bank for Middle and South China.

When the Communists started to suppress "anti-revolutionaries," I was arrested in March 1951, to receive reformation through labor. After completing the sentence imposed by the Communists, which lasted eleven years, I could visit my family in Beijing every year but was not allowed to return.

In 1975, after the special amnesty, I came back to Beijing. When I was in the Japanese prison and when I was receiving this reformation through labor, I was manufacturing clothes, so I got a position in a clothing factory in Beijing. I retired at sixty-two.

Now, I'm staying at home enjoying my life. I love watching TV, chatting with friends on WeChat, and playing on my computer. I use an iPad to communicate with my friends and relatives. I even got in touch with my former classmates.

Looking back at the days when I was in the underground organization, I feel that I have fulfilled the responsibilities as a Chinese. We should be patriotic, but in different ways. I wasn't able to go to the battlefield, so I took part in those underground activities.

Marko Vruhnec

LJUBLJANA, SLOVENIA

My name is Marko Vruhnec, and I was born on June 9, 1922. After World War I, my parents lived in Ljubljana. Later, they moved to Belgrade, in Serbia, where I spent my early childhood until I was nine years old. I learned French there. We moved back to Slovenia, and my father became the director of a coal mine. Our family was well-off, and we were very happy.

In 1940, the Italians occupied the territory; after that, the Germans and Hungarians arrived. In 1941, the war divided our family. My father was sentenced to thirty years in prison, and they confiscated our home. My mother was sent to a concentration camp in Germany. On July 14, 1941, I had to go to Italy, where I was imprisoned. I was released, and soon after, I joined the Slovenian partisans.

It's difficult to think of specific memories from the war. What I remember is that there was a huge difference between the warm and happy home I'd grown up in and the rain and fog and winter that came as a result of the fighting. My father managed to escape from prison. He also joined the partisans, and we were reunited on January 1, 1945. My sister was also an activist. We were together until the capitulation of Rome, which was where we lived at the time.

I was injured in the second half of April 1945. It was a complete miracle that I survived. I couldn't walk. But I believed that everything would end and I would be okay. I remember the bright moment when I returned to Ljubljana, and everything had been worth it. The fighting. Everything was waiting to begin again. The Germans and Italians had already left Slovenia. I searched for my sweetheart and found her; immediately we wanted to get married. On July 12, 1945, we did just that. We had known each other since we were seventeen. She had also been imprisoned and tortured.

I had wondered whether my mother would return from the camp. I learned five days before the war officially ended that my sister had been killed. On the one hand, there was a feeling of euphoria of the war being over. On the other, it was an emotional, heavy time for us.

Everything in Yugoslavia was in ruins, and there weren't enough supplies. But it was rebuilt and became one of the best places to live in the world. Because of Tito, I think. He was very popular. He was the president of the Non-Aligned Movement. I worked in his cabinet as a leader because I had worked with international trade, I had fifteen years of experience, and he saw potential in me. I was his economic adviser. I did this for three years. I also earned a doctorate in law. I was a professor at two major universities in Slovenia, where I taught world trade and economics.

The world has changed since then. We have new centers of power, from technology to economy and so on. I'm not trying to be too romantic about history, because it won't repeat itself and it shouldn't. It's normal that everything transforms.

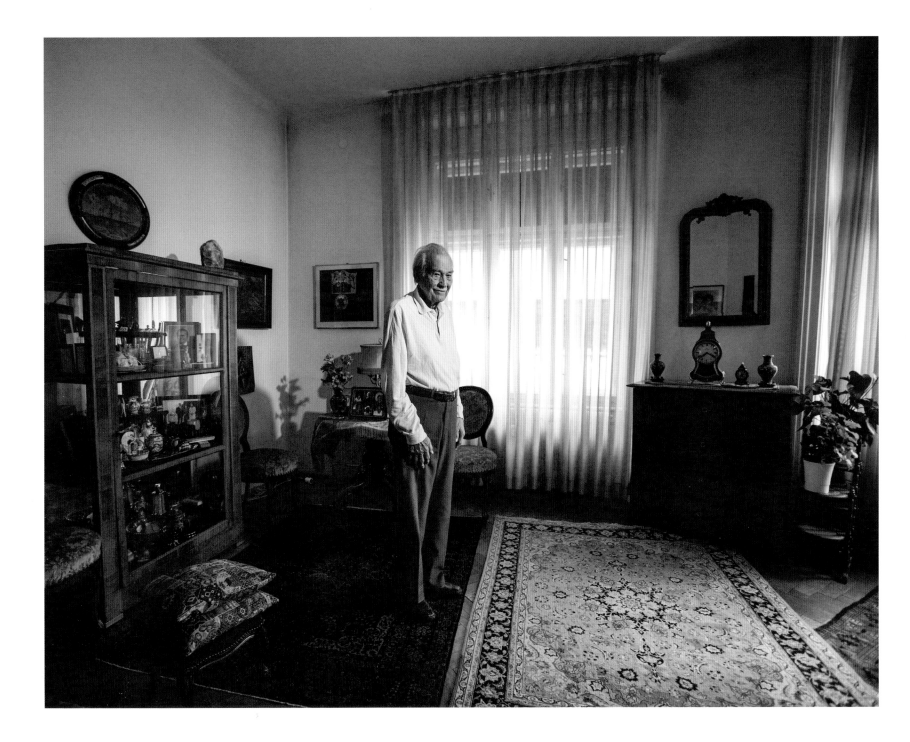

Nicola Struzzi

ROME, ITALY

My name is Nicola Struzzi, but my family and my friends all call me Giorgio. I was born in San Lorenzo on February 11, 1923. My father used to work in a public transport company in Rome. I had two brothers, and one of them went to volunteer for the Italian Navy when I was very young. I started studying at the age of six, but at nine, I stopped going to school because I was discriminated against by the kids from more affluent families. I started working at the age of twelve as an assistant in a metal store, where they used to deliver drain covers.

When I turned seventeen, I started working for a transportation company like my father. In 1940, I was working as a ticket collector for a local tram. During that time, the society was divided into two levels. One level belonged to the upper class, and the other was the working class. The white collar used to go to the events where Mussolini was directly addressing the people. One time, I was on a tram driven by a very old driver who was quite slow, and there was a big queue of people waiting at the bus stop. One of the people was dressed in a Fascist uniform, in whole regalia—with all the symbols and everything. Accidentally, I closed the door when this person was entering, and his hat got smashed. This guy called the authorities and also wrote to my boss, which generated a lot of problems.

In 1942, I was called by the state to join as a soldier, but there wasn't much work, so I signed up as a parachutist. I attended a few months of parachute training in L'Áquila. From there, we were moved by train to Sciacca, where an aircraft was ready to take us to the war zone in Tunisia. However, our aircraft came under attack when we were just about to reach Tunisia. We were lucky that our aircraft survived, because all the other planes caught fire and got destroyed. After crash landing in Tunisia, we were moved close to a place called Sfax, with the Italian Army. We resisted continuous bombing for thirteen days, but eventually, we surrendered.

We were captured by the Allied soldiers. There were about thirty-five thousand Italian and German soldiers in a queue, all divided into different groups to be taken to the American, British, and French prisoner camps. All the Italian soldiers were hoping to be moved into the American camp. Unfortunately, I was moved with the French, who were a little upset with the Italians at that time. They painted a red square on the backs of Italian people to identify us. All the captured Italian soldiers from my group had to walk about a thousand kilometers from Tunisia to Algeria. Later, some of us were transported to a camp in Casablanca. During the imprisonment in Casablanca, I was selected to work at a pork-producing farm near the Algerian border. I knew nothing about the nature of work at the farm, but I had watched a documentary on pork production and I knew a few kinds of pork, which helped me in getting selected.

I escaped from Casablanca. I succeeded in finding an American camp, but they already had too many people, so they moved me back to the French camp. I again managed to escape, in an ambulance, and reached the Casablanca hospital. From there, I went to another American camp; I also tried to escape from this American camp, with the help of Italian personnel collaborating with the American soldiers. I managed to hide in a plane scheduled to take airmail to Italy, but it didn't fly. So I came out of the plane, but I got caught by the American soldiers, and they moved me to another POW camp. I was tortured at this camp with electric shock. Later, I was again moved to the French camp in Casablanca. I got another chance to escape from this French camp and go to the American camp. The first thing I did after reaching the American camp was to take a shower. It was very nice; we could have four meals a day and take showers anytime. Compared to any other camp, that one was a vacation. There was a swimming pool, and we could also play baseball, but there were already too many people, and I was again moved from the American camp to a French one near the Casablanca port.

There was an American freighter, *Isonzo*, loading at the port, and I tried to flee again by hiding under a chair on the ship. There were twenty-four other Italians escaping from the French camp. There were American soldiers on the ship, and one of the Italian workers helped us. I was still worried; however, the person who helped us to hide on the ship also helped us to get to a safe place after landing. We found a man traveling to Rome. When I arrived in Rome, I found a newspaper with my photograph on it that had a caption: "Missing person from war." I was absolutely astonished to see it, because it meant that my family hadn't given up hope and was looking for me.

After the war, I started working with the ATAC public transportation company in Rome and later got married. I was financially stable, and we were able to buy a beach house where we used to spend most of the time in summer. I have two sons and three grandchildren.

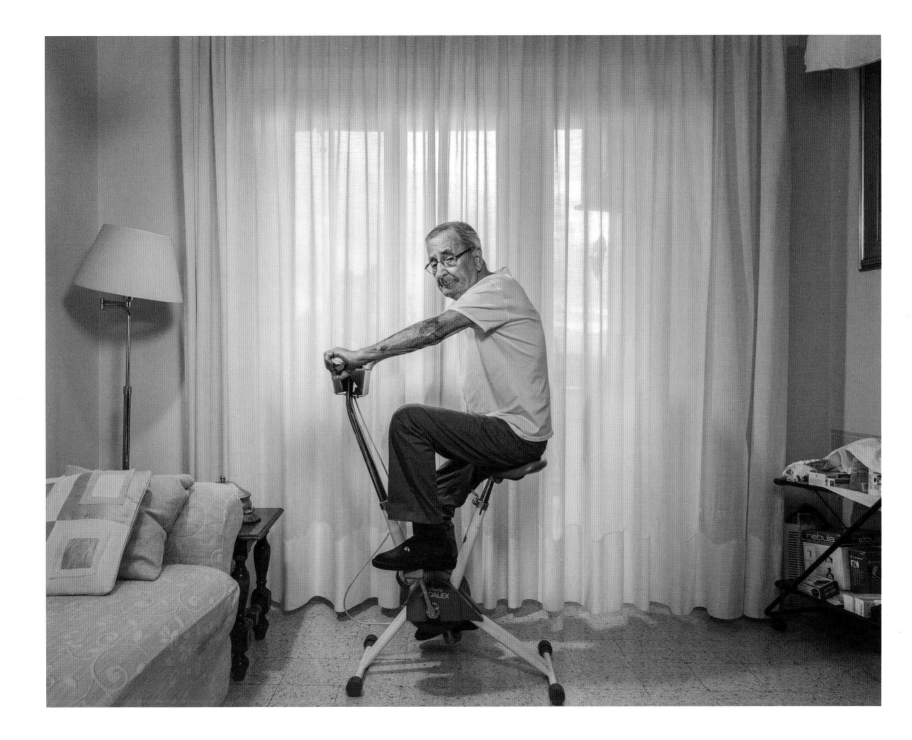

Willie Glaser

MONTREAL, CANADA

My name is Willie Glaser, and I was born in Bavaria, Germany, in 1921. My family were Polish Jews. I was one of five children and lived a happy childhood with my three sisters and a brother. My father worked in the toy export industry, and his job took him all around Europe.

Soon, the Hitler years arrived, and it became very tough. The economy—and even our peace of mind—was gone. My father worked frantically to get us out of the country. He wanted to take the whole family to England, but was unable to make it work. He managed to send one of my sisters there, and then finally, in 1939, he arranged for me to leave Germany. I was seventeen.

My sister and I would frequently travel from England to Belfast in Northern Ireland. My father was in France, and my mother and other siblings were still in Fürth, Germany. It was hard to communicate with them, but I did what I could. The people I stayed with had family in Dublin who could correspond with Germany. So I would send them my postcards, and they would forward them to my mom. Every two to three weeks, she would mail me and my sister.

I'll never forget the card she sent me on my twentieth birthday. She wrote, "May the Almighty protect you from all evil and bad things." I sincerely believe that this blessing put a guardian angel on my shoulder. By the end of 1941, the correspondence ceased with my mother.

In the beginning stages of the war, I was working in England at a garage. We had significant work to do after the London Blitz destroyed so much of the city. We repaired ambulances and other vehicles.

Slowly but surely, all my friends were called up to the army. Eventually, I was practically by myself. In that solitude, I resolved that it was my duty to join as well.

I went to the British recruiting office in Northern Ireland, where they had a bit of confusion on where to place me. The sergeant on duty told me that because I was Polish, I had to see the officer on duty. He was just as unsure as to where to place me. After making some calls, he determined that because I had a Polish passport, I had to join the Polish Army, which was just forming in Scotland after the Dunkirk evacuation. There was a small Polish brigade that had evacuated back to England, and that was the nucleus of the Polish armored division.

I went to the recruiting office, and they gave me a food voucher and ticket to Scotland. Once I arrived, I reported to the Polish reception camp. The camp had opened up because a lot of volunteers from the United States and from South America had come there. In the midst of all these volunteers, here I was: a German-born Jewish boy. I barely knew what was going on there, because I couldn't speak a word of Polish.

Because of my inability to speak Polish, I was exempted from guard duty. That would've been a good thing if not for the cook, who told the camp commander that I wasn't pulling my weight. I was assigned as the cook's helper and woke up every morning at 5:00 a.m. while he slept in. I had to prepare the porridge and coffee for breakfast. After a while, the soldiers actually told me that I made the best porridge and coffee!

After two months, I was assigned to the Sixth Company (heavy machine guns), Second Battalion, Third Independent Infantry Brigade, up the coast of Scotland. I was assigned to guard the area.

Soon, I met the Jewish chaplain, and he would tell us what was going on with the Jews in Poland. He received much of his information from the findings of Jan Karski, a legendary Polish resistance movement fighter. Karski was an emissary between the Jewish underground in Warsaw and members of the Polish government who were exiled in London. Karski was a brave man. To learn the specifics about concentration camps, he infiltrated the circles of Nazi collaborators. He told the Polish government everything he learned, and then there were a couple more steps before the information got to us.

I had a pretty slow two years at this camp. Most of my time was spent participating in military exercises and holding guard duty. I did go to Edinburgh every other weekend and attended Shabbat services at their local synagogue. I developed a friendship with one of the members of the congregation, and he began inviting me for Friday night supper and Shabbat dinner. One of the highlights of my experience in Scotland was participating in Passover and Jewish New Year events in Edinburgh.

I had developed a wonderful relationship with the people of Scotland, as did other soldiers. They loved us. The bond we shared can be seen on the emblem at the Polish HQ, which features a Polish eagle and Scottish lion.

We were so close that rumors spread of Second Battalion members becoming honorary members of the Stewart clan, which entitled us to wear the Royal Stewart kilt. I thought that the rumor was true, so I wore a kilt to a dance. (What did I wear under the kilt? Just gym shorts.) When I returned to camp, it turned out that the rumor was false. I was fined two weeks' pay for being out of uniform, which was a hefty fine. I understood it though, as HQ didn't want to see soldiers walking around in kilts.

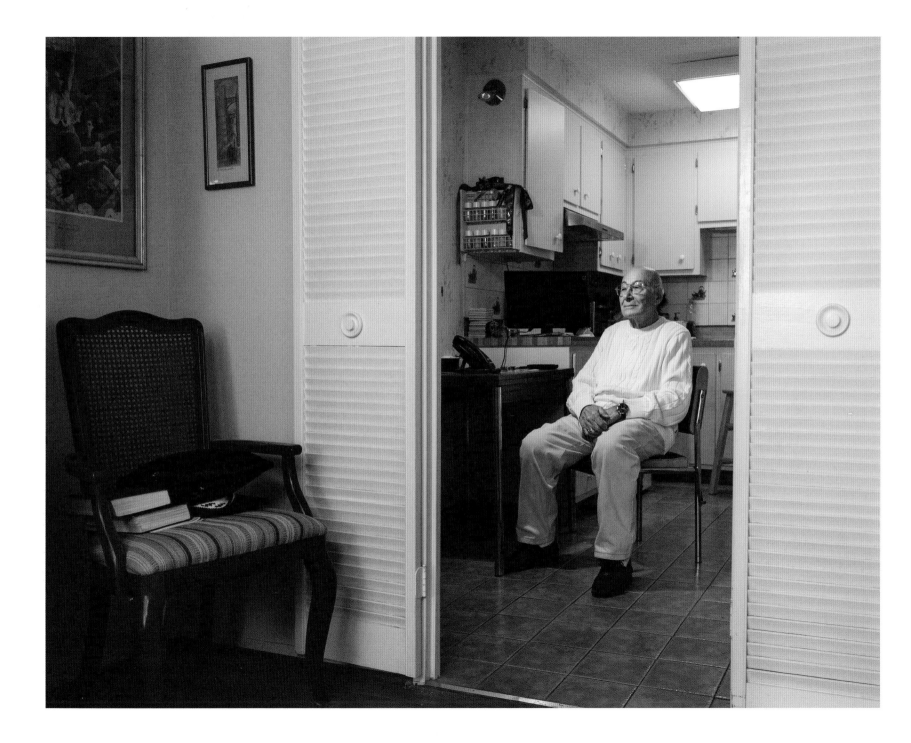

In 1943, I was transferred to the First Polish Armored Division. The Tenth Polish Mounted Rifles regiment was born, and they sought the cream of the crop. The interview process was pretty intense, but I didn't sweat it. I was just twenty and in great shape, so I was exactly what they were looking for. The sergeant major who interviewed me assigned me to the tank regiment as a radio operator. My Polish was still pretty shoddy, but the sergeant wasn't worried.

Our regiment had several reconnaissance tanks. The training process was fairly arduous, but I didn't mind. We trained at various places in Scotland, including Dalkeith Castle, near Edinburgh. The cold, drafty rooms of the castle are unforgettable.

In summer of 1944, bad news came about the Jewish people in Poland and other occupied territories. Here I was on my big tank, but completely powerless to directly help my family.

During that time, the war was reaching a fever pitch. Many of my friends were dying, including over fifty comrades killed in action. One of my biggest comrades, Gustav Goldstaub, was killed when his tank was struck. The driver was also killed and the three crew members wounded.

The regiment was well aware that D-Day was coming; we were just waiting on the order. Finally, we were commanded to get our tanks ready and head to Southampton. From there, we put our tanks on the ship and set sail for Normandy.

Our ship arrived eight days after the invasion commenced. Upon landing, we immediately proceeded inland. Our regiment was composed of what we called tank troops. Each troop had three tanks, with five men to a tank: commander, loader, radio operator, driver, and codriver. I served as a radio operator.

The close quarters of the tank were almost like a tight subway car. I soon learned harmony was the key!

We all had each other's lives in our hands, so if the soldiers didn't click, the commanding officer would split the crew up.

After entering what was previously German-occupied territory, we came across an angry German soldier. He was yelling and screaming, so we asked him what was wrong. He told us he was sick of the war and knew of thirty-five seriously wounded Canadian and Polish prisoners of war nearby. It turns out this angry soldier was a sergeant medic. After we had encroached the German lines, they had withdrawn and left him behind with those POWs. The way he spoke of the wounded soldiers, it was as if they were his family. Tellingly, he referred to me as "Du," which was generally used only for friends or family. This kind of friendliness was unheard of, but I gave him a pass because I realized that he was shell-shocked.

Within weeks, we were thrust into one of the biggest battles of the war, the Battle of the Falaise Pocket. Over fifty thousand German soldiers were surrounded and pounced on by the British, American, and Polish Armies.

Since I was a German speaker, I was given the task of interviewing the German soldiers who had survived. I learned that some of these men were officers of the Twelfth SS Hitler Unit, Hitler's very own bodyguard regiment. These men had killed over five thousand POWs, mostly along the eastern front. Hitler had sent them to Normandy to reinforce the German stronghold in the area.

They could terrorize no one else once we had taken them all as prisoners. One of those soldiers in particular provided a shocking experience. When I asked for his identification, his ID showed that he was from Fürth, in Bavaria! I nearly dropped the ID. I spoke to him in my Fürth dialect, asking things only a resident of Fürth would know. He

looked at me, surprised, and then I told him he was being interrogated by a Jew. That admission really knocked his socks off.

After we finished interviewing the prisoners, we sent them to POW camps and soldiered on through France. Eventually, we got to Belgium.

Antwerp in Belgium had been destroyed, and there was no way for our tanks to cross certain paths. To cross, we had to wait for bridges to be built. This would happen periodically and leave us stranded in one part of the city or another. During one such stoppage, I walked into a nearby house and saw dozens of Jewish people who had been hiding. They were all either from Belgium or people from Poland who migrated to Belgium. I felt terrible for them. Did they know where their families were? Did they know what happened to their mothers and fathers, their sons and daughters? True horror.

There were about ten Jewish soldiers in my regiment, and we had an army chaplain named Major Heshel Klepfish who kept us in the loop. Whenever possible, he would do a synagogue service for us. He had holy scrolls and prayer books. He told us about the Warsaw ghetto uprising and the destruction of those areas by SS units in the spring of '43. The Warsaw Uprising was the first atrocity of the Holocaust that was publicized in German papers, but we got the in-depth story.

At the same time, through various channels, I was trying to find out the fate of my family. Was my father still in France? Had my mother gone there? Or were they able to cross to England? These were thoughts that plagued me as we trudged along through Europe.

The regiment traveled on through Holland and then hit Germany. In Germany, we were sent to Wilhelmshaven naval port, which was surrendered to my commanding officer by the town's mayor.

While in Germany, I got in touch with my uncle Benjamin. He had emigrated to Palestine in 1935. In my heart, I felt like I would never see my family again. He was the saving grace that gave me a glimmer of hope about them.

In my quiet moments, I pondered what this entire war experience was even about. I had no idea how my old Christian playmates were capable of killing so many innocent people. At six and seven, we played at each other's houses and were fed by each other's parents. Throughout my time as a child in Germany, everyone knew I was a Jew. It was never a problem. Not with my friends or the firefighters who let me help clean their fire engines. All of a sudden, though, war had turned them into monsters. It was heartbreaking to think about, but I couldn't let it break me.

Our naval base soon became out of bounds once all the navy ships, submarines, and U-boats began to dock there. At that point, we headed south to Oldenburg, Germany. My regiment was given the task of policing the occupied area. A lot of SS soldiers and high-ranking German officers were hiding among the prisoners in the extermination camps, hoping to escape apprehension by the Allied Forces. Two other German-speaking soldiers and I were given the job of finding these officers. Into the camps we went, dressed as prisoners. We made friends, stayed observant, and sniffed out the Germans. They were placed under arrest, and from there, I'm not sure what happened to them.

After two years in Germany, we finally got the call: the war was over! At that time, I came down with a really bad cold. I was just lying in this feather bed, and I remember the hausfrau at the farm giving me hot tea and nursing me back to shape when everyone else was celebrating.

Once I got back on my feet, I stuck around in Germany until we were called back to England. There, my regiment formed the Polish resettlement core. We were unarmed, and we basically did patrolling and surveying of England in its transitional period.

During this time, many of the Polish boys didn't want to go back to Poland because of the Communist regime. Some boys went back and got arrested, but I stayed in England. To their credit, the English did try hard to assimilate us Polish soldiers into the English society, but the results weren't always successful.

After a couple of months, a notice came that the Canadian government was willing to take in a couple hundred Polish vets. It would pay the expenses for us to travel over on one condition: we had to work on a farm for one year.

I was all by myself; my sister was in Belfast, and London was still stricken by destruction. Why not go to Canada? I went there and landed at the military college in Saint-Jean, Quebec. There, we were officially demobilized.

We stayed in Saint-Jean for a few days, and then there was an event where we met the farmers we were going to be working for. They had all kinds of drinks, pastries, and sandwiches, and we got to know all the farmers. Once you sort of got friendly with the right one, you could sign papers and work for them at a certain pay rate.

I ended up working for one year on a farm in Quebec. After my contract was fulfilled, I came to Montreal, and I got very lucky and found a good job in an experimental testing laboratory. It was a summer job, but by September of that year, it turned into a regular job. I worked there for a while and even met my wife there. She worked as a bookkeeper.

Later on, I worked selling insurance, but my wife didn't like me being gone for long periods of time,

so I had to do something else. Eventually, I found a job at Simpson's department store here in Montreal, where I worked for thirty years before retiring as a manager in 1980. I made a glorious life with my wife, but she passed away seven years ago. It was a tragedy for me; she was my friend and life partner. I couldn't imagine life without her. So as not to let my sorrow consume me, I got involved in all types of things to stay busy.

After the war, I tried to find my parents but failed to do so. Years later, after extensive research, I was able to find out that my parents and three siblings were murdered in the Bełzec concentration camp. I even found where their mass grave was. I've visited there twice.

About twenty years ago, I was able to speak with the great Jan Karski. We got him to speak at McGill University in Montreal, and we had a great time. I spoke with him about the war and thanked him for the job he did as a resistance fighter. My first inkling about Bełzec actually came from him. So just like he was helping us with the information during the war, he helped me personally to find out what happened to my parents.

There are only about ten men still alive from my regiment. I try to communicate as much as I can with them. I'm also busy with the Montreal Holocaust [Memorial] Centre. I found a girlfriend, and we travel often. On another exciting note, I've written a novel. Look out for it!

Hans Ransmayer

BISCHOFSHOFEN, AUSTRIA

My name is Dr. Hans Ransmayer. I was born and raised in Bischofshofen, in the alps of Austria. I spent my childhood there. During school, I was a leader in the Hitler Youth. Along with the rest of my classmates, I was conscripted from the seventh grade onward. The whole class from my school joined the Wehrmacht in 1939. At the time, there was a lot of enthusiasm for the war. I trained in Germany to become a paratrooper.

I was stationed in Braunschweig, and then in France, where I was injured during a training exercise. At the time, the morale was still very good. And we were strictly disciplined. On one occasion, some soldiers from my unit confiscated some wine from a vineyard. The day after, the whole unit had to stand in the barracks, and the French farmer was allowed to pick out the soldiers who took the wine, and it was returned. Another time, we captured a French civilian who had been out after curfew. No one was supposed to leave home after dark. He'd hid from us under a car, but we found him and took him to a cell. The next morning we let him out with a warning. He was terrified.

I was captured on the southern front on November 7, 1943. I was part of the Gustav Line, a defense set up to halt the southern approach of the Americans and to allow for defenses in Monte Cassino to be set up. During an attack, many of my friends died or were injured, and the rest were captured. The Americans took our equipment. They took other belongings. But we were treated fairly. We were sent to the South of France. There, I was inspected by Eisenhower himself. He was there one day and inspected the POWs. I was sent from France to Italy to Africa, where I changed camps every couple of weeks to reduce the possibility of any escape attempts. This was a regulation in place for elite soldiers, often paratroopers or SS.

Eventually, I was sent to an interrogation camp near Algiers. Other German soldiers had nicknamed it the Pressing Mill—I was interrogated there for ten days by an English officer. Each prisoner had one officer assigned to him. Some were French, others English or American. In these ten days, the officer could treat you as he wished. He could come with gifts of cigarettes and chocolate. Or with beatings. The officer interrogating me preferred violence.

It was December, and we were kept naked. It rained every day. We were beaten and starved, isolated. One man in each cell for ten days straight. Afterward, we were allowed back around the other prisoners. We didn't know why they chose those they had. Now, I realize they wanted to claim a range of different people. Young, old, big, small. From every village, one dog, as I say. There were thousands of us and only twenty or so went through the heavy interrogations. There was no possibility of rest.

Then we were sent to Norfolk by ship, and then from there to the States. We were sent to Camp Grant in Illinois, near Chicago. The conditions in the camp were very good. I was then transferred back to France by ship for repatriation. In France, I was kept in an American camp where I was again treated poorly.

The prisoners in the camps were used for labor. There were many different types of labor. I was used as a translator in the camp administrations. I was paid eighty cents per day, camp money. We were able to buy some things from a small shop in the camp itself. It would have been impossible in Germany to think of some of the things there. Chewing gum, chocolate. But no cigarettes, and everything came in small amounts.

In November 1947, we were transported by train from France with American soldiers to a small camp near Salzburg and were released there the same day. I returned to a very bad economic situation. It was difficult in the years after the war to get the things you needed for a normal life. Many of my relatives were in captivity or missing. My father had also been in a prison camp. He was a military doctor, and he was imprisoned a year longer. He died eight days after his release, after returning home.

It was a very hard time for the family.

I studied medicine after the war. I worked in mountain rescue, as a doctor and as a parachute instructor. I taught servicemen about parachuting. It was important for them to use parachutes to get to people in the mountains in the event of emergencies.

I had three children, seven grandchildren, and three great-grandchildren. I'm almost ninety years old. Now, to get to one hundred.

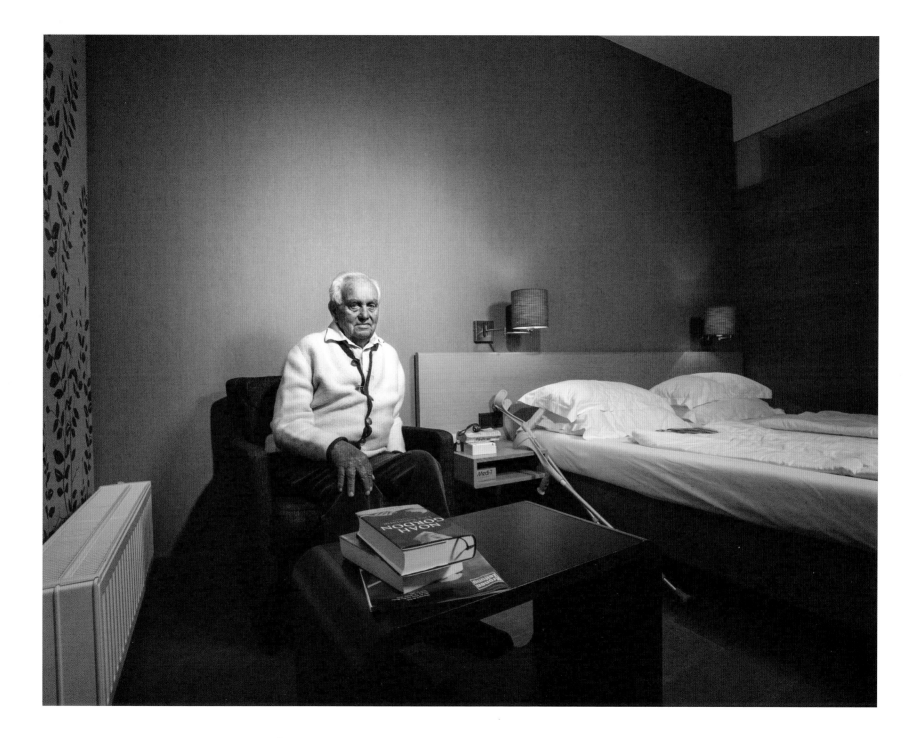

Mickey Ganitch

SAN LEANDRO, CALIFORNIA, UNITED STATES

My name is Mickey Ganitch. I was born November 18, 1919, in Mogadore, Ohio. I graduated from high school in 1937. Because of the stock market crash, jobs were very scarce. I came to California in 1939.

I joined the navy on January 21, 1941. I became a quartermaster, whose job is steering the ship and helping navigate. They assigned me to the USS *Pennsylvania* on August 15, 1941, which was a battleship at Pearl Harbor. I also joined the ship's football team. In December, the Japanese attack came while we were dry-docked because of mechanical issues with the propeller. We had a game scheduled that afternoon with the USS *Arizona*, for the fleet football championship. We were scrimmaging in the morning when the phone rang.

My battle station was up in the crow's nest, about seventy feet up in the air. I didn't have time to change clothes. I had all my padding on except my helmet and spikes, and up I went. Planes were buzzing around, buildings were burning, ships were burning, everybody was shooting in all kinds of directions.

During the second attack, they hit us with a five-hundred-pound bomb. It came between me and the smokestack and missed me by about forty-five feet. It went through two decks before exploding. Had it exploded on contact, I wouldn't be sitting here talking to you. We lost twenty-three men, with many more injured.

Later, in the Philippines, there was a whole fleet of ships because the invasion was going on. A kamikaze hit one of the destroyers and set off the torpedoes. I had one hand holding on, another hand trying to turn the ship. One torpedo went right underneath us. The ship was tilted enough that it just missed.

By the end of our time in the Philippines, our guns would no longer shoot straight. They sent us back to the States to get refitted. In the meantime, we got ready for the invasion of Japan. On August 12, 1945, after both bombs were dropped, we arrived in Okinawa, and that same night, a Japanese plane aimed its torpedo at my ship. It hit the propellers on the right side. Twenty-six quartermasters died that night. The next morning, the Japanese asked for peace. We were towed to shallow waters so that if we sank, we would just sink in the mud instead of any farther down. We were able to stay afloat. Then they towed us to Guam. The war was over.

The military wanted to see what effect the atomic bomb would have on ships. This was September 1946. We scheduled two tests. One in the air, one underwater blast. They put us in the harbor, and we anchored the ships, and they told us to look away from it. Even with my eyes closed, I still saw the flash. After testing on ships, they wanted to know what effect it would have on animals. I'm a farm boy, so they put me in charge of the animals: pigs, goats, mice, sheep. We put them various places throughout ships. We put an atomic bomb at the middle of all the ships, under water. We watched a big wall of water go over the ships. I took inspectors aboard to show them where all the animals had been. After that, they told me to throw away my clothes and take a good shower. That was all the protection I had. (Must not have affected me too much because I have all these grandchildren, great-grandchildren, great-great-grandchildren.) In 1948, they decided that our ship had become too radioactive. They ended up torpedoing it.

That same year, I was assigned to the USS *Mount Katmai*, an ammunition ship. Our job was to supply other ships. I was on that for sixty-eight months. One day, the lookouts reported a floating mine dead ahead. We had eight thousand tons of ammunition. We steered, and the wash of the ship had pushed the mine aside. We had nowhere to go. I could count the spokes on it. We were very fortunate it didn't go off. We set it off with rifles later.

I married my first wife in 1953. I adopted her three kids. My first wife died in 1961, and I was single for two years. I met my second wife when I was recruiting. I married her in September 1963. I retired from the navy a month later.

Those last couple of years I was in the navy, I worked in a bowling alley in East Oakland. One of the bowlers there asked me to come work for him. He was a fishing net manufacturer. I worked for him for twenty years. After I turned sixty-five, I ended up working security in the naval air station in Alameda. I worked there until they closed in 1996. I've been on the unemployed list ever since.

I've been to Japan many times since the war ended. They were our enemies once; now, they're our good friends. To me, it's like a football game, like a sport. You're enemies on the field; maybe you'll go out to supper after. I have no animosity whatsoever. I drive a Japanese car. What is done you can't change. You look to the future.

Now I'm associated with the Fleet Reserve Association, the American Legion, the Veterans of Foreign Wars, the Masonic Lodge, the Disabled American Veterans, what's left of Pearl Harbor Survivors. I've been the head usher of my church for forty-six years. I'm a volunteer at a VA clinic in Oakland. Beyond that, I don't do much of anything. I just goof around.

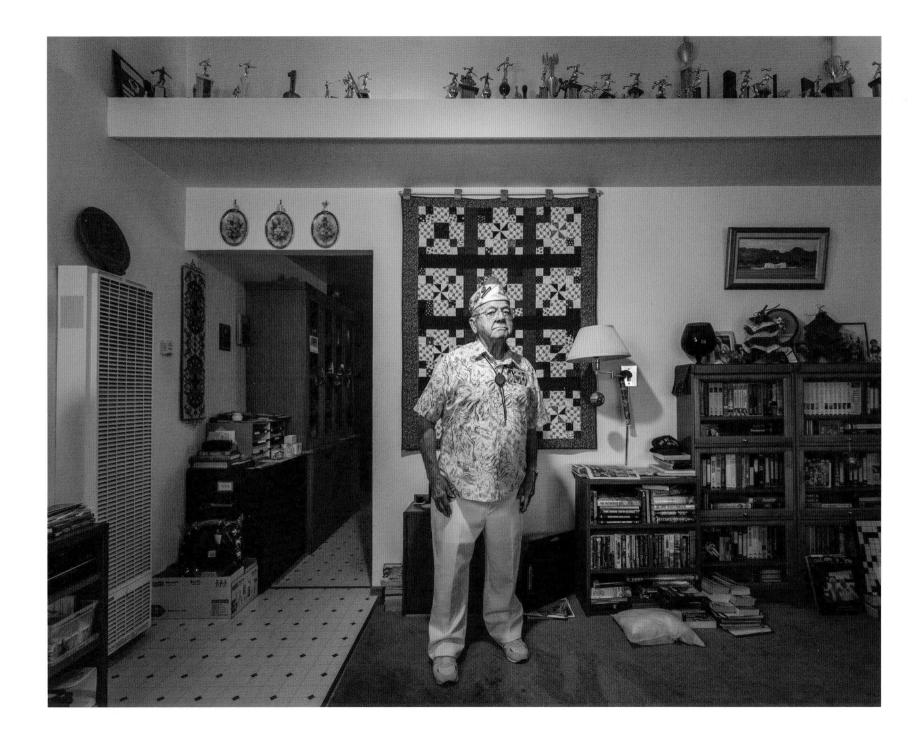

Roscoe C. Brown Jr.

THE BRONX, NEW YORK, UNITED STATES

I'm Dr. Roscoe C. Brown Jr. I'm from Washington, DC, and I was born on March 9, 1922. I graduated from Springfield College in Massachusetts in 1943.

Many people are not aware today that the military in this country was racially segregated. Most black troops in the past had been laborers and quarter-masters. But because of the desire of many African American youths like myself to fly airplanes, we were able to enter the Tuskegee Airmen, after the NAACP and the black press pressured the president to estab-lish a flying unit for African Americans.

My training occurred in Alabama, where there was a famous black university, the Tuskegee Institute. I graduated as a fighter pilot in March 1944. I left to go overseas and join the 332nd Fighter Group at Ramitelli airfield. I flew my first mission on August 21, 1944. Because we flew B-51s with shiny red tails, we were known as the Red-Tail Angels.

We lived in tents all through the airfield, which was about five thousand feet long, going right down to the Adriatic Sea. Many of the Italian civilians worked with us and brought us eggs and chickens and so on. And we would give them a little money to help clean up our tents.

When missions were scheduled, you would have to get up at 5:00 a.m., go to the briefing where they told you the target, and you'd take off around 8:00 a.m. Then you'd fly the mission and come back around 12:30 and go to a debriefing. Then you would rest, play a little poker. Have dinner. Go to bed. The next day, you were flying again. I was there almost a year. Every day, you knew you were going to have to fly. After you flew four or five missions, you'd have a day off, and

after you flew about ten or twelve missions, you'd go to a rest camp in another part of Italy. I flew sixty-eight combat missions until the end of the war.

Our missions were memorable because you were sitting in a single-engine plane for five hours, flying over enemy territory, escorting the bombers. But the most dangerous missions were strafing missions, where you'd come close to the ground to shoot up airplanes or tanks on the ground. That's where we lost most of our pilots. Once, I got too low shooting at a train and hit it and bent up half my wing. But I was able to control it and flew the five hundred miles back to our base and was able to land it.

On March 24, 1945, I was one of the first Ameri-can pilots to shoot down a jet plane. I shot down an Me 262 over the heart of Berlin. Near the end of the war, we went there to bomb a tank factory on the edge of the city. We didn't know we were going to meet any enemy fighters. Then we heard them. They had jets coming out to attack the bombers. I flew down beneath the bombers, turned away from a jet so he didn't see me, then turned back and blew him up.

We flew our last mission in April 1945 and stayed another few months before getting transferred back to the United States.

I resumed my academic career and earned a PhD in 1951 and became a professor at New York Univer-sity. Later, I became the head of the Institute of African American Affairs, which was one of the first black studies programs in the country. In 1977, I became the president of Bronx Community College, where I served for sixteen years. Presently, I'm director for the Center for Urban Education Policy at the CUNY Graduate Center. I think it's important for people to realize that World War II was a watershed. Not only fighting Fascism, but racism. We became aware of the fact that an African American can do anything anyone else can do. And all of us knew we'd made a sacrifice. We had the GI Bill, we went to college, we got degrees, we started businesses. That began, in a sense, the civil rights movement.

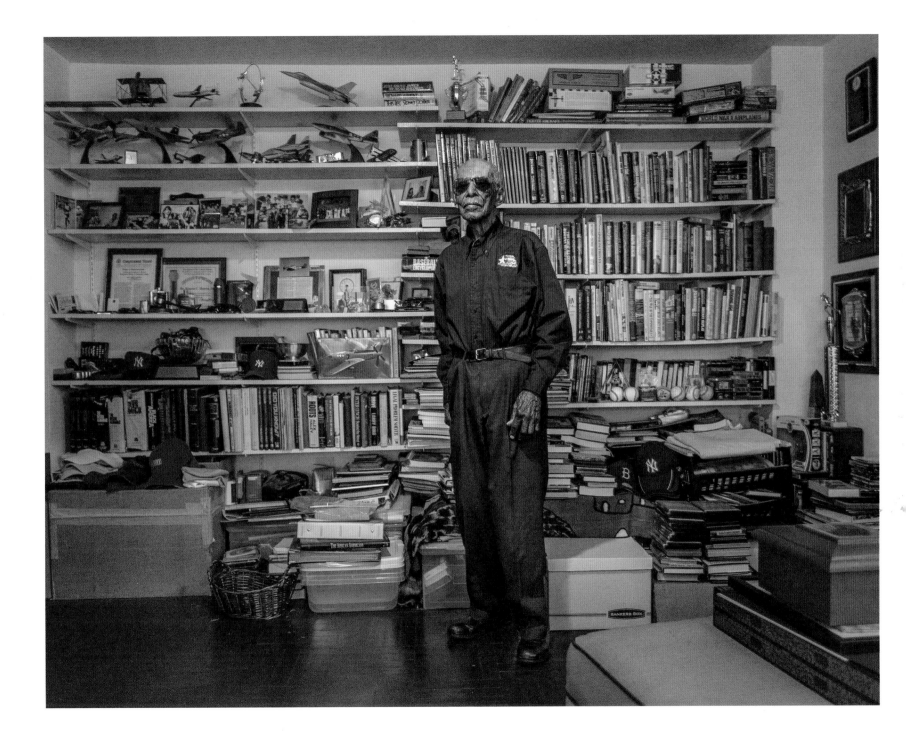

Endre Mordenyi

SZÉKESFEHÉRVÁR, HUNGARY

My name is Endre Mordenyi, and I was born on June 10, 1930, in Gödöllő, a town in Pest County, Hungary. I belonged to a traditional military family. My father also served as an army officer and moved to Gödöllő after World War I. I believe that I had the innate qualities of a soldier, as I had always observed a military environment in my home. When the war began in 1939, I was very young. I applied for military school in 1940, but I didn't get selected because of my poor health. In 1944, I applied again and got admitted to the Gábor Áron Artillery School. The school was located in Romania, but the Soviets invaded the Romanian front in the fall of 1944. The Romanian Army capitulated, and the school was moved to Sopron, Hungary. Later, when the Hungarian government escaped from Budapest, it moved to the same building where the academy was, so the school was moved again to Sümeg, a town north of Lake Balaton in Hungary.

I attended my first training session for four months in Hungary. During the training period, we didn't encounter any fighting, although a little accident happened on the railway lines and a few soldiers were injured. But thank God nobody died! After the training, we went to Bretzenheim in Germany, a few kilometers from our training camp. However, on the way there, American soldiers captured us and took us to a camp in Tirschenreuth, Germany. At first, I was afraid that I was in the custody of the Soviet Army but quickly realized that it was the Americans. The US forces were just closing and vacating this German town. Initially, there weren't many prisoners, but as soon as the war started to end, the US forces

brought more and more captives every day. There was not enough space for more prisoners in the camps, so the American soldiers placed us all in a field, where we used to spend our whole day on our knees with limited food.

We spent two weeks in that field, and there was almost no food, so every morning when we woke up, there were five to eight dead prisoners in the field. We were kept without food one time for four consecutive days. At first, there were American soldiers guarding us, but they soon left, and the French Army replaced them. The area was about the size of a European football stadium, and there were fifty such fields next to each other, which were all fenced with barbed wire. The prisoners were not supposed to cross the three-meter zone near the wire. One night, we were sleeping close to the boundary when we heard the guards shouting, and there was a flash of light. We saw a German prisoner trying to escape through the barbed wire, but the French soldiers shot him dead. After that incident, the guards used to fire shots every now and then as a warning sign for the remaining prisoners to stay in their place. We were really very scared of the French guards, because the American soldiers were much better trained. I remember once, a few prisoners tried to escape, but the American guards shot directly at their feet so that they couldn't run. The American soldiers were more capable than the French soldiers, and they abstained from killing the prisoners.

After a few months, we were transported to France, and while a group of us was escorted by a few soldiers through a town, the French people started throwing tomatoes and stones at us. There were no fatalities, but a few prisoners got injured. I got wounded by a stone to my head, but it wasn't too serious. When we were captured, I was just a student

of the military academy and not a soldier, because I wasn't even eighteen years old. However, I was wearing the wrong uniform, and the insignia on it reflected that I was an officer. The officers were separated in this camp from the soldiers, and the supply of food was a little bit better for them as compared with the other camps. And because of this uniform mix-up, I ended up in the camp with the officers.

In July and August, a few human rights organizations stepped up and started a dialogue with the government for the release of prisoners of war. There were all kinds of prisoners, including Germans, Russians, Hungarians, and Hungarian Germans. The Russians didn't want to go back to their country, because they had been captured by the French soldiers while they were fighting alongside the Germans, which meant that they would be executed or sent to another camp if they went back to the Soviet Union. In the end of October 1945, we were again transported to another camp. While we were traveling in the train, I was sitting near the door of a wagon carrying about sixty prisoners. Another train crossed us, carrying French people, and when that train was passing, the driver threw a big piece of coal toward us that hit my leg, and I got injured. Probably, the driver of the other train recognized us as German soldiers and saw our uniforms.

During that time, I was shuffled around eight different camps in Germany and France. The Voves camp was near Paris, and it was the central camp for French Foreign Legion recruitment. In this camp, a French officer came to us once and started agitating among the prisoners to join the French Foreign Legion. I think five or six people got recruited into the French Foreign Legion, and I later found out that two people from this group received a medal of honor in France. And two others were selected to come back

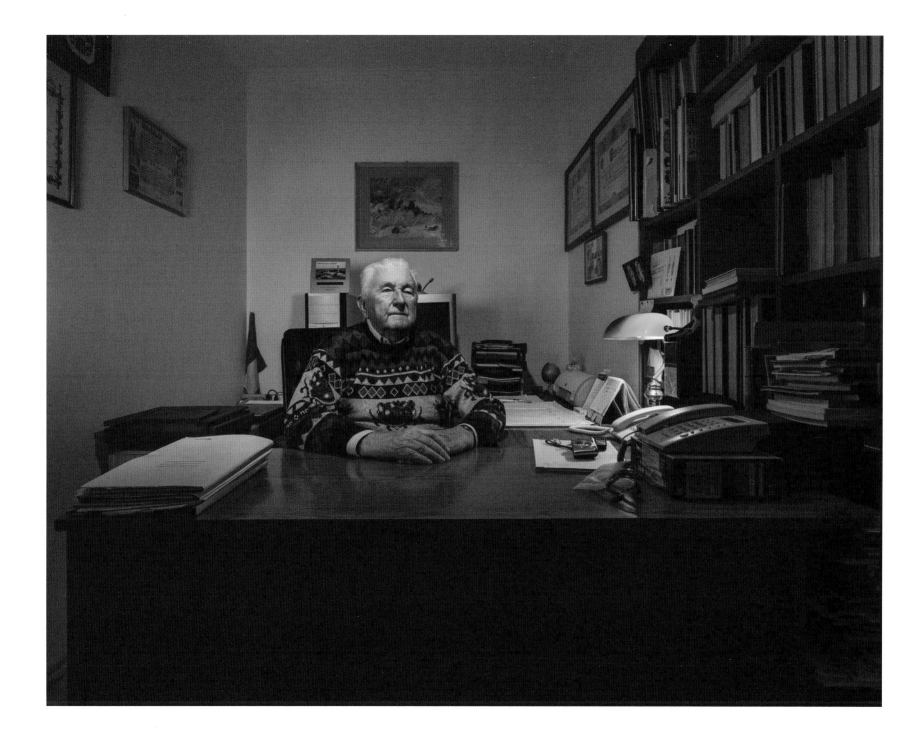

to Hungary and later participated in the Hungarian Revolution of 1956. But after it failed, they had to leave Hungary and only came back after 1990.

As for me, I was sent back to Kapsovár, Hungary, where I signed the papers of my release. I returned to our home in Gödöllő, where I found my mother and our house, which had been completely destroyed during the bombings. There were no windows or doors left in my home, and it was only a structure of bombed-out walls. I came to know that my brother and father also had been captured. My mother didn't know anything about them, but she got a letter in 1947 that they were being held somewhere in Russia. My brother was released later that year, in July, and my father came back to Hungary only in 1951.

I finished my school, and in 1950, I enlisted in the army again. I joined the army as a private and was promoted to a lieutenant after three years. Later, I enrolled in the reserve and began my training at the machinery technical school to get a job. In 1956, I got an invitation from the army to rejoin, as it was the beginning of the Hungarian Revolution. In a few days, I was made the leader of the national guard of Gödöllő. There were hundreds of guards, since there were around thirty-five Russian tanks in the city. On November 4, 1956, I went to the nearby barracks to get some three hundred machine guns for the guards. But the officers in the camps disappeared by noon, and later, by 10:00 p.m., all the soldiers capitulated to the Soviets.

However, we got lucky, because we didn't kill anyone during the revolution. But we were called several times to the police station for further investigation. I didn't have an alibi, so I was punished and got demoted to the rank of a private again. Having that on my record made it almost impossible to get a job, but I got lucky again, because a big factory opened

not far from Gödöllő and they were in desperate need for workers. The factory was manufacturing washing machine motors, and there were hundreds of people applying for jobs. I was a technician, so I easily landed a job there, and after just three months, I was also awarded for being the best employee. I worked in the factory for a few years and later moved to Budapest and got a job in a company that used to manufacture aluminum doors.

In 1968, the same company transferred me to Székesfehérvár, where it opened a new manufacturing plant. I stayed here and retired from work in 1979. I was still under surveillance for my active participation in the Hungarian Revolution of 1956. In 1980, I started my own business for manufacturing aluminum windows and doors. I stayed in that business until 2000. I was working from dawn till night. I also had two kids.

In 2000, I had a heart attack, and I was admitted to the hospital. But I escaped the very next day and sold my business in a few days, because my cardiac arrest was caused by a lot of stress. From then on, I believe that I have a healthy heart. Now, I'm helping veterans and their families in Székesfehérvár County, with the help of my wife. I'm editor of a website about local veterans, and we're working with several partner organizations here and in Budapest. We conduct regular general meetings of the county's membership organizations to improve our service for veterans and their families.

Chisako Takeoka

HIROSHIMA, JAPAN

My name is Chisako Takeoka, and I was born on February 3, 1925, in Hiroshima, Japan. When I was born, I was so weak my parents asked my uncle in Miyajima to take care of me. They believed that the clean air of Miyajima's mountains and water would help me get better, and they were right. It was such a beautiful place. I loved to be with nature, especially the deer there. After school, I would swim all the time. It was a wonderful experience. Once I felt better, I went back to Hiroshima and enrolled in women's school.

The war started when I was eleven. We were embroiled in a conflict with China. In my sophomore year at Yamanaka Girls' High School, they stopped teaching English. Because of this, I wasn't able to study to be a doctor, which was my dream. When I graduated, I went to work at a military weapons factory like everyone else. Outside the building, people thought that it was a factory for making jam, but we were making weapons inside. I was seventeen, making submarine artillery and bombs for the Japanese military.

In the early morning hours of August 6, 1945, I was walking home from an overnight shift at the factory. It was still dark outside. I had planned to go to Miyajima with three friends because we were off for the upcoming day. We agreed to meet at 8:15 a.m. at the Koi Station. As soon as I opened my door, there was a huge explosion. I was blown away and knocked unconscious.

When I woke up, my head was bleeding, and I was thirty meters away from my home, or what was left of it. My house didn't catch fire, but the wind blew it away. I looked up at the sky and there was a dark, gray cloud. The bomb detonated three kilometers from my home. I later found out that the cloud carried massive amounts of radiation. When it started raining that day, we called it the blood rain. It was hysteria. So many people were trying to escape the area. People were badly burned, awkwardly walking. Everybody wanted water. Everyone was looking for their family. I managed to get water for people, but I didn't have any medicine. There wasn't much I could do.

Later that day, I went to the top of a mountain to look down at Hiroshima, and there wasn't a single house in sight. Everything was burned to the ground.

The next morning, I went back into the city to find my mother. She was working as a nurse at an army hospital. She was so busy healing injured soldiers that she stayed at the hospital and rarely came home. While I was traversing the city, I saw thousands of dead bodies strewn about. I went to the factory I used to work at, but I couldn't see any coworkers who were still alive. I went to the Aioi Bridge, which was over the Ōta River. There were layers of dead bodies rotting in the river.

I was screaming out my mother's name in hopes I'd hear her. One body looked like it may have been her, but it wasn't. I closed my eyes and kept my mind set on getting to the hospital. When I finally arrived, there were so many dead bodies there as well. The bodies were so burned, you couldn't recognize any of their faces, so unfortunately, I didn't find my mother there.

I went to the Red Cross hospital next and saw what looked like three mountains of deceased bodies. I surveyed the entire city for six days but still couldn't locate her. I went to a school in Eba. There were many injured people there. I went into each classroom, and there was death everywhere.

I finally found my mother in one of the classrooms. She was badly burned, but still alive. Somebody had put bandages all over her face. I called her name many times. My mother's voice was weak, but she called my name back. There was a man who helped me with a cart to carry my mother out. She was badly dehydrated, as she hadn't had any water in six days. We put her body in a cart and brought her back home to me. There were so many flies on her body, it took three days to clean her.

My neighbors were so happy to have my mother back. One of my neighbors took the bandages off my mom, and we saw her eyes were badly burned; her eyeballs were falling out of the skull. She couldn't see anything. We had no food, no medicine. We couldn't do anything for her.

I was so mad. I wondered to myself who even started this war. I looked at the bomb as a killer that killed eighty thousand people at once. I couldn't forgive the United States for what they did.

Eventually, some doctors came from another city to treat injured people at a small elementary school in my neighborhood. I took my mother to the school. There were hundreds of people there. It smelled so bad—I can still remember the stench from all the burned bodies. I waited for three hours to see a doctor. The doctor couldn't do much for her because eyes weren't his specialty. All he did was rebandage my mother.

On our way home, my mother thought the doctor was my father, her husband. She couldn't see but could tell by his voice. I was so delirious from seven days of starvation that I didn't realize the doctor was my father! He didn't realize that it was my mother because she was so badly burned. I dropped my mother off, then went back to the school.

When I got there, he had left already. His shift was over, and he was driving to another city. I couldn't get in touch with him.

It was hard for Hiroshima to recover. After the war, Japan was so damaged. No one came to our city to help us. They were too busy repairing their own towns. We made small houses out of the trees we found by the river. They were so small, your leg would be outside the house when lying down. We drank water from the river, but there was no food. I lived in the mountains, so I ate the grass to survive.

Eventually, I took my mother to another hospital. People said there may be food, medicine, and doctors there, but the doctors had died by the time we got there. There was only one person there, and he was a veterinarian.

He said that we should take the eyes out of my mother's sockets. He didn't have the proper tools, but used a knife and took them out. I heard my mother screaming while they took her eyes out. It was so hard for me to hear this. It was so hellish, I resolved that war should never happen again. No one should have this experience.

I wanted to go to America and fight them, but in reality, I had no money and no plane or boat to even get there. In lieu of going to America, I decided to work for peace. I was a peace worker in Japan after the war.

I finally got to America in the '60s and met one of the people who created the atomic bomb. There was a big meeting at the United Nations in New York. I talked to him, and he apologized. He said that he felt sorry for the people in Hiroshima, and he could never sleep well after that day. He told me that when he was making the bomb, he didn't know how much damage it was capable of. He also said that since the bomb was dropped, he had been antiwar.

I pray for peace all over the world. I think it's so important for everyone. Weapons make human beings evil, and war is always taking someone's life. We don't always have to fight—we can talk things out. No more war.

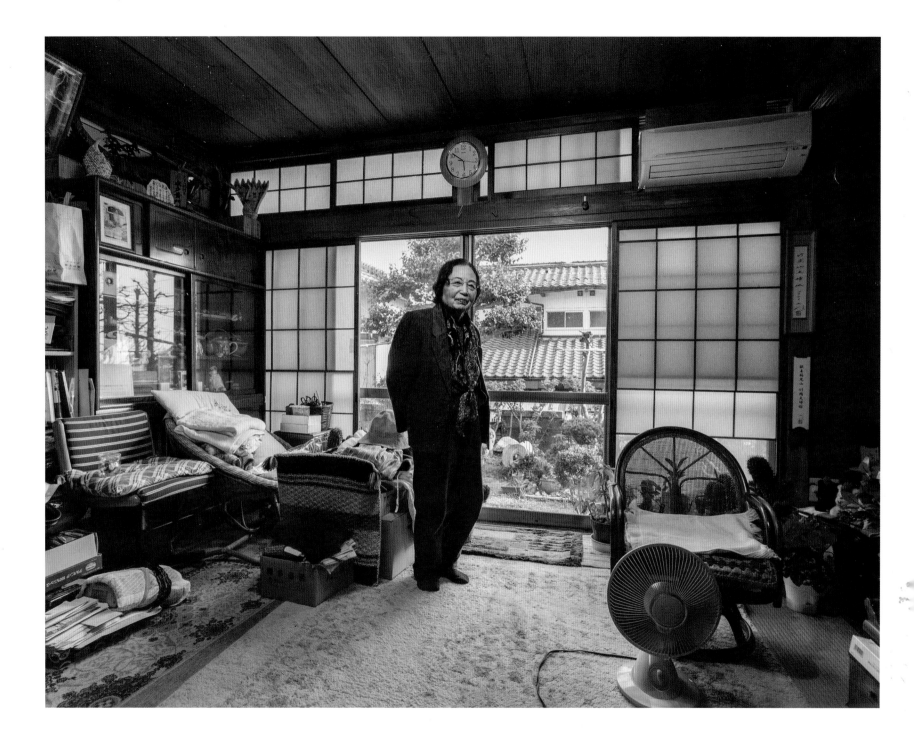

*This book is dedicated to my beloved grandmother Galina Vlasenko,
who has been everything for me and always will be.*

Thanks to the following
for transcribing and
editing the interviews:

Sarah Fahad
Andre Gee
Michael Kazepis
Netzayet Jones
Marina Pustilnik
Patrick P. Stafford

PUBLISHED BY PRINCETON ARCHITECTURAL PRESS
A MCEVOY GROUP COMPANY
37 EAST SEVENTH STREET, NEW YORK, NEW YORK 10003
202 WARREN STREET, HUDSON, NEW YORK 12534
WWW.PAPRESS.COM

EDITOR: SARA STEMEN DESIGNER: BENJAMIN ENGLISH

SPECIAL THANKS TO: JANET BEHNING, NOLAN BOOMER, NICOLA BROWER,
ABBY BUSSEL, ERIN CAIN, TOM CHO, BARBARA DARKO, JENNY FLORENCE,
STAN GUDERSKI, JAN CIGLIANO HARTMAN, LIA HUNT, MIA JOHNSON,
VALERIE KAMEN, SIMONE KAPLAN-SENCHAK, JENNIFER LIPPERT,
KRISTY MAIER, SARA MCKAY, ELIANA MILLER, JAIME NELSON NOVEN,
ROB SHAEFFER, PAUL WAGNER, AND JOSEPH WESTON OF PRINCETON
ARCHITECTURAL PRESS
—KEVIN C. LIPPERT, PUBLISHER

LIBRARY OF CONGRESS CATALOGING-IN-PUBLICATION DATA
NAMES: MASLOV, SASHA, AUTHOR.
TITLE: VETERANS : FACES OF WORLD WAR II / SASHA MASLOV.
DESCRIPTION: FIRST EDITION. | NEW YORK : PRINCETON ARCHITECTURAL
PRESS, [2017]
IDENTIFIERS: LCCN 2016038694 | ISBN 9781616895785 (ALK. PAPER)
SUBJECTS: LCSH: WORLD WAR, 1939–1945—BIOGRAPHY. | WORLD WAR,
1939–1945—VETERANS—PICTORIAL WORKS. | WORLD WAR, 1939–1945—
VETERANS—INTERVIEWS.
CLASSIFICATION: LCC D736 .M325 2017 | DDC 940.54/81—DC23
LC RECORD AVAILABLE AT HTTPS://LCCN.LOC.GOV/2016038694